TRANSIENT
LIGHT

A Photographic Guide to Capturing the Medium

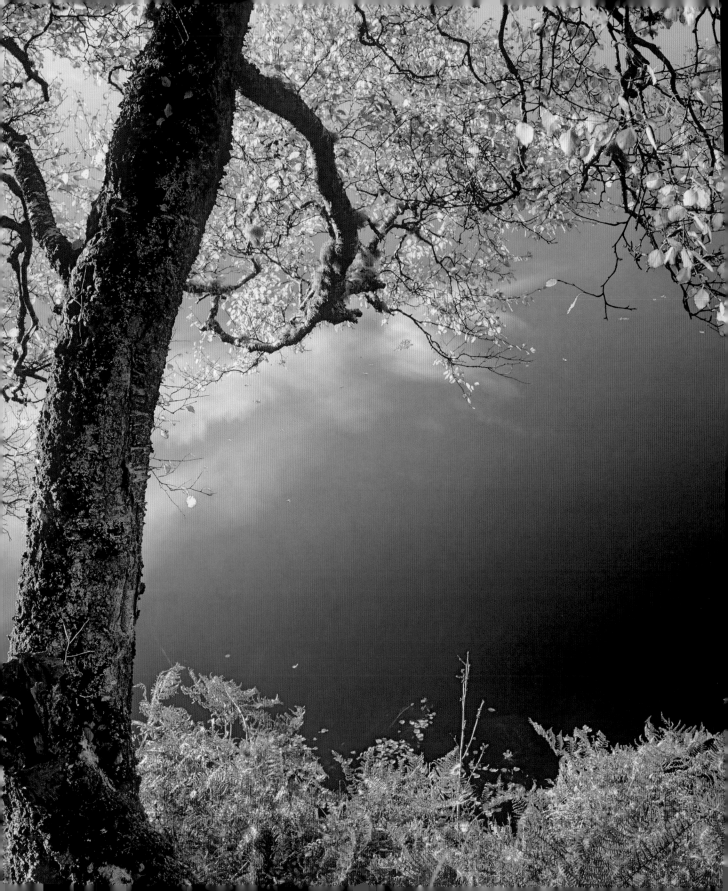

TRANSIENT
LIGHT

A Photographic Guide to Capturing the Medium

IAN CAMERON

photographers'
pip
institute press

First published 2008 by
Photographers' Institute Press
An imprint of The Guild of Master Craftsman Publications Ltd
166 High Street
Lewes, East Sussex BN7 1XU

ISBN: 978-1-86108-524-5

Associate Publisher Jonathan Bailey
Production Manager Jim Bulley
Managing Editor Gerrie Purcell
Project Editor Gill Parris
Managing Art Editor Gilda Pacitti
Designer Ali Walper

Set in Helvetica and Garamond
Colour origination by GMC Reprographics
Printed and bound in China by Hing Yip Printing Co. Ltd

CONTENTS

p24

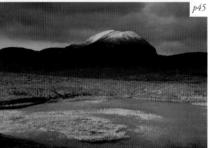

p45

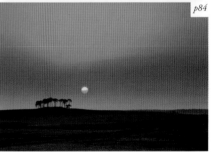

p84

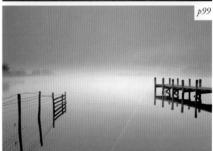

p99

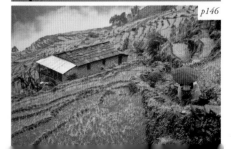

p146

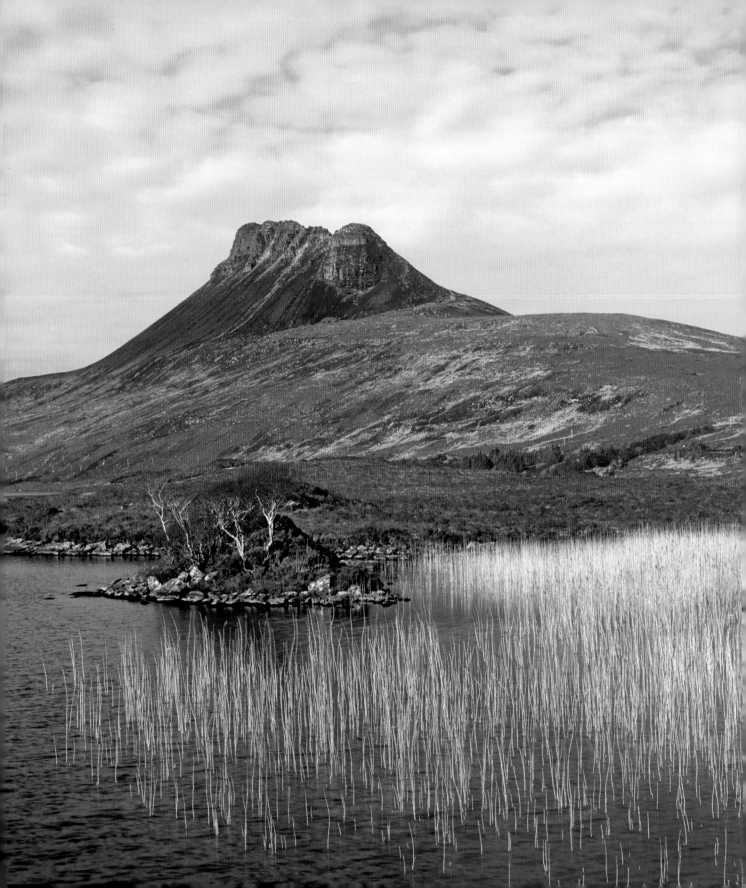

INTRODUCTION

Throughout history – way before the first emulsion was ever conceived – attempts were made to record or interpret the natural world. Whether this was done on an artists' sketch pad or in paints, it could take days, weeks, or even months to finish. The completed picture was often idyllic and romanticized, stemmed largely from the artist's own imagination and bore little resemblance to the original scene.

When photography came along, an image could be captured instantly and, despite its lack of colour, an accurate representation of a scene could be recorded, and so the seeds of a new genre were planted.

The technology developed, colour was introduced and gradually perfected, and photography became more cost effective and available to all. The consequences of this progress have had amazing repercussions: on the one hand photography enabled virtually anybody to bring back a memory of the places they had visited and yet, on the other, it condemned it to being the poor relation of art, its relevance diminished by the ease and speed of image capture.

Eventually, as in the world of traditional art, certain photographers became better known and more popular, imposing their own style. Slowly the commercial value of their work increased and became almost as desirable in some countries as traditional art.

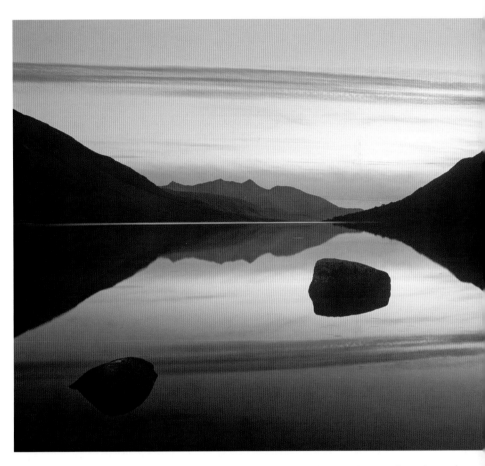

Historically, perhaps the most skilful landscape photographer was the American Ansel Adams (1902–84), who at that time took landscape photography to unprecedented levels. His classic monochrome work led to the creation of national parks and inspired future generations of photographers. At last landscape photography achieved the exalted level of being called 'art', at least by some.

ABOVE As twilight falls over Glen Etive, the wind dies and the loch becomes mirror flat, reflecting the hills and clouds perfectly.

• *Pentax 67II, 55–100mm lens, 0.45ND grad, f/22 at 12sec, Velvia* •

LEFT Stac Pollaidh dominates the surrounding Inverpolly reserve, its brooding shape in direct contrast to the shimmering reed bed below.

• *Pentax 67II, 55–100mm lens, polarizer, f/16 at 1/8sec, Velvia 50* •

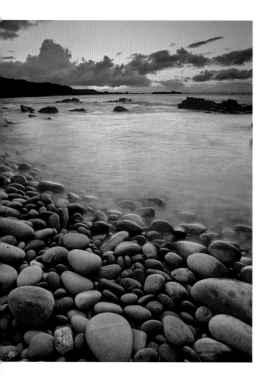

LEFT Pale-coloured pebbles, smoothed by the repeated action of the tides, line Cove Bay, Hopeman, at sunset.

• Pentax 67II, 55–100mm lens, 0.6ND grad down to horizon + 0.3ND grad across sky and water surface, f/22 at 6sec, Velvia 50 •

fraudulently imposing his own 'artistic interpretation' upon it. How ironic is it then, that modern day photographic technology offers even greater flexibility to change the faithful reproduction of a scene, than could ever have been envisaged by the old masters. Now photographers live under the burden of public scepticism and implied betrayal – a belief that, because an image can be altered, it therefore must have been.

Today landscape photography is as popular as ever. Ask any photographic magazine which branch of photography most appeals to their readers and the answer will undoubtedly be landscape. Landscape photography is generally perceived as easy, unhurried and relaxed. Alas, even with today's technology, it is rarely so: to regularly take top quality landscape photographs requires great skill and discipline.

This book sets out to de-mystify the art of landscape photography, to instil a coherent work flow from image conception right through to finished print, whether from a digital- or film-based source. However, I will not dwell on the technology of image production, but instead stress the supreme importance of subject matter, composition and above all light, and back it all up with sound technique.

The foundation stone of landscape photography is not post-production, but rather skilled and precise pre-production or, as I prefer to call it, quality, field-based technique.

Just as importantly, any workflow needs to be practical, not theoretical. It needs to be simple and automated so that when ice-cold water trickles down the back of your neck high on a remote hill, you remain unphased and assured in your ability to capture that elusive transient light. To that end, a significant proportion of the book is given over to field-based tuition, where the technical advice provided in the preceding chapters is put to good effect.

Finally, this book is not just another technical tome, merely reconstituting that which has gone before. Landscape photography centres around an emotional response to both light and land and I hope to convey that sense of emotion and passion to you, in the same way that it overwhelms and possesses me. They say that a picture is worth a thousand words; but to open a window and transport somebody into your world, a world that they not only see, but taste, and feel, so that it captivates their very soul – that is beyond words, and a goal worth striving for.

At each stage in its development there have been photographers who have set new milestones. The late Galen Rowell (1940–2002), who tragically died following his passion, epitomized a new breed of landscape photographer. He eschewed the traditional heavyweight, large-format equipment of his predecessors in favour of small, light, 35mm equipment, enabling him to travel light and fast and capture the very edge of the most dramatic light in the most inaccessible locations.

Photographers such as Galen succeeded in increasing the public's awareness and wonder at the natural world. Indeed, some of the light he captured was so extraordinary, and so rarely seen by others, that he was on occasions accused of

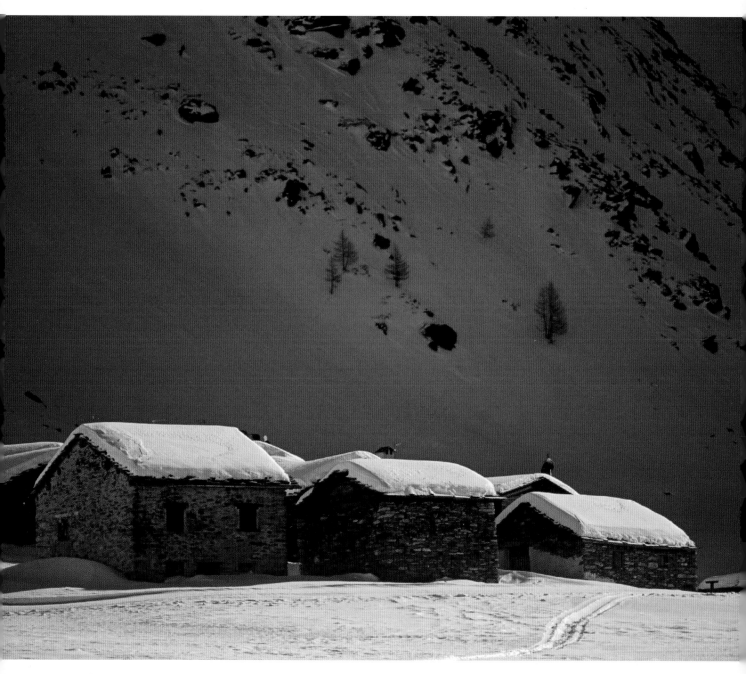

ABOVE Alpine huts glint brightly in the morning sun, high in the Italian Alps.

• Contax ST, 80–200mm lens, polarizer, f/16 at 1/30sec, Velvia 50 •

Understanding Light

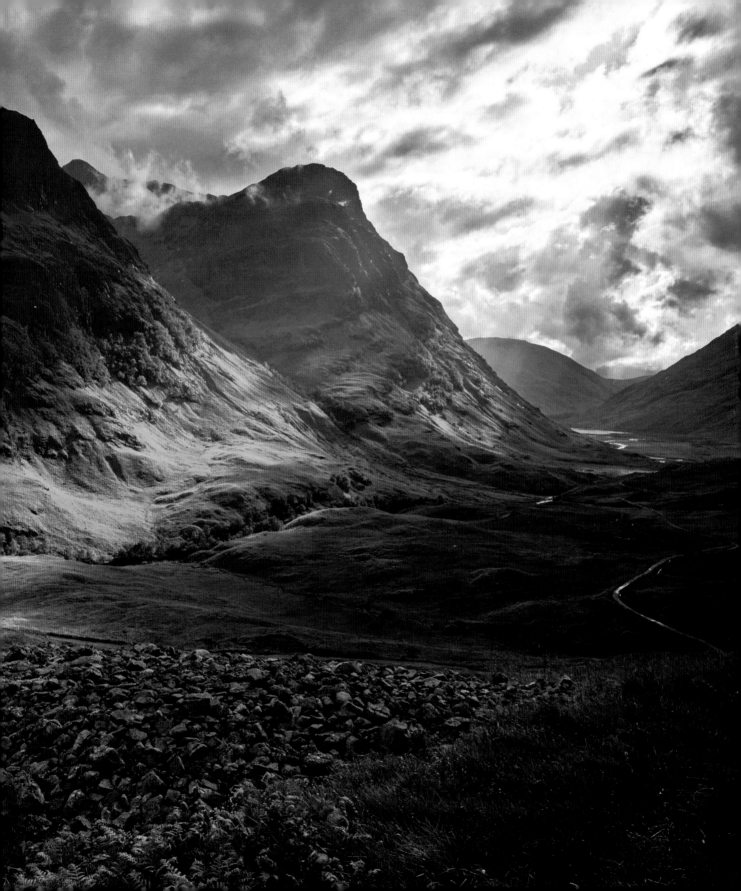

THE FUNDAMENTALS OF LIGHT

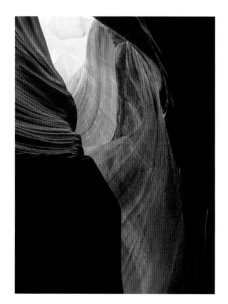

LEFT Midday sunlight filters down into the slot canyons, turning the inky depths into a cathedral of light.

• *Contax ST, 28–85mm lens, f/16 at 1min 30sec, Velvia 50* •

BELOW Reflected light strikes the underside of clouds prior to sunrise, bouncing light onto the velvet, grass-covered hills.

• *Pentax 67II, 200mm lens, 0.9ND grad, f/16 at 8sec, Velvia 50* •

Light is complex and relatively difficult to understand; it travels in waves and yet also has the physics of particles. It can be bent (refracted), bounced (reflected) and even split into its constituent colours. The photographer normally deals with visible light, although some exploit the infrared and ultraviolet extremes to unusual and ghostly effect. I will be dealing exclusively with the visible spectrum of light, whether naturally or artificially sourced.

The literal translation of photography is 'to write with light'. Light is the language of the photographer: it can be moulded and shaped and used to convey mood and atmosphere.

With most genres of photography the quality of light is of equal importance to composition and subject, all factors that influence the success and impact of the finished picture. However, the management of light is absolutely fundamental to the success of landscape photography.

For the landscape photographer, good-quality lighting can transform a scene from ordinary to extraordinary and relegate the other elements to mere supporting roles.

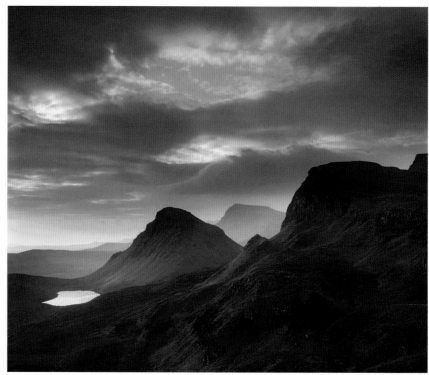

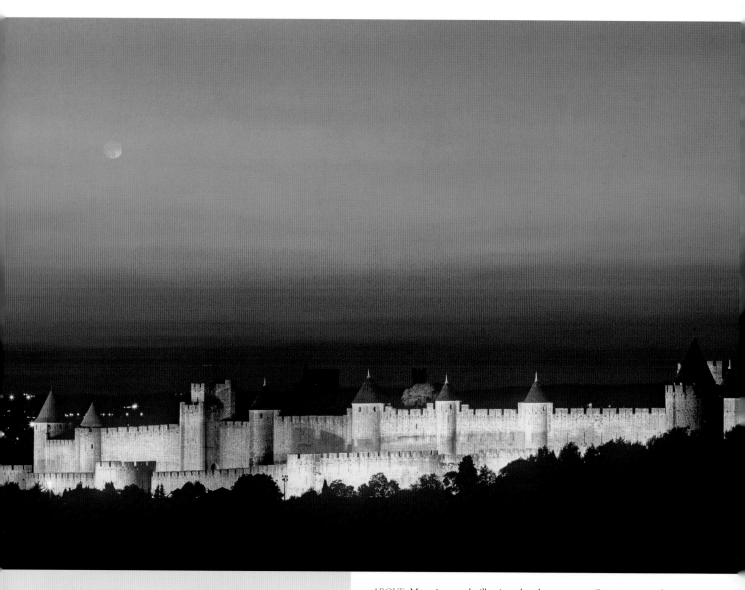

NATURAL LIGHT
- Sun/Moon
- Lightning
- Aurora

ARTIFICIAL LIGHT
- Commercial/ Man-made Lighting

ABOVE Moonrise over the illuminated castle ramparts at Carcassonne, south-west France, at twilight. • *Pentax 67II, 55–100mm lens, f/8 at 20sec, Velvia 50* •

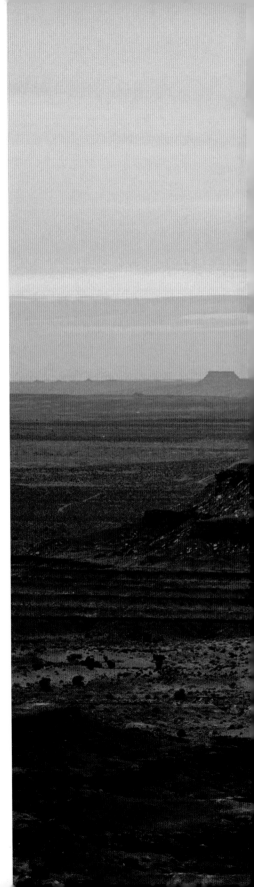

NATURAL LIGHT

Sun

Natural light is usually regarded by photographers to be sunlight; while it is by far the most powerful and influential source of natural light, whether direct or indirect, there are other sources, such as the eerie greens of the aurora borealis, the lurid light and atmosphere conjured by lightning strikes and even the phosphorescent glow from micro-organisms. These secondary sources of natural light are not often available to photographers and tend to be the preserve of the specialist.

Our sun is 93 million miles (150 million kilometres) from the earth; it is a massive ball of hydrogen, helium and other exotic elements in an ongoing fusion reaction. Light travelling 186,000 miles (300 thousand kilometres) a second takes approximately eight minutes to reach us.

Fortunately for mankind, the earth's atmosphere is little more than a gigantic filter, it removes a high percentage of ultraviolet light and other harmful radiation, yet to the photographer it means much, much more.

Clouds, mist and even atmospheric pollution reduce the sun's intensity; microscopic dust particles and water droplets refract and reflect light and consequently change its colour throughout the day.

As the earth is spherical and turns on its axis, near the beginning and end of each day the sun, for a short time, will be just above the horizon. Light from the rising or setting sun is at such a low angle that it has to pass through a comparatively thick tangential layer of disturbed atmosphere, choked with dust and debris. The consequence is significantly lowered light levels, to the extent that you can look directly at the sun's orb (still not with a lens). The bluer wavelengths of light are impeded, so the light becomes warmer and redder and any solid object the light strikes throws out long shadows creating texture and shape.

It is little wonder, then, that landscape photographers regard sunrise and sunset as the best and most exciting light of the day, referring to them as the 'golden hours'.

SAFETY WARNING

Even though it is so far away, looking directly into the sun on a clear day is virtually impossible and, to do so with a lens attached to your camera, would cause irreparable damage to the eyes.

RIGHT A tiny letterbox gap on a distant horizon allows the setting sun to peek through. The huge distances in combination with dust turns the light blood red.

• Contax ST, 80–200mm lens, 0.45ND grad, f/11 at 1/15sec , Velvia 50 •

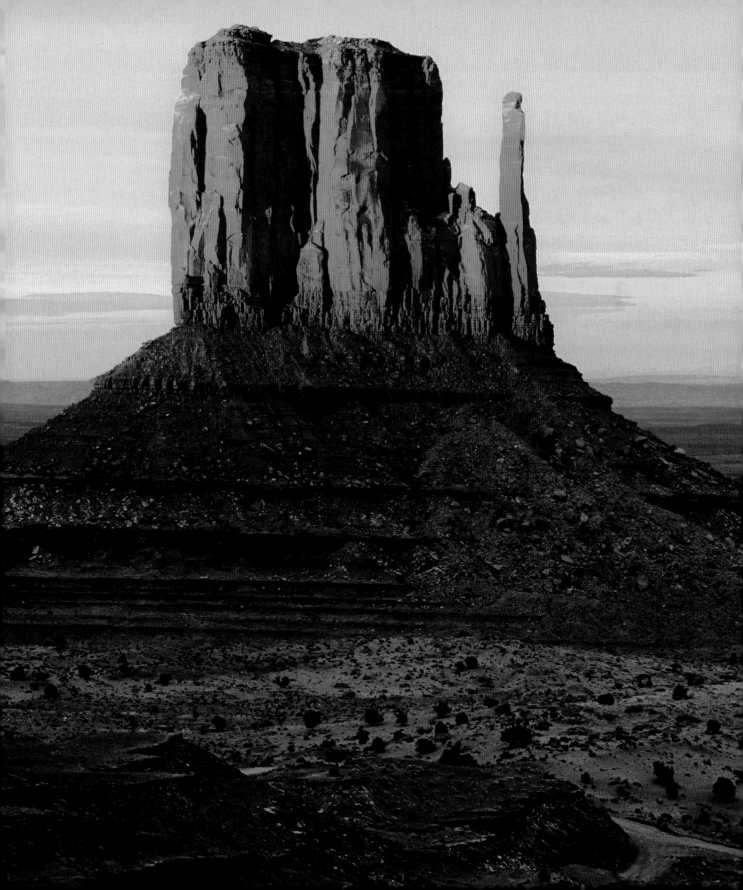

The Moon

Included under the umbrella of natural sunlight, is another astral body, the moon. The moon of course does not generate its own light, it simply receives direct sunlight in the same way our earth does, but does so a quarter of a million miles further away. It becomes visible and useful to photographers as our earth descends into darkness; then the reflected light of the moon becomes a subject in its own right, even providing landscape photographers with sufficient light to shoot by, though exposure times tend to be extreme and the results somewhat monochromatic. Including the moon in a landscape photograph, shot at night – or preferably during the twilight hours – is a useful option to consider, often providing an additional point of interest to an otherwise bland night sky.

PRO TIP

Beware of using a large depth of field, long lenses, or lengthy exposure times when including the moon in your landscape, as movement will blur its outline, due to rotation of the earth. Unless you photograph the moon at twilight, or shortly after it rises or sets, it will record as a featureless white disc.

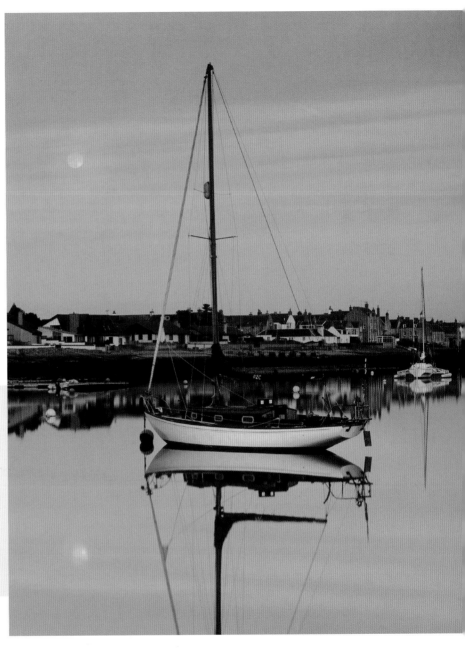

ABOVE A full moon rises into a twilight sky, reflected in still water. At this time of the evening detail is still visible in the moon's disc; as the evening progresses, the contrast increases until the moon's features are impossible to discern.

• Pentax 67II, 200mm lens, 0.45ND grad, f/8 at 1/2sec, Velvia 50 •

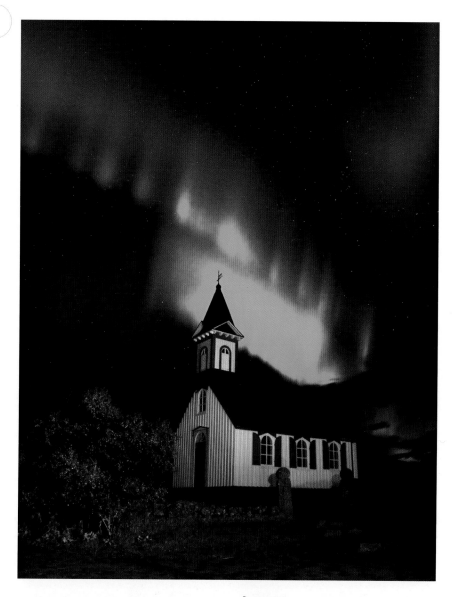

RIGHT A captivating picture by Icelandic photographer Orvar Artli, utilizing the flickering luminescence of the aurora borealis in a single Raw capture, double-processed for highlight and shadow detail, then digitally blended.

• *Canon EOS 30D, 16–35mm lens (additional illumination from LED torch), f/4.5 at 20sec, ISO 800* •

Lightning

This spectacular display of natural light can provide some truly inspirational photography. It is most intense in hot, humid climates and generated over vast, open spaces. The rate at which lightning is produced can vary from one or two flashes every couple of minutes, to several distinct flashes every second.

By far the most dramatic type of lightning is that which strikes the ground, as opposed to sheet lightning. It is of course unpredictable, but your chances of successfully recording it are increased many fold by the use of a wide-angle lens and the simultaneous use of long exposure times. Not only is the bolt of lightning going to be crisply recorded (lightning is a huge flash gun), but the ambient light from the resulting strike should contribute to illuminating the scene.

You needn't stop at one lightning strike either, if you want to magnify the drama then simply hold a dark card over the lens, anticipating when a second or third strike is likely to occur, recording these on the same frame and hence building up the required exposure time. A low ISO setting will assist in extending exposure time.

Aurora

This last type of naturally occurring light is the realm of the specialist photographer and occurs only at the more extreme latitudes; some photographers have exploited the astonishing beauty to good effect, mixing it with ambient or even artificial light to create surrealistic images with tremendous impact.

ARTIFICIAL/MAN-MADE LIGHT

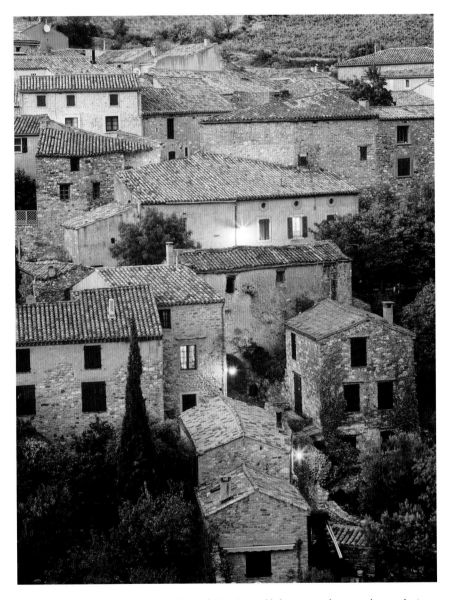

Although many photographers do not permit any artificial or man-made influence in their landscape photographs, to eliminate all trace cuts down another weapon in their armoury. Human beings have helped shape the landscapes that we see today and not all of it has been adverse. Many so-called wilderness areas have been very skilfully managed to minimize disturbance to the land. Woodland will be randomly thinned to allow light to reach the forest floor stimulating new growth, while controlled burns strip out old growth material and bring about seed germination. In some places man and landscape combine seamlessly and the scenery is considerably enhanced by human presence.

When humans coexist with the land they supplement natural light with artificial. Light is used to illuminate the streets, homes and offices. As darkness falls and colour drains from the land, artificial lighting provides the landscape photographer with an intoxicatingly beautiful combination of both natural and artificial light.

ABOVE A subtle blend of colours, created by artificial and natural light, intermingle in a much more pleasing way than if this were taken in single source light.

• Pentax 67II, 200mm lens, f/16 at 30sec, exposed during the period of crossover lighting, Velvia 50 •

PROPERTIES OF LIGHT

Distinctive landscape photography is much more about creating atmosphere and an emotional response, than a visual record of the scene. Landscape photographers do this by managing light, and understanding how it reacts with the medium it's recorded on.

Our eyes are remarkable tools, they are able to distinguish upwards of thirteen stops of light between pure white and jet black. Whether you use film or pixels to record an image, a camera's ability appears to be woefully inadequate; five stops is the very best you can hope to achieve, without resorting to filters or blending exposures. Not only that, the brain automatically processes the information accumulated by the eyes and removes colour casts, while a camera faithfully records them all, whether you want it to or not. Ironically, a camera's inability to deal with colour and dynamic range can be utilized to the photographer's advantage, to enhance both mood and atmosphere.

Three factors, all working in conjunction with each other, govern the successful interpretation of mood:

- Quantity of light
- Colour of light
- Quality of light (direction)

All the above are subject to significant variation throughout the day and all of these factors affect each other. It is therefore impractical to discuss one without referring to the other.

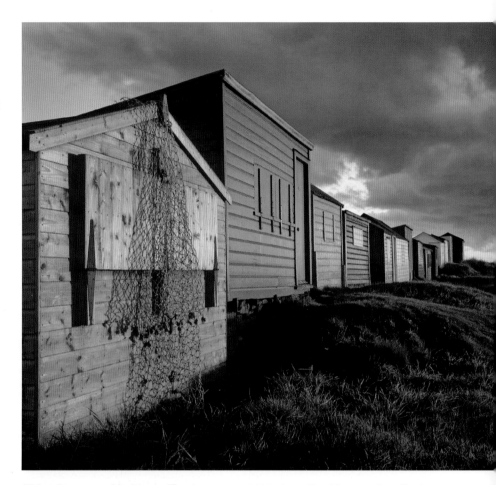

ABOVE A row of beach huts, transformed by the magic of low sunlight, surging beneath heavy cloud.

• Pentax 67II, 55–100mm lens, polarizer, f/22 at 1/2sec, Velvia 50 •

QUANTITY OF LIGHT (EXPOSURE)

Just as our eyes are able to govern the amount of light received at the retina, so a camera can mimic the human eye, regulating the amount of light that hits the image sensor, or film. If these receive too much light, then detail in the brighter areas is lost, becoming pure white, whilst shadow areas appear insipid, with no true blacks.

Conversely, underexposure causes shadows to record jet black, with large areas of the picture blocking up. Occasionally, no matter what your choice of aperture and shutter speed, it is impossible to hold detail, as the range of tones, from pure black to dazzling white, exceed the film or sensor's ability to record it – something photographers refer to as dynamic range. Under these circumstances you either accept its shortcomings, choosing the best compromise, or you try and use filters, or a blending of multiple exposures, to moderate it. In truth there isn't really a correct exposure, only the exposure you choose to use to interpret a scene.

PRO TIP

A correct exposure is one that you, the photographer, assign to a scene, not one that is deemed correct by your camera. Used intelligently it can influence mood and atmosphere.

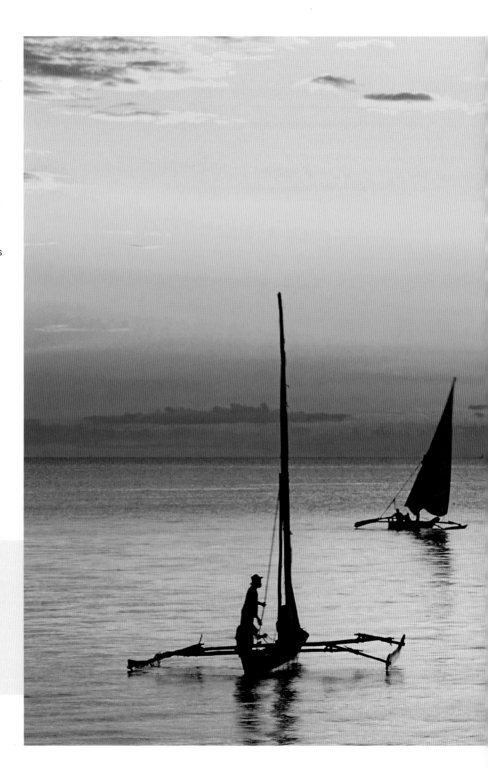

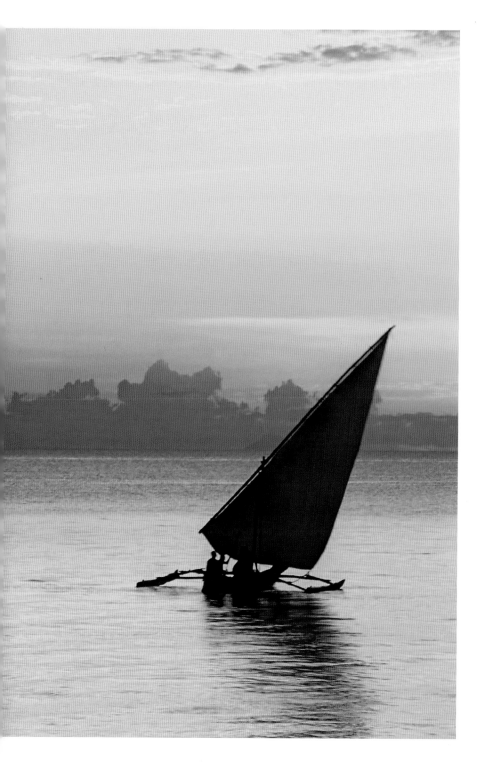

The quantity of light recorded by a camera can be altered in four ways:
- Changing the intensity of the light source
- Adjusting the sensitivity of the image sensor (film ISO)
- Altering the lens aperture (f-stop)
- Changing the period of time over which the light is received (shutter speed).

These four parameters, working together, can be adjusted to ensure a correct exposure; moderating any one will require a corresponding shift in the other to maintain correct exposure.

Changing the Intensity of the Light Source

This would normally be done in one of two ways: either by moving the light source closer to, or further, from the subject. Light intensity decreases at a rate inversely proportional to the square of the distance away from it, meaning that if you double the distance from subject to light source, then the light received by the subject will reduce fourfold. For the landscape photographer, this is of little consequence as 93 million miles plus or minus 10 feet, is still 93 million miles.

Another option is to reduce the intensity of light reaching the sensor or film by partially obscuring the light entering the camera. The presence of clouds or mist will do this quite naturally but, if you wish to offer a little assistance, then the addition of neutral-density filters to the front of your camera lens will achieve a specified reduction in light levels.

LEFT A magical sunrise was deliberately underexposed by a half stop to saturate colour and render the dhows in silhouette.

• *Contax ST, 80–200mm lens, f/8 at 1/125sec, Velvia 50* •

Adjusting the Sensitivity of Camera ISO

In the past a photographer was offered a huge choice of films from many different manufacturers, and each had its own distinctive colour palette and character, e.g. transparency, negative, monochrome (black and white). Other films responded to different wavelengths of light, such as infrared, but the biggest variable of all was film speed, and this was specified in terms of its ISO rating, or sensitivity to light. The higher the number, the more sensitive the film (faster) and the less light required to record a decent exposure.

Whichever film was loaded into the camera, you were stuck with the same ISO rating for the entire film. As far as most film-based landscape photographers are concerned, this particular parameter is more or less an unalterable constant.

Not so with digital; the image sensors of digital cameras offer considerable flexibility. ISO ratings can be changed from a lowly 50 right up to 3200 and beyond, and the desired change in sensitivity can be made on a frame-by-frame basis.

Even in the digital age you still don't get something for nothing; the stark truth is that landscape photographers rarely lift the ISO ratings of their digital cameras above ISO 200, as the quality tends to deteriorate. However, this extra flexibility is most welcome in testing conditions that might stump the film shooter, and the quality is improving all the time.

BELOW The use of a grainy film complements this atmospheric harbour shot, adding grit and texture to an industrial scene.

• Contax ST, 80–200 zoom, f/16 at 1/30sec, Fujichrome Provia 400 •

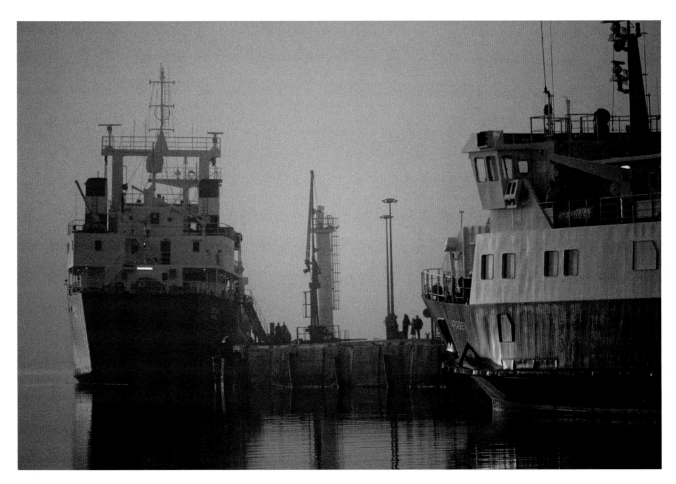

Altering Lens Aperture and Shutter Speed

These last two parameters are the primary means of adjusting the light that strikes the recording medium, and those that are most often used by the photographer to determine correct exposure. Both functions have a direct bearing on each other, so will be dealt with together.

Many camera lenses have a series of markings around the barrel which relate to its aperture. The sequence of markings usually ranges from f/1.4 for a short focal length, fast high-quality prime lens, up to a more leisurely f/5.6 or so, for a slower, standard zoom lens. The same sequence of numbers will often continue to around f/22 or f/32, which represents a tiny aperture for light to squeeze itself through. Each marked aperture in the sequence is universally referred to by photographers as an f-stop and each one in the series (shown below) represents a one-stop reduction (half as much) of light getting to the film/sensor.

F1.4	F2	F2.8	F4	F5.6	F8	F11	F16	F22	F32

Ironically, fast lenses are of limited use to the landscape photographer as, although the quality is undeniably high, their weight and size can be prohibitive in the field. Landscape photographers tend to operate with small apertures – f/16 or f/22 – in conjunction with slow shutter speeds to realize the correct exposure for a scene, so wide apertures are used less. My preference is for light, small, extremely high-quality glass.

The final means of governing the amount of light received, directly under control of the photographer, is exposure time, namely moderating the period of time that the camera's shutter is open. A series of numbers, each approximately half the duration of the previous one, can be selected on the camera by altering the shutter speed dial (see below).

4sec	2sec	1sec	–	–	1/8	1/15	1/30	1/60	1/125

The shutter speed and aperture are inversely proportional to each other: if you halve the shutter speed, you need to increase the aperture by one stop to permit the same quantity of light to reach the film or sensor. The old adage that a candle that burns twice as bright, burns half as long applies.

ABOVE The Pentax has the apertures on the lens and a separate shutter speed dial, which can quickly be set manually.

The relationship between shutter speed, aperture and ISO is shown in the table below.

ISO100	F2.8	F4	F5.6	F8	F11	F16	F22
	1/30	1/15	1/8	–	–	1sec	2sec

ISO200	F2.8	F4	F5.6	F8	F11	F16	F22
	1/60	1/30	1/15	1/8	–	–	1sec

A quick glance at the table for ISO 100 shows that if the exposure for a particular photograph is deemed correct with the aperture set to f/4 and a shutter speed of 1/15sec, then it is also correct at f/22 and a shutter speed of 2sec. Should the sensitivity be changed to ISO 200, the overall exposure in terms of the combination of aperture and shutter speed can be halved.

COLOUR OF LIGHT

The human eye, in conjunction with the brain, is adept at normalizing visual information. It is not readily apparent that such visual processing is taking place until we look at the results presented to us on a monitor, or on transparency film directly out of the camera. All too often strong and unpleasant colour casts become apparent. Most people have seen evidence of this in their photography at some stage, for example bright orange prints coming back from the processors, where the subject has been photographed indoors under tungsten light.

Light has colour, and natural light changes colour throughout the day. Our eyes adapt accordingly; a camera doesn't have this capability, it needs to be made aware of the colour temperature of the light that is present. The colour of light is represented in terms of degrees Kelvin; the higher the colour temperature, the bluer the light.

Kelvin Colour Temperature Scale

LIGHTING	COLOUR OF LIGHT	TEMPERATURE	FILTER
Candle light	Red	2000K	80A Blue
Sunset	Red/orange	2500K	
Tungsten	Orange	3000K	80B Blue
Golden hours	Yellow	4300K	
Fluorescent	Green	–	FLD filter violet
Midday sunlight	White	5500K	None
Overcast	Cool white	6000K	
Cloudy	Blue	8000K	
Open shade	Deep blue	10000K	81B Yellow

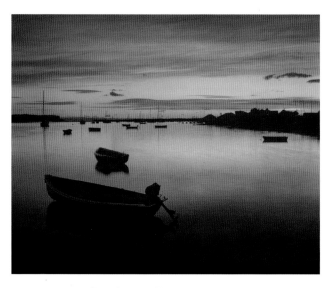

ABOVE An intense flush of crimson fills the evening sky, which is reflected in the still waters of Findhorn Bay, a full hour after sunset.

• *Pentax 67II, 55–100 lens, 0.45ND grad, f/22 at 45sec, Velvia 50* •

BELOW Morning sunlight streams over the distant Cairngorms, causing the mist-filled bowl of the Spey valley to glow with astonishing luminosity.

• *Contax ST, 80–200 zoom, f/16 at 1/30sec, Fujichrome Velvia 50* •

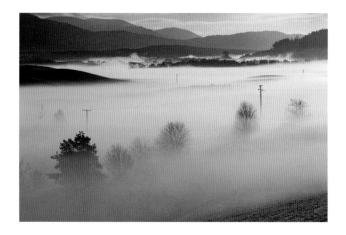

Midday sunlight (approx. 5500K) is the commonly used reference point; most daylight film is balanced to this value and it is the value to which the white balance of most digital cameras is set.

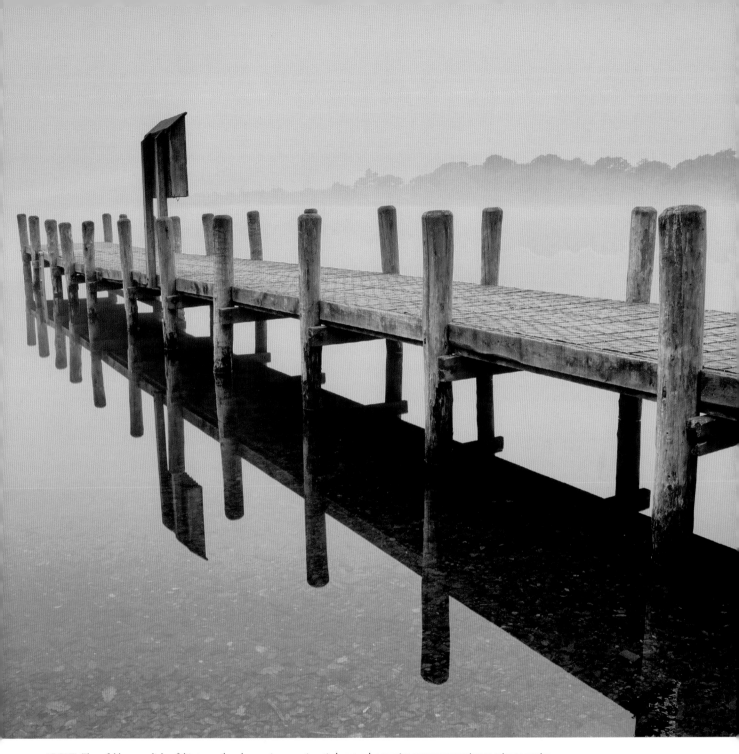

ABOVE The soft blue-tone light of this tranquil, early morning scene is entirely natural, occurring some twenty minutes prior to sunrise, but the effect is exaggerated on film by reciprocity failure. • *Pentax 67II, 55–100 lens, 0.45ND grad, f/22 at 45sec, Velvia 50* •

BELOW The same scene shot at the same time of day, two days apart: the first in raking early morning sunlight represents a colour temperature around 3500K; the other, beneath a white, cloudy sky after a dusting of snow, colour temperature approximately 6500K.

• Contax ST, 28–85mm lens, polarizer, f/22 at 1/2sec, Velvia 50 • *• Contax ST, 28–85mm lens, polarizer, f/22 at 2sec, Velvia 50 •*

Most landscape photographers prefer the cosy glow imparted by warm light so, despite the golden hours being markedly different from the midday standard (5500K), this warm shift feels both natural and desirable.

Colour-compensating filters tend to be used to correct colour casts in film cameras. Digital cameras use their white balance settings to offset colour casts; by default they are set to Auto and under most circumstances that is a perfectly reasonable option.

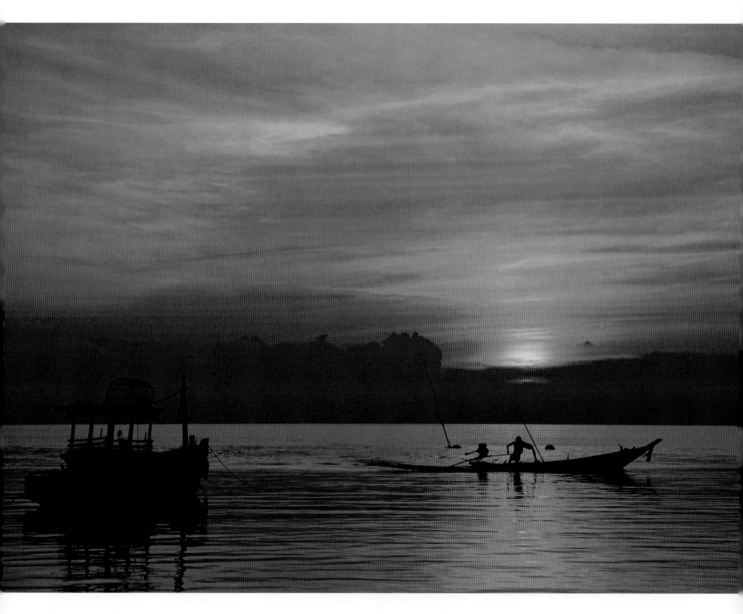

However, those digital photographers that shoot in Raw mode don't need to bother with white balance at all – save for a satisfactory output appearing on the LCD display of their camera, white balance can be changed later in Raw processing software.

I rarely intervene to influence colour temperature, preferring instead to let the colour balance select itself; even to the point of permitting the film I use the opportunity to impose its own colour palette.

ABOVE A tranquil sunset paints the sky with soft orange light; rather than attempt to correct a colour temperature of 2500K, a great many photographers might choose to enhance it still further with an 81B filter.

• Contax ST, 80–200mm lens, 81B warm up, f/5.6 at 1/90sec, Velvia 50 •

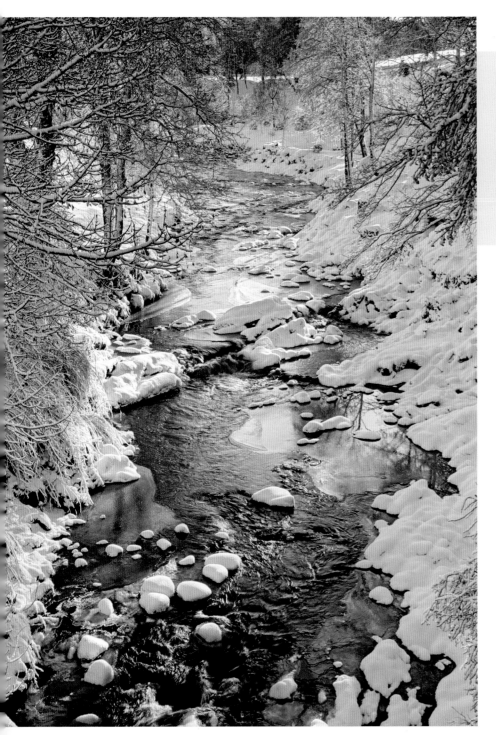

The colour of light creates mood and ambience; understanding that light changes colour gives you the power to dictate its effect, but choosing whether or not to correct for it is entirely up to you.

LEFT A picture that works effectively because of the subtle blend of warm and cool colours; adding a warm-up filter would have exaggerated the pink glow at the expense of the opposing hue.

• Pentax 67II, 55–100mm lens, polarizer, 0.45ND soft grad, f/16 at 1/4sec, Velvia 50 •

QUALITY OF LIGHT

A familiar scene can look very different from one day to the next, due to the quality of the light that strikes it. At the risk of labouring a point, it is fundamental to landscape photography; it is the single biggest influence on my own artistic endeavours and the yardstick by which I measure the quality of my own work.

The quality of light is influenced by the colour, quantity and the direction of light that strikes a scene. Our sun is a single-point light source; untethered by cloud cover, it produces shadows of various length, shape and density, dependent on season, latitude and time of day. Shadows shape the landscape giving it texture and form, emphasizing and de-emphasizing various aspects of a view. Unlike the stereo vision of our eyes, a camera has to represent a scene in just two dimensions. These same shadows give depth and vitality, enabling a successful photograph to be made. If you add to this the ingredients of light of different strength and colour, a familiar scene will display an astonishing variety of moods, even though captured on successive frames just a matter of minutes apart.

RIGHT Both these shots were taken within 15 minutes of each other and show an astounding difference in the quality and the colour of light, even in such a short space of time. At other times of the year you probably wouldn't give this view a second glance.

• Pentax 67II, 55–100mm lens, polarizer, 0.6ND grad, f/16 at 1/8sec, Velvia 50 •

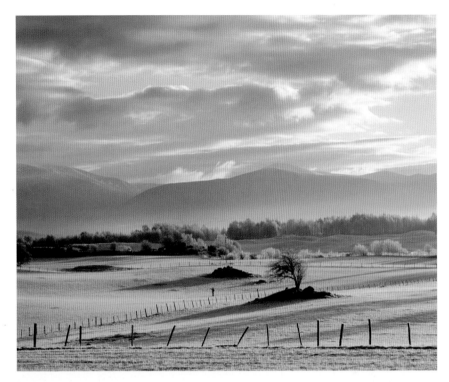

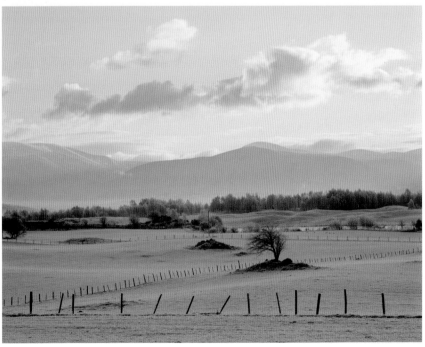

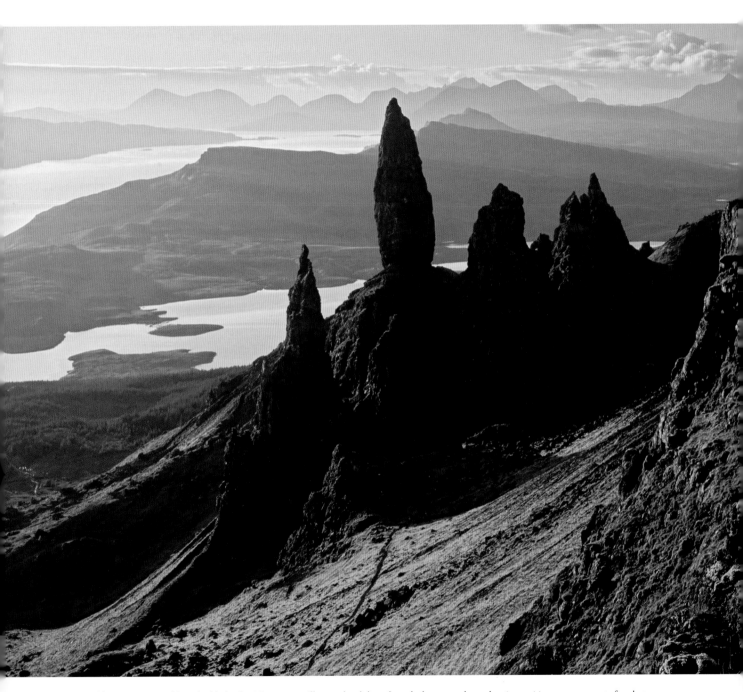

ABOVE The granite spires of Storr, backlit by the rising sun, are silhouetted and throw long shadows towards my shooting position across a carpet of verdant grass.

• *Pentax 67II, 200mm lens, polarizer, f/16 at 1/4sec, exposure taken from sunlit grass, Velvia 50* •

DIRECTION OF LIGHT

A landscape photographer will encounter many types of light in the field and some will inevitably be more appropriate than others for best interpreting a scene. Recognizing the type of light you encounter will ensure its correct management, and assist in the making of a memorable photograph.

Below is a list of the types of lighting that make up a landscape photographer's diet:

- Overhead lighting
- Front lighting
- Side lighting
- Back lighting
- Diffuse light
- Ambient light
- Transient light

Overhead Lighting

Direct overhead lighting is most likely to occur during the middle of the day. It is characterized by very short, deep-black shadows. The light tends to be extremely intense and often high in contrast, enabling small apertures and relatively fast shutter speeds. Colours are weak and washed out with atmospheric haze being generated that further reduces image clarity. During the middle of the day a typical scene appears flat, lifeless and two dimensional. Most landscape photographers regard this light to be poor, claiming that it kills mood and atmosphere.

However, there are some circumstances where direct overhead lighting is the only useful light: slot canyons and steep-sided gorges – black and lifeless at the extreme ends of the day – miraculously blaze with colour and luminosity as direct overhead sunlight bounces off the sides of the canyon, adopting its hue and colour and projecting it to the valley floor below.

Coastal scenery can also benefit from the intense light of midday sun penetrating the depths of the sea, bringing it to life with luminous vivid colour, particularly in conjunction with a polarizing filter.

RIGHT Direct overhead lighting reveals the colour and luminosity of the sea, particularly in conjunction with a polarizer, which removes surface glare.

• *Contax ST, 28–85mm lens, polarizer, f/16 at 1/90sec, Velvia 50* •

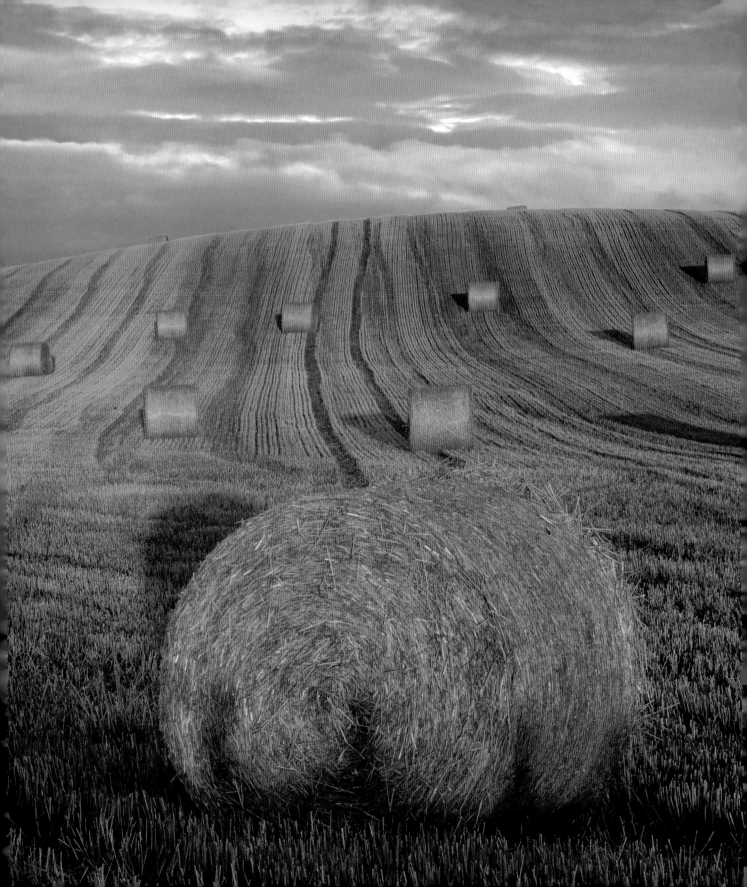

Front Lighting

Front lighting is the most basic kind and the easiest to expose for. The sun is directly behind the photographer and shadows fall sharply away behind the subject, rendering them invisible. It is the most commonly used light and the lack of visible shadows tend to create two-dimensional results; it can, nevertheless, be used very effectively, especially if the sun is close to the horizon, where the low colour temperature of the light adds greatly to the mood of the scene. A polarizer, often used to intensify colours, is not effective in this plane.

Side Lighting

This is the bread-and-butter light of landscape photographers and generally their favourite – long, raking shadows scythe horizontally across the landscape, creating crisp three-dimensional imagery and bringing scenes to life. If that wasn't enough, a polarizing filter is at its most effective with side lighting and can be used to devastating effect, vividly enriching the resulting image so that it literally bursts with saturated colour.

PRO TIP

Polarizers can cause the shadows to block up to pure black. You can abstain from using one, or weaken the effect by twisting the polarizer away from maximum effect to soften its impact on the picture.

PRO TIP

With front-lit scenes, make sure that your own shadow doesn't intrude into the photograph you're taking. Use an uneven foreground, or water, to break it up and render your shape indistinct.

LEFT Warm summer sunlight washes over a newly cut field of straw bales, the shadows falling directly behind the subject.

• *Pentax 67II, 55–100mm lens, 0.3ND grad, f/22 at 1/4sec, Velvia 50* •

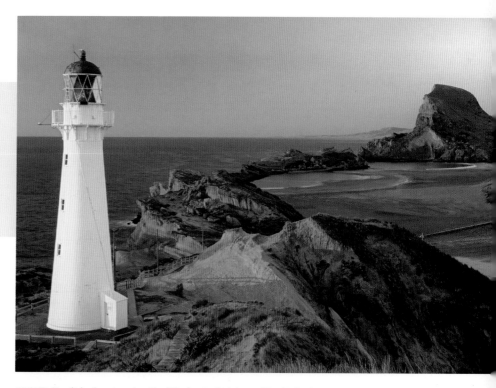

ABOVE First light slams into the side of Castlepoint Lighthouse, New Zealand, creating texture, colour and shadows, helping to recreate a three-dimensional portrayal. A polarizer improves the colour saturation still further.

• *Contax ST, 28–85mm lens, polarizer, f/16 at 1sec, Velvia 50* •

Backlighting

The most dramatic type of lighting occurs when a scene is backlit. It requires very careful management of the light and a good understanding of what is likely to be recorded. If direct light from the sun is not extremely low, is partially concealed behind mist, or it is not masked by a solid object such as a rock or a tree, then flare will result and the image will be worthless. With scenes such as this, the contrast is likely to be considerably greater than your camera's ability to record it, so the exposure will need to be biased (probably towards the brightest area), so that those parts of the image that are a little darker record as stark silhouettes. It is also likely that the silhouetted shapes will need to be separated so that they don't overlap, otherwise the integrity of any distinctive shapes will be lost. For sheer drama, backlighting is almost unbeatable.

PRO TIP

Under backlit conditions, it is worth bracketing exposures, as a very slight change will bring about a totally different mood. A polarizer is ineffective under backlit conditions.

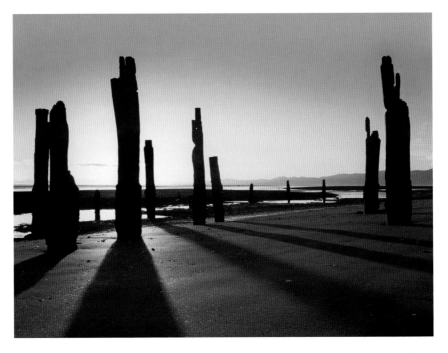

ABOVE Hiding the sun directly behind one of the wooden posts is the only solution to photograph this strongly backlit scene, allowing light to spill around the side of solid objects rendered in silhouette.

• Contax ST, 28–85mm lens, 0.9ND grad, f/22 at 1/4sec, exposure off sunlit sand, Velvia 50 •

Diffuse Light

Given a choice, nearly all landscape photographers crave direct sunlight to illuminate a scene. However, there are some situations that positively demand soft, even illumination, that which occurs beneath a thick, white mantle of cloud. The colour temperature of this light is optimal at 5500K, which gives rise to subtle colours that glow with vibrant intensity. Diffuse light has the ability to penetrate deep into dark places like dense woodland, gorges and waterfalls. In these situations, the presence of sunlight would result in unmanageable levels of contrast. Beneath soft, diffuse light the film or sensors' ability to record a scene is greatly enhanced, such that even the brightest and darkest areas contain a wealth of visual information.

PRO TIP

Under diffuse lighting a polarizer can prove extremely effective, intensifying those colours already present still further, and eliminating surface reflections.

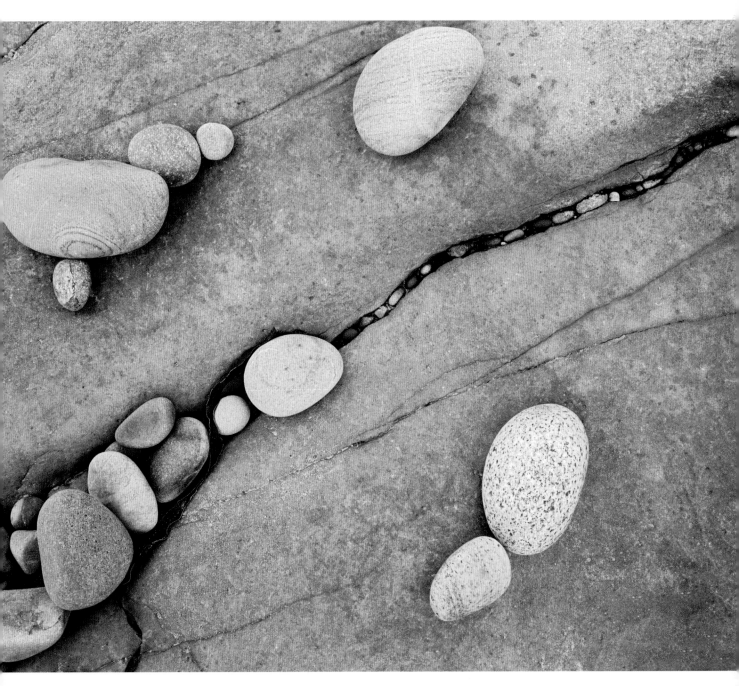

ABOVE Diffuse lighting is ideal for bringing out the delicate colours in shots containing fine detail, such as the stones blocking this vessel in a sandstone slab. The shadowless light ensures maximum detail.

• *Pentax 67II, 55–100mm lens, polarizer, f/16 at 4sec, Velvia 50* •

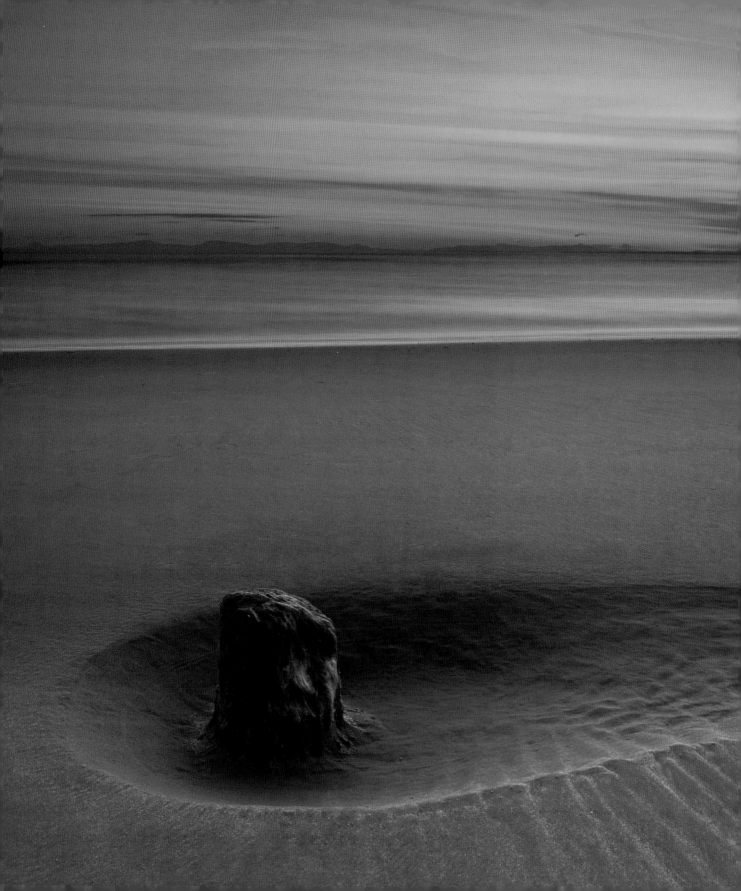

The rules of reciprocity outlined below break down for film-based cameras when exposures are in excess of a few seconds. If no additional exposure time were added, over and above that of normal reciprocity, then underexposure would result and also a shift in colour, dependent on the type of film used. This colour shift is often considered desirable, but additional time should always be calculated for reciprocity failure.

Ambient Light

Similar to diffuse light, it is soft and shadowless, but ambient light occurs at the extreme ends of the day, in the twilight hours before sunrise and after sunset. The colour temperature of ambient light tends to be either very low (reddish) or very high (bluish). Ambient light is coloured, it has been reflected and tinted by the presence of another object such as overhead sky, low cloud, a canyon wall, or other large surface. It usually requires lengthy exposures of seconds, sometimes minutes. Any moving object, such as water or clouds, records as a soft ethereal blur, suffused with the rich hue of the ambient light present. Some of the most evocative images are made under these conditions. Photographers occasionally place several stops of neutral density filter in front of their lenses to extend exposure times massively, resulting in an image that steps outside the reality that we see with our own eyes; film photographers take this surreal world still further, exploring an inherent failing of film known as reciprocity failure, an effect which causes colour casts to appear when inordinately long exposures are made.

LEFT The crimson glow of ambient light bounces off the underside of a cloudbank at Findhorn Bay, creating soft shadowless light with a rosy hue to tinge the wet sand beach.

• Pentax 67II, 45mm lens, 0.9ND grad, f/27 at 45sec, Velvia 50 •

Transient Light

Transient light is a phrase I have coined to describe light that is fleeting; light that passes by with extreme rapidity, usually occurring in a relatively small area of the frame, which makes its presence all the more powerful. I liken it to theatre or stage lighting. It can happen at any time of the day; it is always dramatic and very different from any other light that is present. It is the sheer contrast between extraordinarily dramatic light and mundane, uninteresting light, combined with strong subject matter and good composition, that ultimately makes this the most compelling light for landscape photography.

Transient light is by nature largely unpredictable, though there are certain clues that will enable you to predict its sudden appearance. If the sky is dark and forbidding a clear patch of blue sky could give rise to a shaft of sunlight that descends from the heavens, illuminating a tiny but special element in your chosen scene. In that short defining moment is a landscape of exquisite and rare beauty, a moment that transcends. This last form of light is my personal Shangri La; I spend every waking moment trying to capture it at its elusive best.

ABOVE A very ordinary scene instantly and amazingly transformed by the unexpected appearance of sunlight during inclement weather.

• *Contax ST, 300mm lens, polarizer (twisted to maximize colours), f/11 at 1/60sec, Velvia 50* •

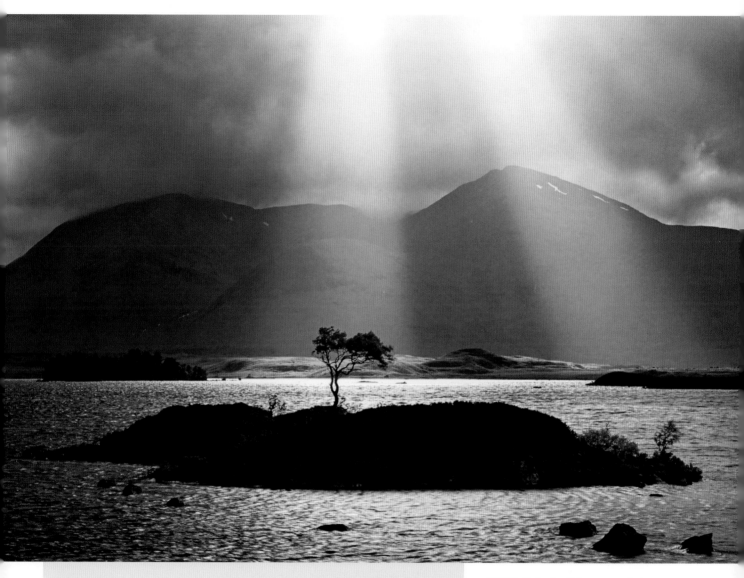

PRO TIP

Trying to intensify the colours of a rainbow by adding a polarizer is likely to cause it to disappear completely, but by backing off the polarizer from its maximum effect there is a point where contrast is increased at little cost to the intensity of the colours displayed, ultimately producing a photograph with even greater impact.

ABOVE Shafts of sunlight puncture a leaden grey sky, illuminating the distant shore while silhouetting an island tree.

• *Contax ST, 80–200mm lens, 0.6ND grad, f/11 at 1/30sec, spot metered from the sunlit shore behind the tree, Velvia 50* •

When to Shoot

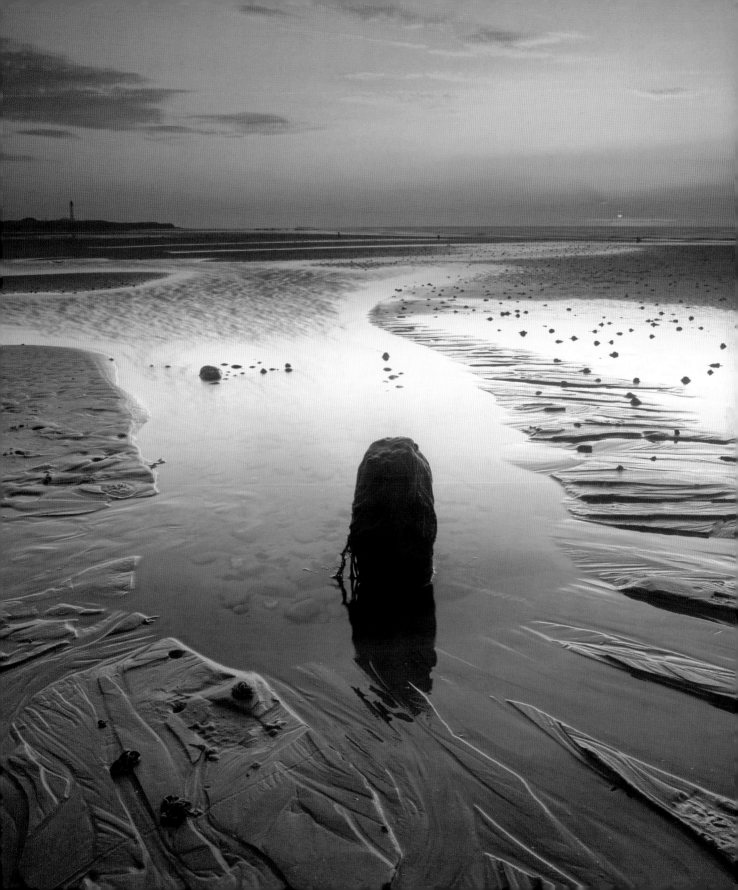

COPING WITH THE ELEMENTS

I'm often asked what the difference is between a professional landscape photographer and an amateur. The short answer is, simply, that a professional has to make a living from photographing the landscape, while an amateur has the distinct luxury of not having to worry about it.

Amateurs can, and do, produce work every bit as good – and sometimes better – than the professional, but they will probably shoot work with a different mindset. Professional photographers are frequently commissioned to meet certain briefs and, whilst a lot of these briefs permit them the luxury of fairly diverse interpretation, one thing that isn't open to negotiation is the deadline for presenting it.

Producing an outstanding piece of work for a client when horizontal rain, poor visibility and dull uninspired lighting continue throughout your time on location is at best frustrating and at worst can ensure that your commissions dry up considerably faster than the weather you had to endure. It seems sensible, then, to ask yourself the following questions before deciding whether to stay, or go to your choice of location.

- Do I have any choice?
- Are the conditions predicted to be unfavourable?

If the answers to the above questions are 'yes', then a more productive day might be spent doing necessary photographic housekeeping.

If you don't have a choice because you're on assignment or – an infinitely preferable option – it looks promising, then you should be taking full account of the following.

- Prevailing weather conditions
- Seasonal influence (sun's position)
- Time of day

LEFT This was a commission shot to meet the brief of wide open space at a specific location.

• *Pentax 67II, 55–100mm lens, 0.45 ND grad, f/22 at ¼sec, Velvia 50* •

BELOW Turquoise waters from alpine glacial melt wend their way through the French town of Sisteron, at the gateway to Provence.

• *Pentax 67II, 45mm lens, polarizer, soft 0.9ND grad, f/22 at 12sec, Velvia 50* •

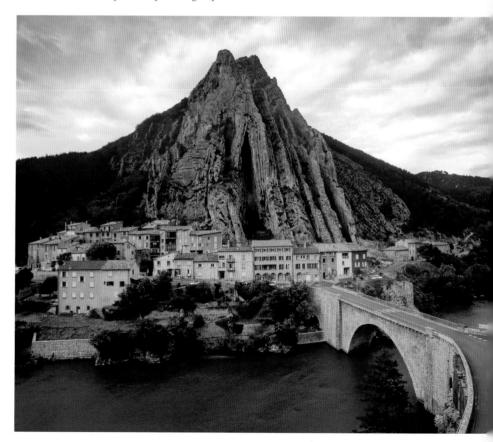

WEATHER

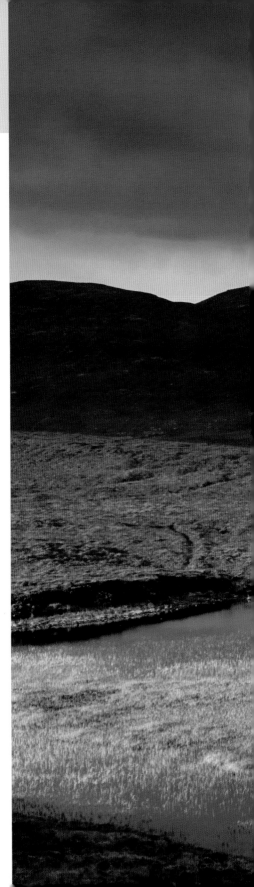

I have been very careful with my choice of words here, deliberately avoiding the term 'good weather' – after all, what is good weather? The general public and the casual snapper will undoubtedly be happiest taking photographs when there is a clear, blue, cloudless sky in the middle of the day. But landscape photographers tend to shun these conditions, preferring something a little more interesting: they seek light and shadow to enhance their subject matter and inject a little bit of life into an otherwise flat scene.

I am much more likely to be found roaming around a Scottish glen on the boundary of a weather front – for that is when the true majesty of light and land work in harmony and great images occur.

Different subjects need different conditions and light. The best weather is that most appropriate to the choice of subject and location; but I won't deny that continuous, unbroken, horizontal rain, gusting high winds and poor visibility with no prospect of change are just about the worst enemy of the landscape photographer. If this is predicted, I strongly recommend getting on with other things, unless, of course, you have no choice. When conditions are against you and quality of light is non-existent, normally subservient components of good photography – namely composition and subject matter – become critically important. Used imaginatively, fine composition and strong subject matter can save the day.

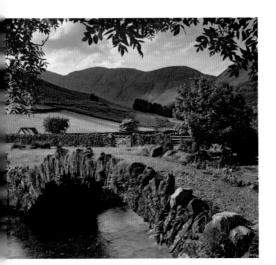

LEFT A mixture of light and shade bring this mid-afternoon scene to life, creating the illusion of depth.

• *Pentax 67II, 55–100mm zoom, polarizer, 0.45ND grad, f/22 at ½sec, Velvia 50* •

RIGHT Fine weather for photographers – a mix of sunlight and thunderous skies.

• *Pentax 67II, 55–100mm zoom, polarizer, f/16 at 1/8sec, Velvia 50* •

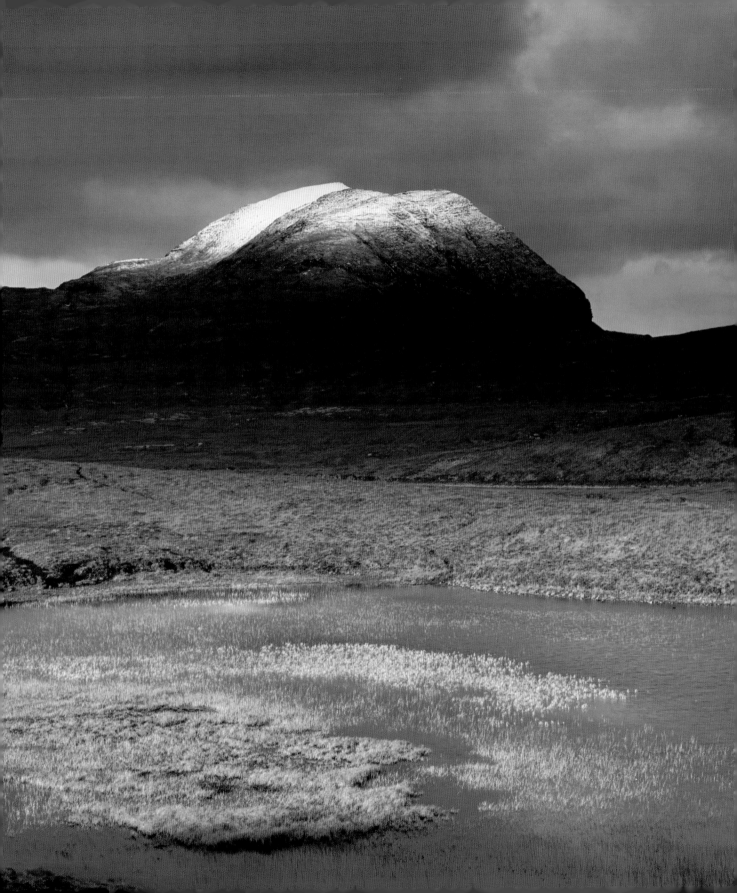

WEATHER	SUBJECT/LOCATION	TYPE OF LIGHT
Gusting high winds, discrete rain showers, broken heavy cloud. Hard work but often the most rewarding.	Dramatic coastal locations, mountain scenery, lighthouses. Rainbows.	Strong likelihood of *transient light*.
Undefined, unbroken, solid-white cloud.	Appropriate for woodland scenes, intimate landscape details and waterfalls. Poor for large classic landscapes.	*Diffuse light*. Perfect for accurate polarized saturated colour rendition.
Fog, mist, haze and sunshine. Great for imaginative images with a difference.	Hillside landscapes, sunsets, recession layers, temperature inversions, exotic phenomena such as Brocken Spectre.	*Backlit* studies overlapping elements revealed as tonal layers.
Sunshine and showers, low, thin cloud (approaching weather front). Best general weather conditions for exploiting most types of light.	Suitable for most subjects particularly classic grand three-dimensional landscapes or seascapes. Colourful sunsets from cloud-patterned sky. Poor for high-contrast scenes (woodland, waterfalls).	*Front lit, side lit, ambient, backlit and transient light.*
Blue sky (no clouds). Bright sunshine. Needs the right subject combined with the right season.	Snow/hoar frost, ice, exotic coastal landscapes, slot canyons, gorges, deserts, dunes. Great for exploiting colour and form.	*Front lit, overhead lighting, side lit, backlit.*
Heavy continuous drizzle, unbroken dark cloud, high winds, poor visibility. Not recommended!!	Possibility of salvaging something by shooting monochrome or subsequent conversion with additional toning to enhance mood.	*Diffuse lighting.* Monochromatic and muted.

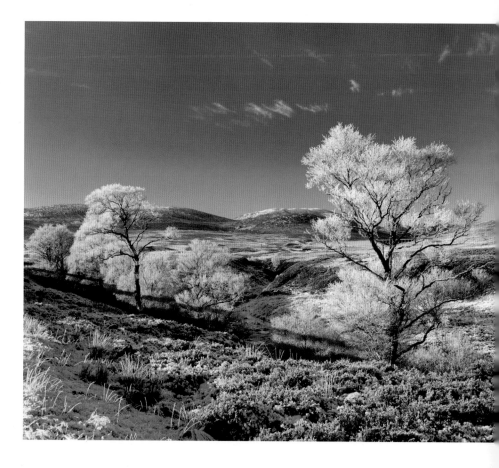

RIGHT A clear blue sky combined with a polarizer guarantees to show hoar-frosted trees at their best.

• Pentax 67II, 55–100mm zoom, polarizer, f/16 at 1/8sec, Velvia 50 •

While many countries enjoy fairly stable weather conditions, with just minor fluctuations from what is considered to be the normal, Britain does not. The British are obsessed by the weather. This obsession is further reinforced by the mass exodus out of the UK to continental Europe during the summer holidays. However, it is this variability in our weather that permits such diversity in landscape photography, ensuring that no matter how many times we visit a location the light will never be the same twice. As Scotland is particularly notorious for experiencing every conceivable type of weather in one day, it seems the perfect way to introduce you to another variable – the seasons.

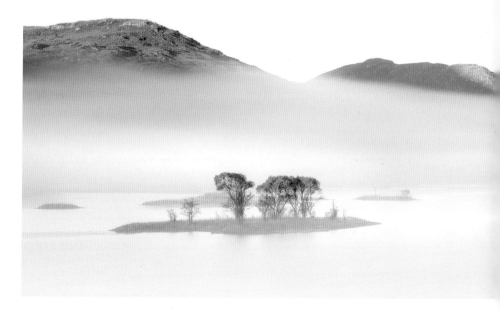

RIGHT Mist and cloud can turn familiar locations into an otherworldly experience.

• Pentax 67II, 200mm lens, f/16 at 1/8sec, Velvia 50 •

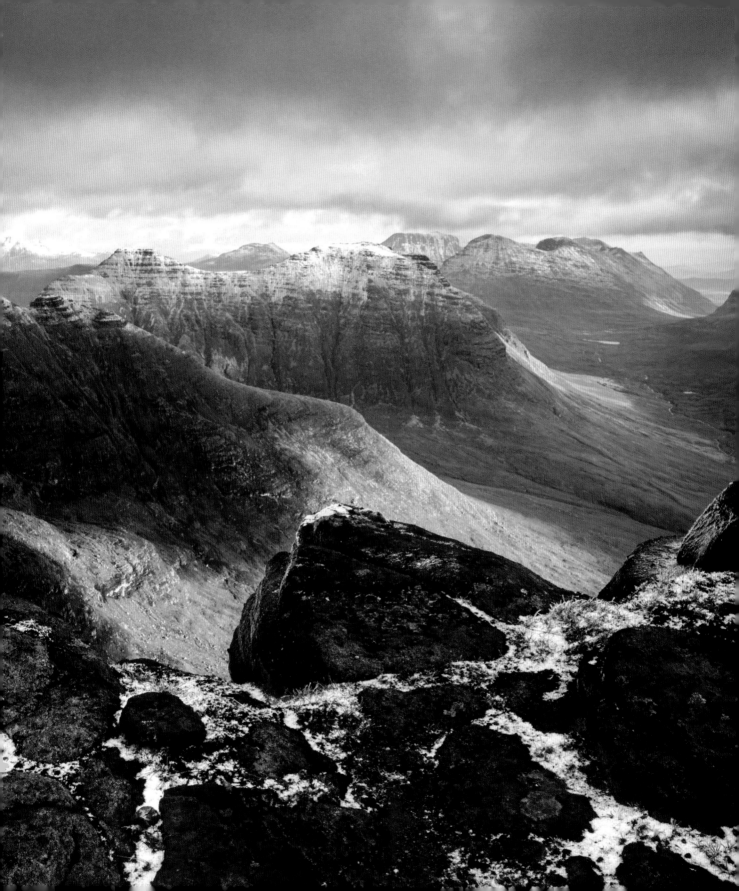

SEASONS

Although the year is divided into seasons, some countries experience virtually no change, save for a minor temperature fluctuation. However Scotland, along with many other temperate zones, exhibits pronounced seasonal change.

In Scotland the weather varies enormously, with sunshine, snow, fog, rain and high winds all occurring on the same day.

SPRING

Ranked third amongst my list of favourite seasons, spring still has a lot to commend it. It is a season of immense and very rapid change. In the early stages, harsh frost and occasional patches of snow will linger in the loftier hills, especially in those crevices that the relatively low-angled sun is unable to penetrate. At the same time the first signs of life are bursting forth, flowers, leaves, grass, all start growing with amazing rapidity, only to get thwarted by another late-season frost. It is the return of colour that is really inspiring. Winter can be long and grey as well as starkly beautiful; a swathe of colour from fresh new growth, or budding flowers in the midst of the sombre colours of winter, is incongruous and therefore photographically compelling. Even later in the season when spring is well under way, the freshness of new greenery and warm sunlight filtering through a new canopy of leaves is a joy to commit to film and image sensor alike.

ABOVE A chestnut tree bursting with new life at the onset of spring. The diffuse light and mist helps to isolate it from the background.

• *Contax ST, 80–200mm zoom, polarizer, f/11 at ¼sec, Velvia 50* •

LEFT Heavy cloud increases the drama but, without the occasional break in the clouds, the scene would be flat and lifeless.

• *Pentax 67II, 55–100mm zoom, polarizer, 0.6ND grad, f/22 at 1/2sec, Velvia 50* •

SUMMER

Everybody has a least favourite time of year and from a photographic standpoint this would be mine. While the public understandably revel in the heat of summer, I tend to regard it as one of my least productive seasons. In Britain everything away from the coast turns green, but not the fresh, yellowish and vibrant greens of spring – these greens are uniform in colour, more mature, I refer to them as tired. In the height of summer there seems to be little relief from it, save for the increasingly rare display of wild flowers.

During the summer I tend to migrate to the coastal areas, but not those popular with holiday makers. At the coast, green gives way to blue, yellow and browns.

Although the sun is far too high to give good quality light for most of the day, in the mornings and evenings there is a window of opportunity. Beaches are full of textures and patterns and the coast often brings with it sunsets and sunrises of incredible and lasting intensity.

At extreme latitudes the sun barely sets at all, before clambering up again at a ridiculous hour for sunrise. In northern Scotland, and zones of the same latitude, during midsummer it never truly gets dark, the twilight that follows sunset lingers, the sky blushing crimson. Summer produces some beautiful surreal shots where ambient light is responsible for the quality of the finished result, but overall I still prefer the vivid colours of autumn.

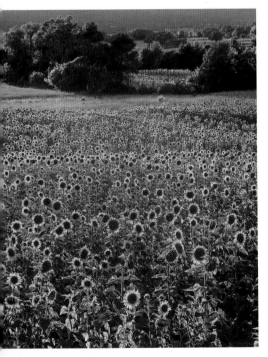

LEFT A field of backlit sunflowers is compressed together with a long lens, providing a classic floral display.

• Pentax 67II, 200mm lens, polarizer, f/22 at 1/4sec, Velvia 50 •

RIGHT The rim light on the edge of a tide pool forms a ribbon of gold, but the window of opportunity is just seconds, due to lens flare.

• Pentax 67II, 45mm lens, Singh Ray 0.9ND reverse grad, f/22 at 1/8sec, Velvia 50 •

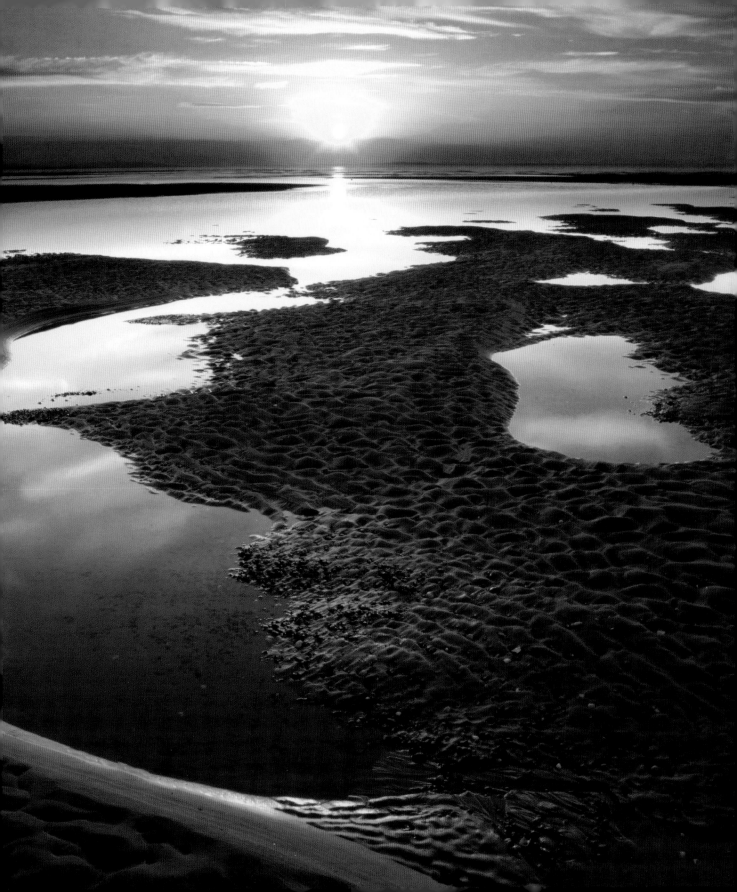

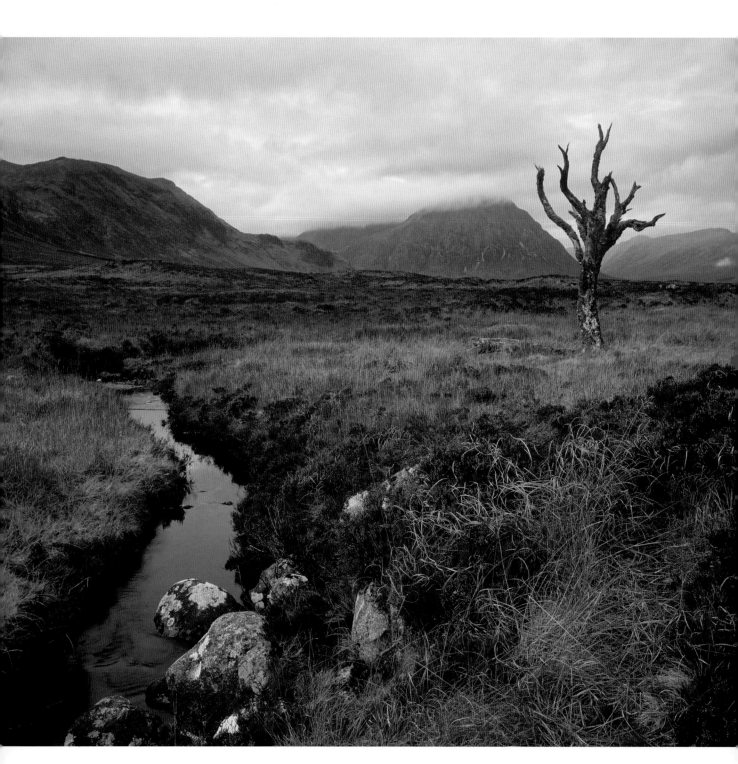

AUTUMN

An inspirational time of year; gone are the worn-out greens of summer and in their place is an artist's palette of hues. The first to change colour is bracken – it forms a barren green carpet over the forest floor in summer but, as the season progresses, green turns to vivid yellow, a fiery orange and then finally to rust red. Carpets of it cloak the Scottish hills lending tremendous colour to the landscape.

Fringing the edge of lochs are the other early autumn changes: silver birch – similar to its American cousin, the aspen – drops leaves of yellow and gold on the peaty waters of the loch, which float there like golden confetti.

The sun's noon-day azimuth is at a relatively shallow angle, sympathetically producing long, raking shadows which lend texture and quality. Around the end of October, autumn colours seem to reach a

peak, particularly in Scotland. The colours are luminous; ironically these colours are often best conveyed and most vibrant after rain, in diffuse light and beneath a white, cloudy sky. A polarizer removes the reflections on the leaves, but the contrast is low enough to faithfully record the intense colours without blocking up the shadows. When the sky is overcast or white, it is best to disregard it and home in on more intimate landscapes, where colour alone is the reward for your photographic endeavours.

Autumn is my second favourite season, but perhaps my favourite time of all is that short period when autumn reluctantly gives way to winter and the first splash of snow paints the top of the mountains. The intense autumn colours in the immediate foreground give way to monochrome near the summits of the higher hills, where they have succumbed to a thin dusting of snow. The contrast and juxtaposition of this abrupt seasonal change is staggering and immensely photogenic in virtually any light.

LEFT It isn't just deciduous woodland that responds to autumn, these spiky moorland grasses that grow on the peat hags of Rannoch moor, Glencoe, Scotland, glow with astonishing brilliance, particularly on a wet, overcast day.

• Pentax 67II, 55–100mm lens, polarizer, 0.6ND grad, f/22 at 4sec, Velvia 50 •

RIGHT Bracken fronds change colour with the onset of autumn.

• Pentax 67II, 55–100 zoom lens, polarizer, inverted soft 0.3ND grad, f/22 at 2sec, Velvia 50 •

WINTER

Often the favourite season of the landscape photographer. Winter alone has the ability to completely transform the familiar to the unfamiliar – a blanket of snow, or a thick coat of rime (hard frost) can provide instant otherworldly inspiration. Snow and frost are highly reflective and have the capacity to bounce amazing amounts of light into dark subjects, revealing an astonishing quantity of otherwise hidden detail. This same reflectance often causes automatic cameras a fit of apoplexy as their exposure meters enthusiastically underexpose.

Glassy icicles and frozen waterfalls look tremendous when partially backlit, plates of ice with intricate fracture patterns or trapped pockets of air make fabulous monochromatic abstracts, often tinged blue by the reflected light of a clear overhead sky. The sense of wonder is amplified by the sheer perfection of wind-carved forms and outlandish shapes, which at dawn remain pristine, untouched by any living thing. At extreme latitudes the sun hugs the curve of the earth all day, producing long shadows that stretch across the land. Ironically during these short days, it's quite possible for fabulous light to be present throughout, so your productive photography time is of surprisingly long duration.

Finally, there's the light itself, the quality of winter sunlight raking across a virgin, silent, snow-covered landscape at dusk or dawn gives me a feeling of wellbeing that is quite beyond my capacity to express.

So much for the seasons, they directly affect the landscape that you will be photographing and obviously relate to the appearance of your subject, but the time of year will also determine whether or not your chosen landscape receives direct sunlight. Throughout the seasons the sun changes its azimuth and the position of sunrise and sunset. During the winter months the sun rises and sets quite far south of true east and west, whilst in mid-summer the sun climbs very high, rising and setting north of true east and west. A check with a detailed Ordnance Survey map and a device known as a sun compass will confirm when the light is optimal, to reveal your chosen landscape at its best.

RIGHT A tussock of green spike grass, frozen into a puddle, reflects blue sky onto its contoured, fractured surface.

• *Pentax 67II, 200mm lens, polarizer, f/16 at 1/4sec, Velvia 50* •

ABOVE Drifting snow disguises shapes, filling in holes and bouncing light into the darkest voids.

• *Pentax 67II, 55–100 zoom, 0.6ND grad, f/22 at 1/15sec, Velvia 50* •

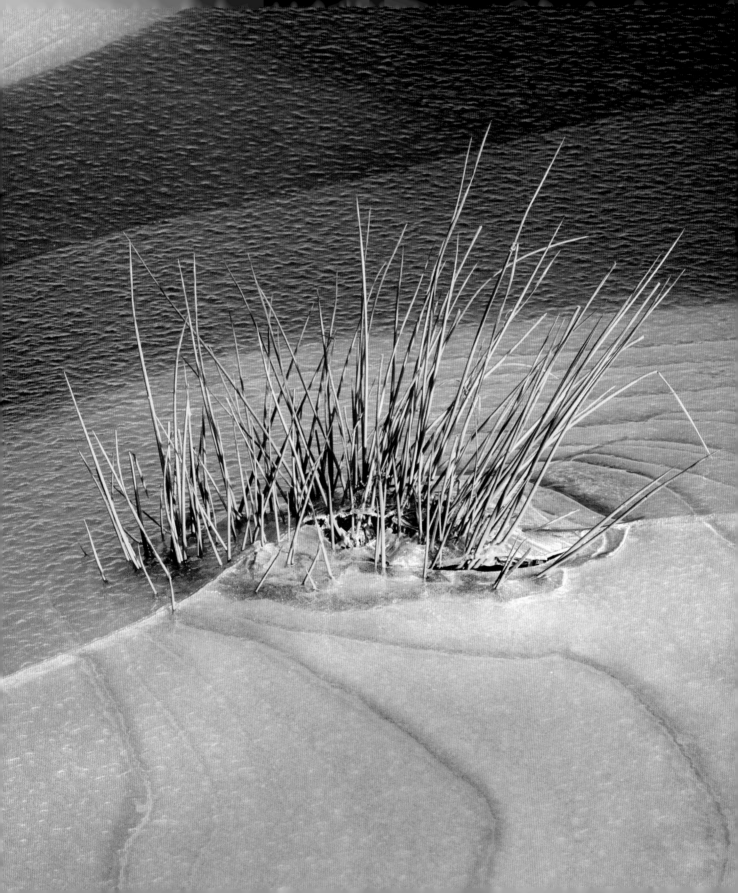

LOCATION: LOCH A CHROISG, ACHNASHEEN, SCOTLAND

One of the best ways to challenge yourself and at the same time be reminded of the effect that different seasons and weather conditions have on a landscape, is to photograph an easily accessible and familiar place at different times of the year. That doesn't mean that you need to stick religiously to the same identical subject, in all honesty that would be pretty dull. Instead, you should explore your chosen location and do so with the aim of coming back with at least one satisfying image, representative of that season.

Of course you are likely to form a distinct seasonal preference and that's fine, but the goal is to find an unexpected gem that might just make you re-evaluate your expectations as to when it's best to visit.

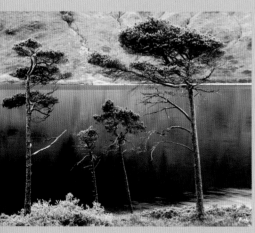

Loch a Chroisg is one such location that I constantly find myself drawn to. It's not particularly well known, but it lies in an approximately east–west direction and is remarkably sheltered from the wind, being surrounded by plunging hills which slide directly into the depths of the loch. Smooth water and mirror-like reflections are frequent. Revisiting this beautiful place at different times of year, in different weather conditions, reminds me just how important it is not to take the attitude – 'been there done that'. I will doubtless return and 'milk' it for many years.

ABOVE AND LEFT Virtually identical shots – the first shot in mid-summer, the second during a sharp frost in January. The winter version is one of my personal favourites.

• Pentax 67II, 200mm lens, polarizer, f/22 at 4sec, Velvia 50 •

BELOW AND RIGHT A few hundred yards from the straggly pines (left), is this lone tree, reportedly struck by lightning. The first is taken during late autumn, while the second was taken in winter.

Pentax 67II, 200mm lens, polarizer, f/22 at 1sec (right), f/22 at 4sec (below), Velvia 50,

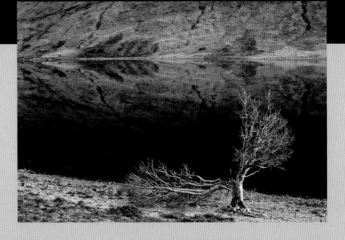

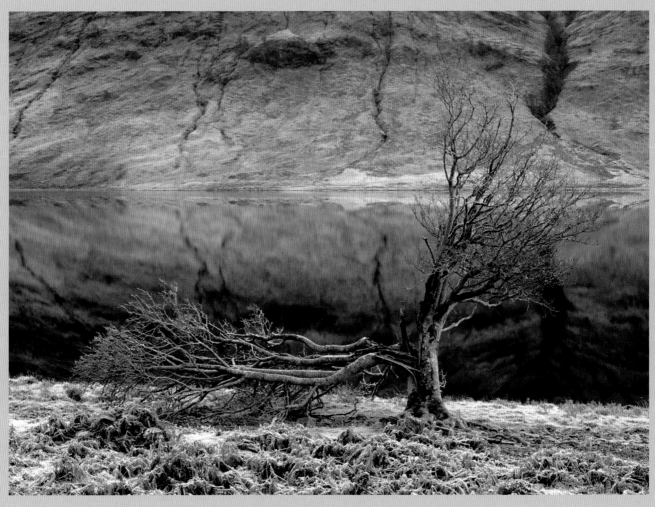

TIME OF DAY

Whereas the weather and time of year are liable to influence your decision to visit more distant locations, the choice relating to time of day is much more of a short-term factor and has very much greater relevance when visiting local scenery. There are two major additional considerations to think about, not including the afore-mentioned importance of knowing when to expect sunrise and sunset. If your choice of location is not random or spontaneous, but based on an area that you're keen to photograph as a result of previous research, then you need to consider not only the position of sunrise and sunset but also how long it will take you to get there, scout an exact location and set up to take the shot. This may seem patently obvious, but I have lost count of the times I have decided to go for it, photographically speaking, and then found that I'd seriously miscalculated the time I would require and got there far too late to capture the anticipated shot.

SAFETY WARNING

Another consideration is arguably even more important, not least for your own personal safety. If you are visiting the coast, then checking the tide times is extremely useful and may just save your life. There is no point taking a trip to your local estuary to photograph tide patterns and sand ripples, only to find that the beach is beneath several feet (metres) of water. Worse, if you happen to find yourself on a long strip of beach at the foot of some inaccessible cliffs it is quite possible to find yourself cut off by an incoming tide.

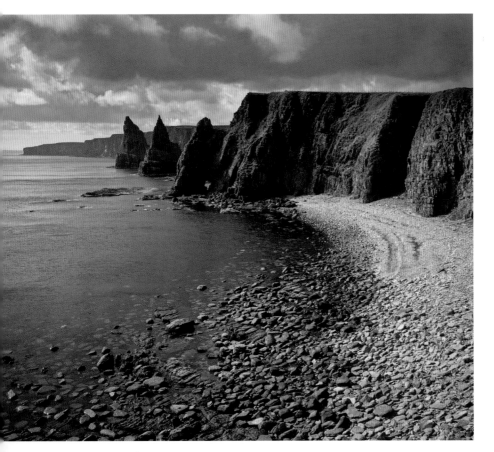

LEFT Not a place you would want to miscalculate the tide times. It would be all too easy to find yourself engrossed on the beach, only to turn around and find yourself trapped against the base of the cliffs.

• *Pentax 67II, 45mm lens, 0.6ND grad, f/22 at 1sec, Velvia 50* •

LOCATION: FINDHORN ESTUARY, MORAY, SCOTLAND.

Findhorn is a north-facing coastal bay that opens into the Moray Firth in northern Scotland. It lies within the rain shadow of the west coast mountains and has a remarkably dry climate with relatively clear skies.

During the months of June and July my own photography tends to wane a little. Sunrises are ridiculously early, sunsets correspondingly late, and the light is typically of poor quality, except at the extreme ends of the day. Due to the time of year the sun rises and sets considerably further north of east and west respectively, meaning that the sun rises and sinks over the sea. For that reason I can be fairly sure of getting decent light, weather permitting. Sunset is around 10pm and I would expect a twilight afterglow to last anything up to an hour after the sun sinks beneath the horizon.

Already I have established a probable location and time of day to visit. Although the weather varies significantly and changes by the hour it looks promising.

There isn't a breath of wind and there is a dappled sky filled with stratus clouds stretching almost to the horizon, through which the setting sun must pass. I hoped that this wonderful cloud pattern would catch the reflected light of the sun and light the undersides of the clouds with radiant intensity. The breathlessly still conditions would suggest that the cloud formation is not going to change significantly, and that any sheltered water surface might permit reflections, which I was sure would lend interest to a classic landscape scene.

At this stage I would be packing up my gear ready to leave, anticipating a decent sunset, but I would still be undecided on the exact location. One final factor confirms the choice – a glance at the tide tables establishes that sunset and high tide coincide. Findhorn Bay is separated from the sea by sand dunes and a kink in the outflow of the river Findhorn, so the bay is extremely sheltered. With the windless conditions and no net movement in the tide, I might just get some coastal reflections off the wide expanse of the estuary, with the moored boats hardly moving.

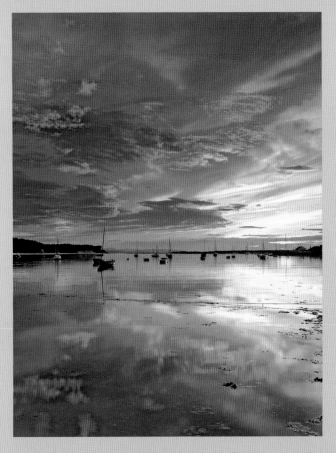

ABOVE The combination of high tide and breathlessly still conditions ensure that the movement of the boats is minimized and impact is doubled in reflection.

• *Pentax 67II, 55–100 zoom, 0.45ND grad, f/13 at 1/2sec, Velvia 50* •

This sort of pre-preparation and consideration is typical of my own workflow and simply balances the odds of success in my favour. I recommend that you adopt a similar approach.

Preparation to Shoot

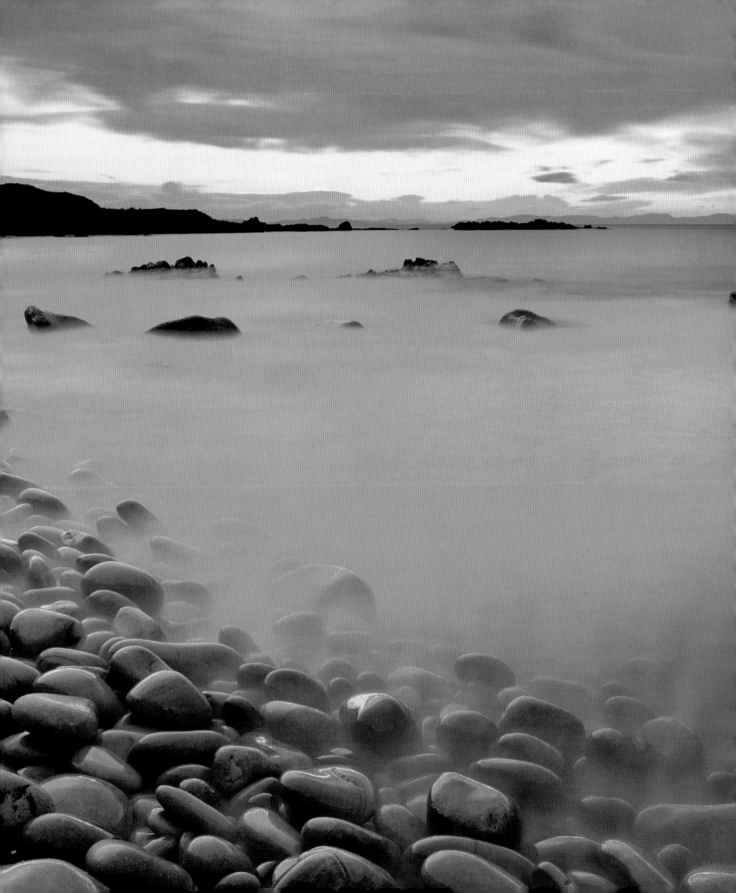

PHOTOGRAPHIC EQUIPMENT

We have dealt with when and where to shoot landscapes, so now we need to bring together the most relevant pieces of equipment to capture them at their best. This requires us to make informed choices with respect to the equipment available, and then sort out a preparatory work flow to optimize their use in the field.

THE CAMERA

The choice of cameras available to photographers is overwhelming and I certainly don't propose to name brands or models that I think are best; in any case they will be superseded the moment this book goes to print. Instead, I will include a list of 'need-to-haves', that I think are relevant to a landscape photographer and to me in particular.

The list is surprisingly minimal and very different from photographers that work in other fields. Most modern cameras far exceed my personal requirements, instead offering a huge array of features that have little relevance to the way I work, and simply constitute needless clutter on a camera. The following is, therefore, a list of my own requirements, yours may be very different and you should adapt your choice, whether digital or conventional, to suit your needs.

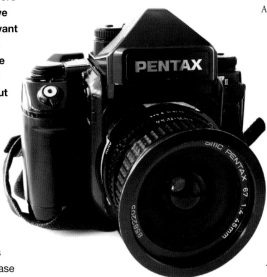

LEFT Pentax 67II fitted with 45mm f/4 lens and AE prism finder.

High Resolution

Resolution is supremely important to all landscape photographers. I sell large photographic prints in excess of 24 x 20in (60 x 51cm) and need a camera capable of producing work to at least these dimensions. There are a few choices open to me in the digital arena, but at a cost – my preference is to use a medium-format film camera and then scan the results to the necessary dimensions. Of course film processing takes time and is relatively costly, but with medium format, the number of shots taken tends to be less, and it should be a case of quality not quantity.

Depth-of-Field Preview

Ironically, this feature incorporated within most enthusiast cameras is of limited use to me, at least in its traditional concept of viewing the depth of field through a lens that is stopped down to the intended aperture. The viewfinder is usually too dark to accurately assess whether the front and rear elements of a proposed composition are held in sharp focus at small apertures.

A more useful aspect of the depth-of-field preview, is with filter alignment. It is far easier to judge the correct position and alignment of graduated neutral density filters when you view a scene through a stopped-down lens. Digital cameras incorporating live view may well make the depth-of-field preview redundant.

RIGHT Although the horizon line was pretty level, misalignment of the required three-stop, graduated neutral-density filter would have been apparent on the snow. The depth-of-field preview enables much easier alignment.

* Pentax 67II 55–100mm lens, 0.9ND hard grad, f/22 at 1sec, Velvia 50 *

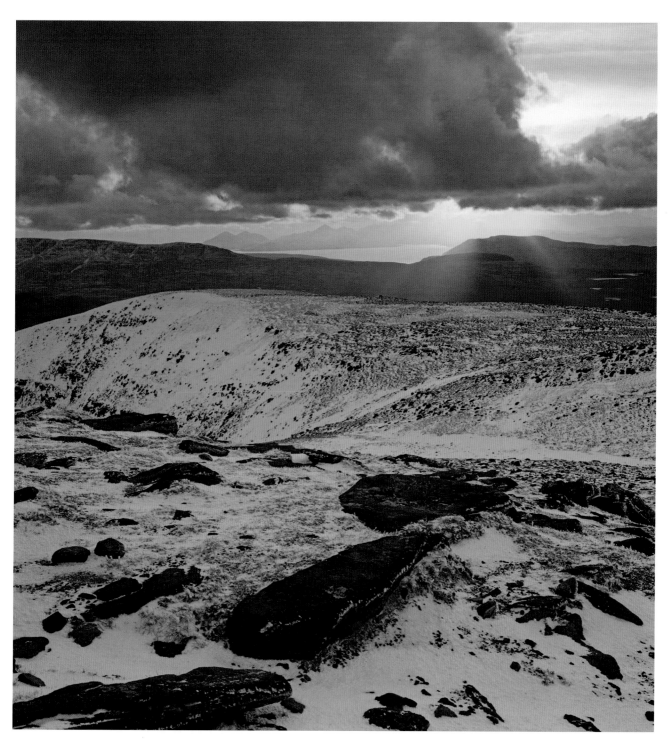

Lens Choice

Landscape photographers need to travel light, they don't need or want to carry, wide-aperture optics – my preference is for high- quality distortion-free glass in a light package at medium apertures. Since a landscape is unlikely to get up and run away, I focus manually and do so only when I've finalized my choice of composition. The camera I use needs to have a good range of quality lenses, with generously proportioned manual focus rings and good tactile feedback.

Format Choices

The format of a camera refers to the image-sensing area, namely its physical dimensions. The choice is bewildering and now there are even more options as new cameras emerge with different formats, even within their own manufacturer's range. Each format has its benefits and you should examine your own needs to decide on the most appropriate. Below is a guide to those formats available with an indication of the advantages and disadvantages of each. Currently they can be broken down into five groups.

Esoteric

Hasselblad, Mamiya, Pentax
(digital medium/large format)
These cameras have adopted their own sensor sizes independently, they have the very highest resolutions, but a system incorporating camera and lenses will cost many thousands of pounds. If you are seriously considering this option your research needs to be very thorough and it's worth considering that some of the other products available in the sections below will in all probability catch up and surpass their performance.

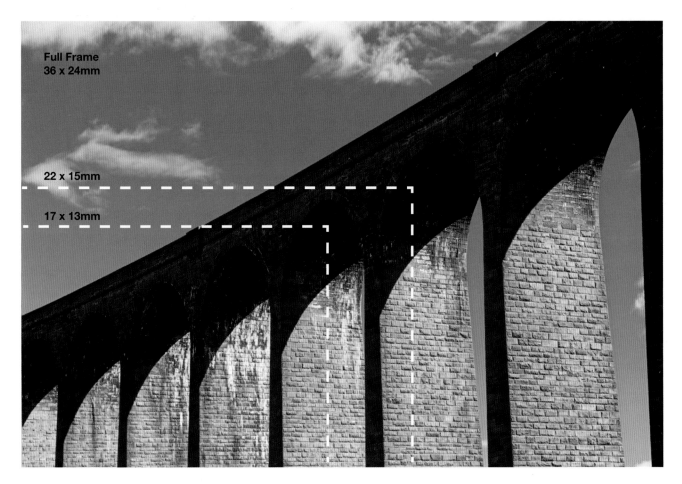

Full Frame
36 x 24mm

22 x 15mm

17 x 13mm

Full Frame

Up until very recently, Canon was the only digital camera manufacturer producing full-frame sensors, meaning it occupied the same dimensions as a conventional 35mm film camera. Now Nikon have incorporated virtually full-frame cameras in their line up, the result is a range of lenses that corresponds directly to the old 35mm film equivalents.

Full-frame cameras are particularly useful to landscape photographers and they have become the digital format of choice amongst professionals. As a rule, landscape photographers tend to bias their lens selection towards the wider angle of view and full-frame sensors make this option an easier choice.

APS-C Sensor

The vast majority of currently produced digital SLR cameras fall into this category. The image sensor is significantly smaller, measuring just 22 x15mm. It is not a terrible shortcoming and for other types of photography this decreased image-sensor size can be a distinct bonus, especially for wildlife and sports photography. A conventional 35mm film camera, or full-frame digital sensor with a 300mm f/4 lens attached, would, if attached to an APS-sized digital sensor, become an equivalent 450mm f/4 lens, exhibiting greatly extended reach and no loss in light-gathering ability.

LEFT Culloden Viaduct, Inverness, Scotland. The full image was shot using full frame – the crop lines show the respective dimensions of APS-c and 4/3 sensor options.

Four-thirds System

When digital truly came of age and the manufacturers decided it was definitely here to stay, some of them, most notably Olympus, decided that it was an opportunity to design a new system from the ground up. They came up with the four-thirds system. It demanded new lenses, new sensors and a whole new concept to extract the best out of the technology available. The four-thirds system has produced neat, compact high-performance cameras.

Arguably the concept has worked, though my personal belief is that it still lags in performance terms behind the big two, namely Nikon and Canon. For landscape photographers it has both benefits and caveats. The benefits come in terms of physical size – what a pleasure it must be to carry such a light, small, high-performance piece of digital technology with you on arduous trips. The caveat is the sensor size – consensus of opinion among photographers indicates that the smaller image sensor is less capable of gathering light and there is a corresponding increase in sensor noise.

Film

There has always been a wide variety of film formats available and they have established themselves over many years as being best suited to specific fields of photography. Some formats have become redundant as the technology improved, but the general starting point for producing quality images on film is considered to be 35mm. Despite the massive rise in the popularity of digital, film is still used by some, including myself, and it is in the field of landscape photography that film lingers the most.

STANDARD

The quality of 35mm film has arguably been surpassed by digital cameras, particularly by those in excess of eight megapixels. Technically, a scanned piece of film will produce a higher overall bit count, but sheer resolution isn't the only factor. Film has grain; a digital capture is grain-free and appears incredibly clean, giving the illusion of higher resolution and sharpness. When measured against other film formats, 35mm enables a photographer to work fast and it is relatively easy to carry into the field, but the stark truth is, if 35mm film was the only film format available I would have moved to digital quite a while ago.

FILM FORMATS

Standard:	35mm
Medium:	6 x 4.5cm, 6 x 6cm,
	6 x 7cm, 6 x 9cm,
	6 x 17cm
Large:	5 x 4in, 7 x 5in,
	10 x 8in, 14 x 11in

OVERLEAF Mono Lake, USA. A 35mm transparency is considered to be the minimum acceptable quality for producing enlargements up to A3, with the appropriate choice of film.

• Contax ST, 28–85 zoom, polarizer, 0.3ND grad, f/16 at 6sec, Velvia 50 •

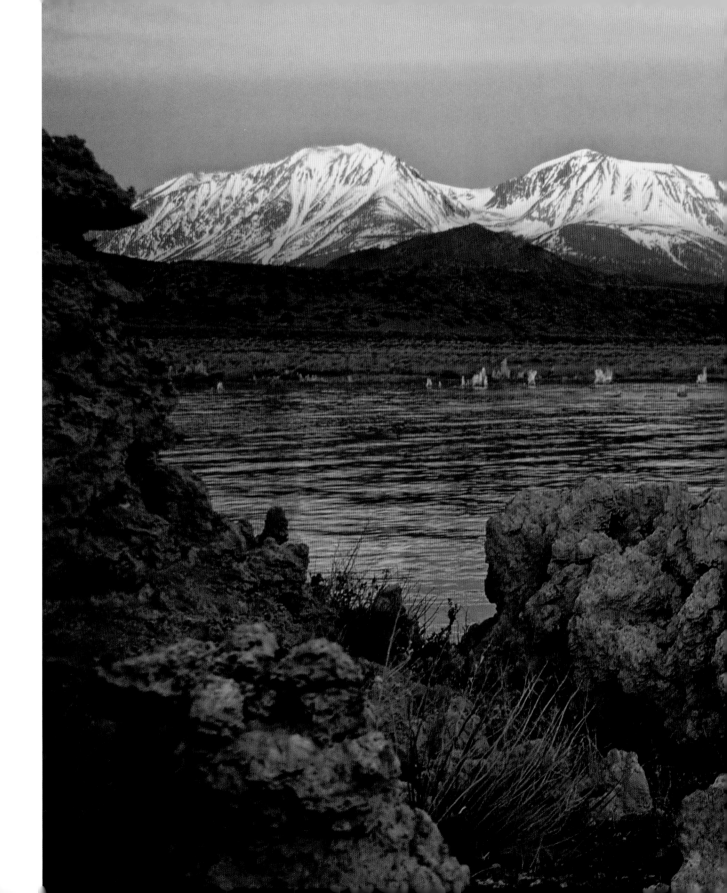

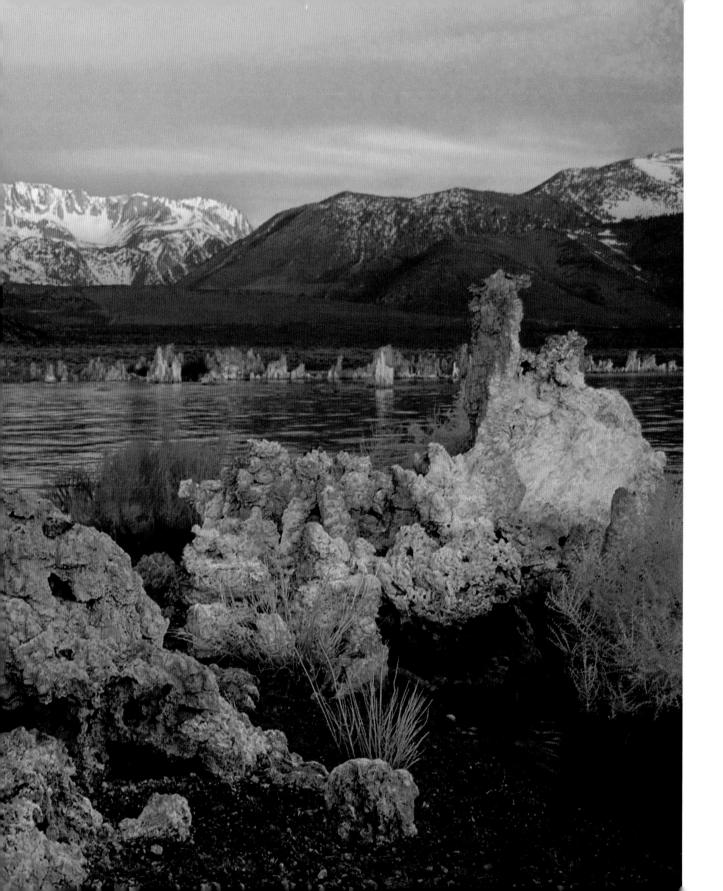

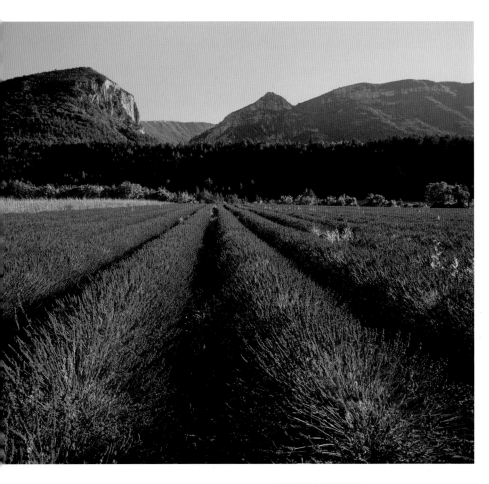

ABOVE Provence, France. A higher-quality alternative to 35mm, a 6 x 7cm frame displays finer gradation of tone and has a surface area 4.5x larger, providing an easily discernible increase in image quality.

• *Pentax 67II, 55–100 zoom, polarizer, f/22 at ¼sec, Velvia 50* •

MEDIUM FORMAT

This is the format I currently use. It has, for me, the best mix of resolution and tonal smoothness combined with a fast working speed. The resulting developed image is of such a size (I use 6 x 7cm format), that you, or more specifically an art editor, can see it on a light box quite clearly without magnifiers or other visual aids. The speed at which the image can be viewed is still a very relevant factor for picture editors; opening up a number of individual files saved on a CD is relatively slow, especially if those files are sizeable.

Medium-format cameras all use the same 120/220 roll film, but the way a camera slices that film up relates to the format used. The smallest medium-format camera produces images that occupy a 6 x 4.5cm frame, which is 2.5 x the surface area of its smaller 35mm cousin. Next is the 6 x 6cm format made popular by Hasselblad, Rolleiflex and Bronica; the image is of course square and many believe that this isn't the best choice of format for landscape photography. My favourite format is 6 x 7cm; it used to be called the ideal format because it quite neatly fitted the proportions of commercially produced photographic papers. Its proportions suit my personal vision, you get ten images off a roll of 120 film and it occupies an area 4.5 x larger than a standard 35mm transparency.

After that there are 6 x 9cm formats, a few intermediate formats and then perhaps one of the most celebrated of landscape formats, the massive panoramic of the 6 x 17cm image, the birthright of Fuji and Linhoff. These cameras produce transparencies with an incredible amount of visual information; however, the panoramic format can be awkward to accommodate and, with only four images off a roll of 120 film, the cost does tend to escalate.

LARGE FORMAT

This is the daddy of the film formats – film sizes start at 5 x 4in and increase right up to 14 x 11in and beyond. The visual information on a piece of film with these dimensions surpasses that which the human eye can resolve. Currently there is no conventional digital camera that truly matches the quality of output from these giants of the photographic world. Large-format cameras have no automated features; they are simply constructed, and consist of a ground-glass screen and a taking lens with shutter mechanism interconnected by a set of bellows. Most of these cameras enable the photographer to use lens movements, something that empowers the landscape photographer with enormous versatility. It is used to create pictures with highly selective depth of field, correction of tilting verticals and, perhaps most useful of all, the ability to extend depth of field to an incredible degree, whilst maintaining a wide aperture. The technique employs the Schleimpflug principle, which involves altering the plane of focus by means of shifting and tilting the front and rear elements.

Unfortunately, the disadvantages are also many: the cameras, lenses, film plates and tripod are heavy and cumbersome and the speed of working is slow – too slow for my preferred style of photography. The expense of buying, developing and processing sheet film is undeniably prohibitive. For those photographers seeking the ultimate in quality there is no substitute, but for me the quality and convenience of medium format are a trade-off that I prefer.

Making the Right Choice

With such a bewildering assortment of formats and cameras available, how on earth can anyone be expected to make the right choice? I have been taking pictures for a great many years and have had the opportunity to try out most – if not all – of the options currently available. A good starting point to help choose the best camera for you is to garner opinion from other landscape photographers that you admire and find out from them why they have made the choice that they have.

For me the choice is simple and can be answered in just three questions.

1. Am I completely satisfied with the results I achieve?
2. Can I realize my full potential as a photographer?
3. Does the quality and format of my work satisfy everyone else?

At present, the answer to all three questions is 'yes'. Nevertheless, I still keep an eye on product development, just in case a serious shortcoming with my own choice leaves me at a significant disadvantage.

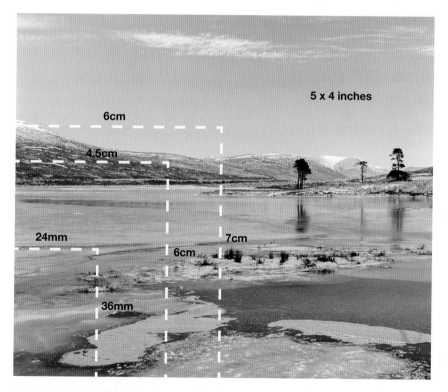

ABOVE Transparency showing the relative area of coverage associated with the various film formats. Image contains markings to designate comparative film sizes.

• Pentax 67II, 55–100mm lens, 0.6 ND hard grad, f/22 at 1/2sec, Velvia 50 •

LENSES

Choosing the right lens for your camera is extremely important – cameras are so seductive that it is sometimes difficult to remember that your camera is essentially a box that controls the amount of light entering it. It is the lens that dictates the quality of the results.

Although there are hundreds of lenses to choose from, every manufacturer has different mounting systems to prevent inter-changeability with other manufacturers, thus ensuring brand loyalty. Even lenses from the same manufacturer cannot be used seamlessly with all the various models of camera within its range, thanks to the variation in image-sensor size and developments in automated functions, such as metering and auto-focus.

The overriding requirements for landscape photography are lightweight, high-quality optics, with fairly modest apertures that permit all the camera's functions to operate seamlessly. One way to guarantee this is to use the manufacturer's recommended marque lenses, but be aware that you pay extra for that assurance. In an effort to reduce the number of lenses that a photographer would need to carry, manufacturers have been developing the one-lens-does-everything super zoom.

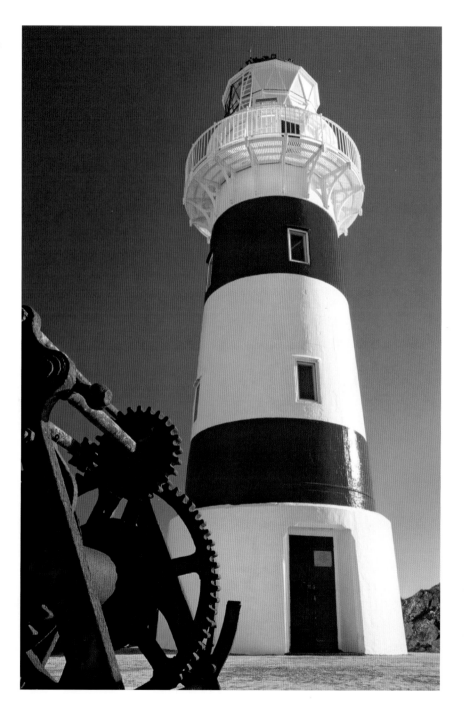

LEFT Dunottar Castle, Stonehaven, Scotland. A similar perspective to the human eye, exhibiting very little distortion.

• *Pentax 67II, 55–100 zoom, 0.6ND grad, polarizer, f/16 at ½sec, Velvia 50* •

ABOVE Cape Palliser Lighthouse, New Zealand – here, perspective is stretched by the use of wide-angle lenses.

• *Contax ST, 21mm lens, polarizer, f/16 at 1/8sec, Velvia 50* •

These lenses offer a phenomenal zoom ratio, some like the 28–300mm have an 11x zoom ratio. On the face of it you can't go wrong with one of these lenses – no risk of dust intrusion into the delicate inner workings of your digital camera, no problems with weight – and the ability to work faster, as the lens you need is always attached to your camera.

Unfortunately, a closer examination of the performance of these extreme zooms will show a significant decrease in quality compared to modest zooms with a 3 to 4x zoom ratio. Given the balance between weight, aperture and performance, I would prefer to split the job between two lenses and use the best glass I could get hold of. After all, if you have spent umpteen thousand pounds on a very high resolution digital camera, capable of resolving the hairs on a fleas leg at 200 metres, the last thing you want to do is dull its performance by attaching the optical equivalent of a milk bottle.

Focal Length

Landscape photographers tend to go through phases – some like to drift towards the telephoto end, extracting multiple small elements of interest from the wider view, while others drift to the opposite end and get caught up in the drama and excitement of the ultra-wide lens that gives rise to pictures with immediate impact. After a while photographers usually tire of these visual extremes and their photographic vision returns to more modest levels.

I have briefly indicated that the different formats available give rise to totally different angles of view. Below is a table listing equivalent focal lengths of popular lenses, based on a variety of formats. Where practical, these have been rounded up to the nearest available focal length.

FOCAL LENGTH 35MM FILM	STANDARD (DIGITAL)			MEDIUM FORMAT (CM)				LARGE FORMAT (INCHES)	
	APS-C	Full Frame	4/3	6 x 4.5	6 x 6	6 x 7	6 x 9	5 x 4	8 x 10
24	18	24	12	35	40	50	55	90	180
35	24	35	17	50	60	70	80	120	240
50	35	50	25	75	80	100	115	180	360
100	65	100	50	150	160	200	–	360	720
200	135	200	100	300	320	400	–	720	–
300	200	300	150	450	480	600	–	–	–

ABOVE This image of Ayers Rock and red gum trees illustrates how the elements compress together to emphasize scale and proportion.

• Contax ST, 80–200mm lens, polarizer, f/16 at 1/15sec, Velvia 50 •

LOCATION: HOPEMAN, MORAY, SCOTLAND.

It's easy to forget that the various focal lengths of lenses at your disposal have many more uses than simply including the wider view or abstracting small areas from a larger scene.

Here is a field-based example, where two focal lengths have been used in very different ways to interpret the same subject. Both are equally viable and each

sells regularly. The only difference between the two is the physical position from which I took them. One is taken close to the brushed green foreground rocks, no more than two feet (60cm) off the ground, and about three feet (90cm) from its leading edge with a wide-angle lens.

The result is a foreground that telescopes and stretches, reducing the sun's impact to an insignificant dot. The other is taken from 30–40ft (9–12m) away, from a standing position with a short telephoto lens.

Although the foreground rocks are approximately the same size on the transparency, the telephoto flattens perspective, effectively closing the distance between the foreground and the sunset backdrop. In both cases careful attention to the depth of field was needed to ensure each scene was in sharp focus front to back.

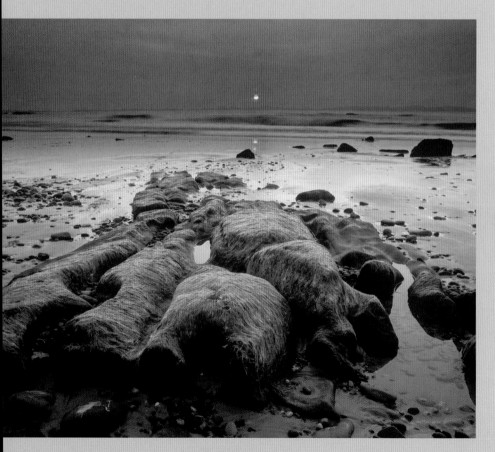

LEFT AND RIGHT Two lenses, two different perspectives – note how the longer lens compresses the foreground and background elements of this scene together, whilst the wide-angle lens stretches them.

• *Left: Pentax 67II, 55–100 zoom, 0.6ND grad, f/22 at 2sec, Velvia 50* •
• *Right: Pentax 67II, 200mm lens, 0.6ND grad, f/22 at 3sec, Velvia 50* •

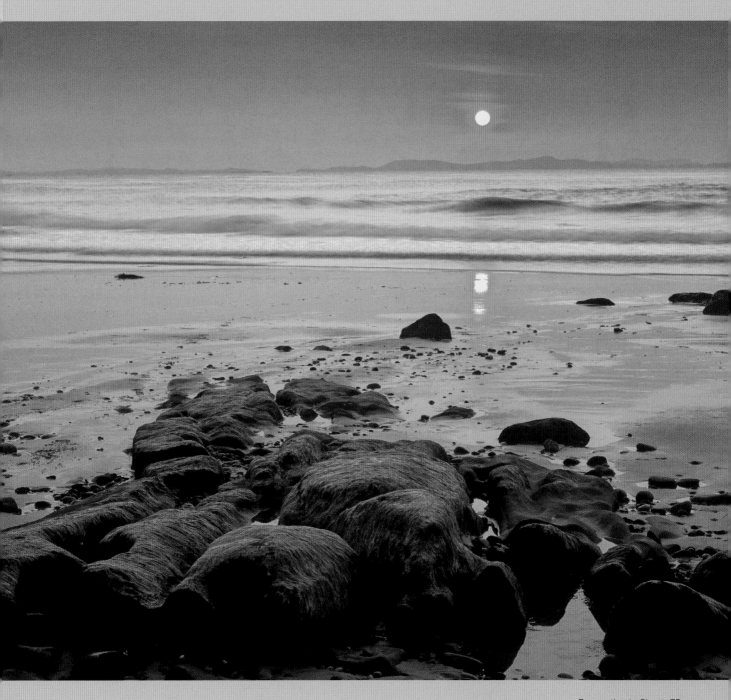

ACCESSORIES

Whenever you're out in the field taking photographs you need to consider all the extra bits and pieces that contribute to the smooth process of capturing an image. The items I take have been honed over many years and are particular to my requirements; you should develop your own accessory kit and check and clean it religiously before commencing a field trip.

Filters

Digital cameras, together with the improved technology of post-processing, have arguably made conventional filters redundant. It's quite possible to take several different exposures of the same scene moments apart and blend each together to get satisfactory results. I believe that conventional filters still have a role to play, and they are essential for the film user, significantly reducing the amount of post-processing required. I happen to take the slightly old-fashioned view that a photograph is a single capture, one exposure made at a single instant in time, not an amalgamation of several.

Certain filters are not reproducible with image-processing software. A perfect example is the polarizer, which saturates colour and removes reflective glare from shiny surfaces. It is an important addition to any landscape photographer's kit and conveniently acts as a two-stop neutral density filter. There are basically two types of polarizer – linear and circular – this does not relate to their shape, rather the action by which they work. If you use a modern camera, a linear polarizer will upset the metering system and give false readings. I recommend using circular polarizers, despite the slight increased cost.

Filters are the main tools I use to take control of exposure at the moment of image capture. A landscape photographer will usually have some, if not all, of the following filters at their disposal: neutral-density graduates in various strengths to manage dynamic range, a basic warm-up filter to remove blue casts in shadow areas, or to accentuate the warm light that is already present and a polarizer. There is little else in terms of filtration that is necessary.

Tripods

One accessory that I couldn't do without is a decent tripod – let me really drive the importance of that home to you. I'm not talking about a spindly three-legged afterthought that stands two foot off the ground, passes for camera support, but falls over in the first puff of wind. I am talking about a solid, heavyweight piece of kit, that doesn't shiver uncontrollably in the bitter winter wind, but instead stands proudly at head height, exuding confidence, dwarfing the camera that sits upon it. To contemplate landscape photography without your three-legged companion, is in my opinion pointless. A good tripod is quite literally worth its considerable weight in gold, consequently the purchase of a good one should be a priority and it should have the following attributes.

• Solidity/rigidity/weight
• Eye-level operation without centre-post extension
• Easy option of adjustment for low-level work
• Independent tripod head.

A tripod needs to be rigid, sturdy in construction, unreasonably heavy and mechanically dead (i.e. it doesn't 'ring' when struck). A comfortable eye-level operating height, without centre-post extension, is vital, so as not to compromise stability. The tripod should have the flexibility to work six inches (15cm) off the ground, be easy to adjust to work at this height in a matter of seconds, and have independently adjustable legs to accommodate extreme slopes or awkward conditions. Some tripods are constructed of aluminium, others have carbon-fibre legs. The latter increases the cost quite

drastically but the benefits are a significant reduction in weight (without loss of rigidity) and better damping. It also feels 'warmer' to carry in the middle of winter.

I recommend looking at the following manufacturers: Manfrotto (Bogen), Slik, Giotto, Gitzo and Benbo. They vary in price considerably and are supplied independent of the head mechanism.

Tripod Heads

Of at least equal importance is the type of head mechanism that you choose to marry with your tripod. Although you might think that the tripod manufacturer's own head would be best, it is rarely the case. Some of the independent tripod-head makers concentrate exclusively on the machining of these pieces of equipment, and usually produce a far superior product, offering a number of different options, relating to the style of use and weight of the camera placed upon it. The best of these heads are frighteningly expensive, costing almost as much as a mid-range digital SLR.

There are two types of tripod head to consider for landscapes:
• Ball heads
• Three-way pan and tilt

LEFT The Gitzo 1325 doesn't have a centre post but with its three section legs fully extended it still reaches eye level and beyond. A centre post will convert your stable tripod into a three-legged monopod.

Try out both before you buy, as there are advantages and disadvantages to each. I prefer ball heads and unsurprisingly I have my particular favourite model. Look at manufacturers such as Manfrotto, Gitzo, Giotto and the specialist makers such as Linhoff, Kirk and Arca Swiss.

Whichever tripod head you eventually go for, insist on a quick-release mechanism – I would never choose a head that didn't have this feature. A good quick-release head enables you to remove the camera complete with attached metal plate in seconds, while you fine-tune your shooting position away from the tripod.

BALL HEADS
These have a relatively small physical size and are quite lightweight; they come in various sizes and offer different control mechanisms, but all permit quick setup and lock into place with a single twist on a clamping dial.

THREE-WAY PAN-AND-TILT HEADS
These heads offer an equally robust method of ensuring a good solid support for your camera. They can be cumbersome to use as there are three control knobs, one for horizontal, one for vertical and one for rotation. The disadvantages are speed of use, increased physical size and the weight of the mechanism. The three handles do tend to snag on things when the tripod is slung over a shoulder.

Three-way pan-and-tilts are more valuable for wildlife or sports photographers. But, whichever brand of tripod and head you end up going for, be prepared to spend some money on it. Get the best quality and the sturdiest model you can bear to carry.

ABOVE The Arca Swiss Ball Head; although battered and bruised it holds my heavy camera and lens combination at any angle with reassuring solildity.

PRO TIP

If your camera is fitted with a vibration control mechanism make sure you turn it off when attaching your camera to a tripod. Otherwise the system tries to compensate for movement that isn't there.

Memory cards

A camera needs to write an image to a storage medium. Digital cameras use memory cards, which have evolved to become smaller and cheaper, yet offer higher memory densities and write speeds. They have proved themselves to be ultra reliable; they have no moving parts and can accommodate enormous amounts of data. I would suggest getting a few smaller capacity cards rather than one large card – then, should loss or damage occur, at least all your eggs aren't in one basket.

Film

This is the recording medium of the conventional camera – a light-sensitive gelatine base composed of extremely fine-grained silver halide crystals and colour coupled-dye layers. The image is latently stored and subsequently undergoes chemical development to reveal and fix the picture in place. The finished product, if exposed correctly, is a full-colour, perfect miniature of the landscape you earlier photographed. Film has had decades of technological research poured into it and the result is a very refined product.

Landscape photographers generally choose slow speed film for its grainless appearance and saturated colours. Different types of film have come and gone, but the runaway favourite is Fuji's Velvia 50 – it has incredibly fine grain, luxuriant three-dimensional colour and unparalleled vibrancy, which always manages (in my opinion) to stay on the side of reality. The film you choose makes a difference and, unlike digital storage, it imposes its character on the finished image.

LEFT Burghead, Moray, Scotland. The original Fuji Velvia 50 film was, in my opinion, the finest landscape photographers' film ever made.

• *Pentax 67II, 55–100 zoom, polarizer, f/16 at 1/8sec, Velvia 50* •

Photographers are always fascinated by the equipment that others take with them into the field, so out of a sense of duty I have included mine. It is occasionally adapted for more extreme environments, but essentially this is it. By choice I choose to shoot film, but the contents of my camera bag could just as easily be organized to suit digital. Everything in your camera bag should have a purpose, otherwise it's just unnecessary bulk. I make a point of checking and cleaning all my kit before venturing out.

Daypack: Lowepro Dryzone 200 Photographic Daypack

This contains all my kit and it was chosen for field comfort and efficiency, it has a completely waterproof lower section, is well padded and accessible.

Camera: Pentax 67II

The big Pentax is a medium-format camera that mimics a conventional SLR, albeit the camera appears to have undergone a course of steroids. It has little in the way of automated functions, but it's got no more or less than the functions I need on a daily basis. The layout is simple and clear and everything is solid and robust. Probably the least appealing thing about the camera is its weight (2kg without lens).

Lenses: 55–100 zoom lens, 200mm lens, 45mm lens

I work with a modest range of high-performance lenses that cover 45 to 200mm wide, to short telephoto. I don't use longer focal lengths, as atmospheric

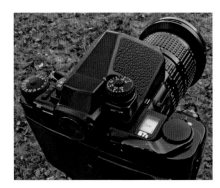

haze tends to soften image quality and I dislike the distortion found in very wide-angle lenses. 90% of my shots are taken with the 55–100mm zoom lens, consequently it is left permanently attached to the camera.

Accessories

I have a long list of accessories that are in various sectioned compartments of my camera bag – everything in there is useful to me: Pentax digital spot meter; spare batteries for both the camera and the spot meter; a spare tripod release plate; a set of jeweller's screwdrivers; a leatherman multi-tool; a pretty floral shower cap (I kid you not!); a lens-cleaning cloth; drying cloth; bin-liner bag; lastolite fold-up diffuser/reflector disc; sun compass; 50-pence piece; map; small box of matches zip-up CD wallet with white inserts (for filter storage).

I use a spot meter in preference to the camera's built-in meter because it is highly accurate and offers a defined area of measurement. I seek out extremes of light and sometimes only a very small

percentage of the scene receives the light I'm interested in. The Pentax spot meter is capable of reading just that area and nothing else.

Filters

Screw fit Heliopan 81 linear polarizer, 2 off Hitech 100 wide-angle system filter holders, Hitech 100 adaptor rings (one for each lens).

- Hitech 100 0.3ND grad hard-edged filter
- Hitech 100 0.45ND grad hard-edged filter
- Hitech 100 0.6ND grad hard-edged filter (+ spare)
- Hitech 100 0.9ND grad hard-edged filter
- Hitech 100 0.9ND grad soft edged filter
- Hitech 100 0.6ND grad soft-edged filter
- Singh Ray 5 x 4in Singh Ray two-stop reverse grad
- Hitech 100 1.2 neutral-density filter.

NEUTRAL-DENSITY GRADS

I use neutral-density graduated filters to manage light. My aim is to produce the best transparency I can and do as little post-processing as possible. It is pretty unusual for me to take a landscape photograph without incorporating a neutral-density graduated filter of some sort, particularly in the UK.

Taken only a minute apart both pictures were metered from the sandstone rock in the foreground – the first is unfiltered and shows little detail in the sky, the second had a hard-edged three-stop neutral density graduated filter aligned with the horizon and is much closer to what I was seeing with my own eyes.

BELOW, LEFT AND RIGHT Hopeman, Moray, Scotland.

• *Pentax 67II, 55–100 zoom, f/22 at 2sec, Velvia 50* •

• *Pentax 67II, 55–100 zoom, 0.9ND hard grad, f/22 at 2sec, Velvia 50* •

The Hi-tech 100 range of filters cover all my lenses and minimize the risk of vignetting, they are also completely neutral unlike some cheaper grey graduates which display colour casts.

Neutral-density graduated filters can be bought in various densities and rates of transition. A soft-edged graduated filter is one that gradually changes from transparent to its ultimate filter strength, while the hard-edged filters change abruptly from transparent to full filter strength.

Below is an indication of the equivalent filter strengths relating to the apparently arbitrary numbers given and an indication of the percentage of use I get from each type:

- 0.3ND grad is a one-stop graduated filter 2% use
- 0.45ND grad is a 1.5-stop graduated filter 20% use
- 0.6ND grad is a two-stop graduated filter 70% use
- 0.9ND grad is a three-stop graduated filter 7% use

The decision to use a hard- or a soft-edged filter is influenced by the shape of the affected horizon which, incidentally, doesn't have to be horizontal. Occasionally I will stack or overlap two filters to achieve a desired result. The object of these filters is to create a seamless transition of tone that is undetectable to the viewer when they review the final image.

NEUTRAL-DENSITY FILTER

A neutral-density filter maintains the same density throughout. For the record I already own a two-stop neutral-density filter, its other name is a polarizer, but a 1.2 ND filter is four stops darker and is a very worthwhile addition to your kit. If you stack both filters together then up to six stops of light can be lost. Neutral-density filters allow you to create quite surreal effects, exposures are no longer measured in tenths of seconds, but as much as minutes; anything moving will become soft and vaporous even during daylight.

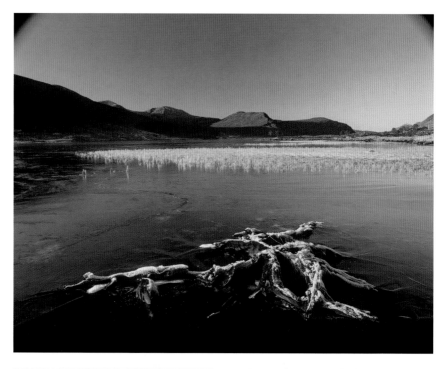

ABOVE A selection of large-sized neutral-density graduated filters made by Hi-tech, one of several manufacturers that offer a comprehensive range, free from colour casts.

ABOVE Loch Droma, Scotland. Be wary of using too small a filter system to accommodate your wide angle lenses or you may find vignetting of the corners will occur.

• *Pentax 67II, 55–100 zoom, polarizer, f/22 at 1/4sec, Velvia 50* •

RIGHT Glen Etive, Scotland: the choppiness of the water on this blustery day has been smoothed out by extending the exposure time to over a minute.

• *Pentax 67II, 200mm lens, 1.2 ND, polarizer, f/22 at 1min, Velvia 50* •

OVERLEAF Nairn, Scotland. Fuji Velvia film is extremely efficient at depicting the incredible tonal range but exposure accuracy and management of the light are crucial to its success.

• *Pentax 67II, 200mm lens, 0.9ND and 0.3ND grad, f/16 at 8sec, Velvia 50* •

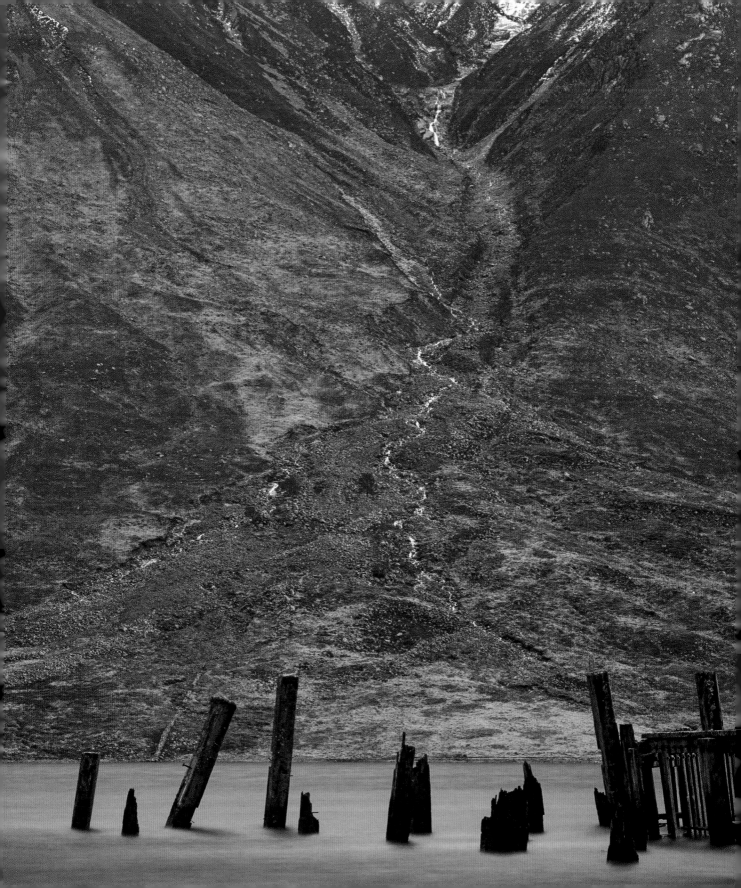

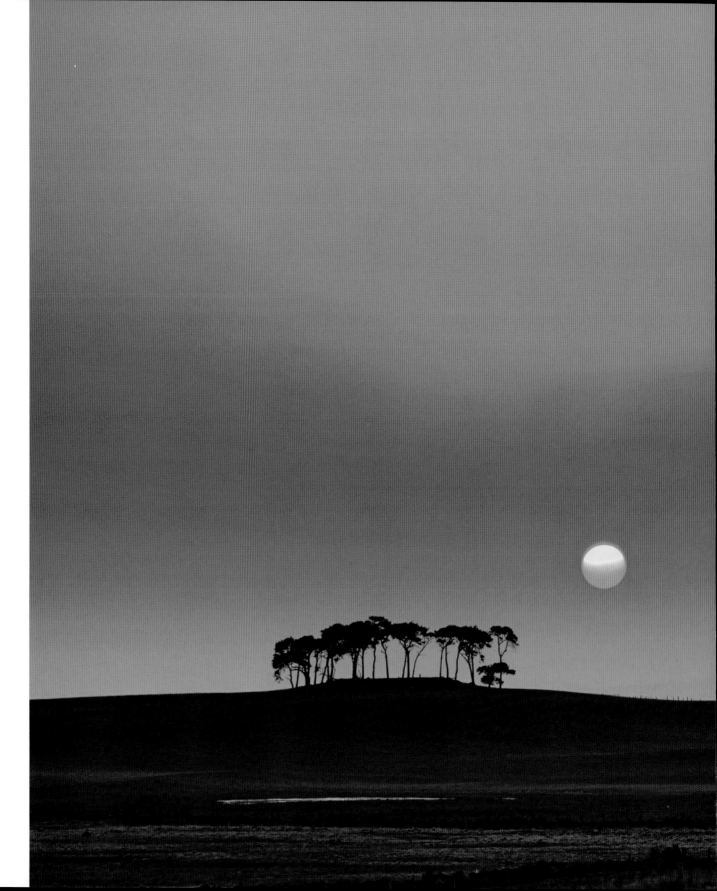

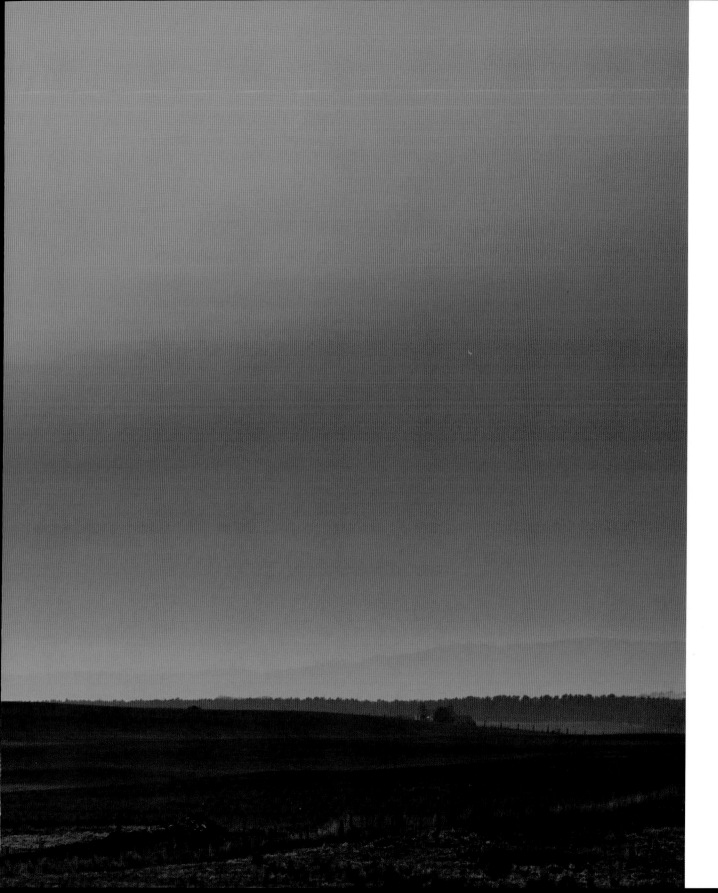

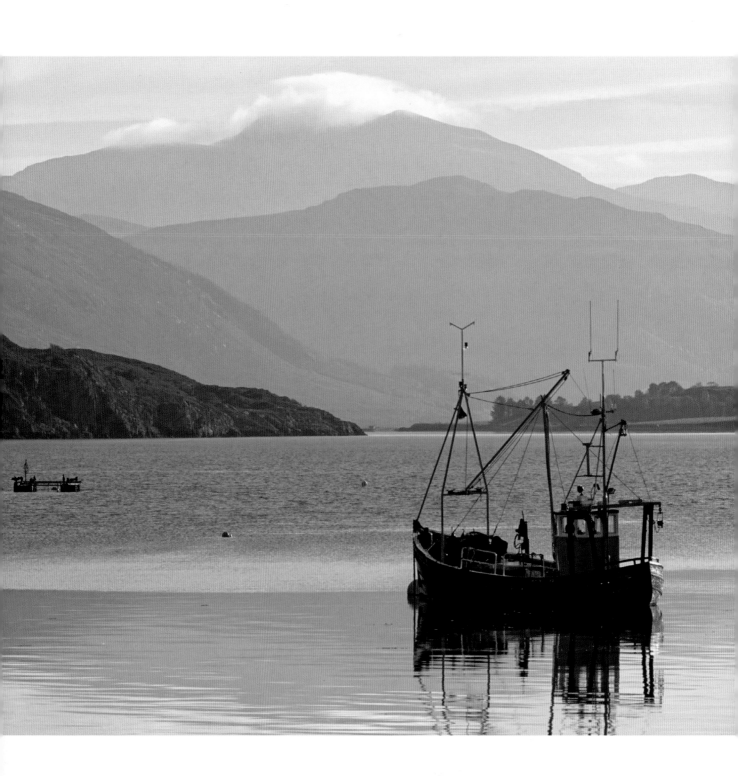

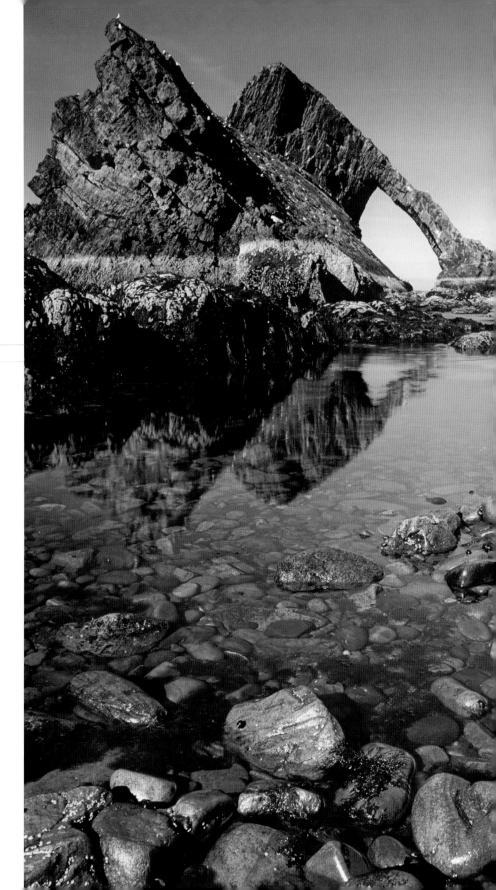

POLARIZERS

I use a large diameter (95mm) heliopan linear warm polarizer, as this matches the thread diameter of my zoom lens. The filter is made of schott glass and is off the highest optical quality. Most polarizers impart a cool cast to a picture so a built in 81 series filter negates that effect.

Polarizers need to be used with respect, over enthusiastic use will bring about fantastic colour saturation, but at the expense of blocked up shadows with no detail. I prefer to use them on overcast days just to remove surface reflections, as this effectively maintains colour saturation and retains detail in the shadows.

LEFT Ullapool, Scotland: a polarizer would have had little effect other than to work to its detriment blocking up the shadows and needlessly increasing contrast.

• *Contax ST, 80–200mm lens, f/11 at 1/60sec, Velvia 50* •

RIGHT Bowfiddle Rock, Portknockie, Moray, Scotland: attaching a polarizing filter exaggerates the colour in the sky clarifying the rocks and anemones beneath the surface of the water, having removed the surface glare.

• *Contax ST, 28–85mm lens, polarizer, f/22 at 1/4sec, Velvia 50* •

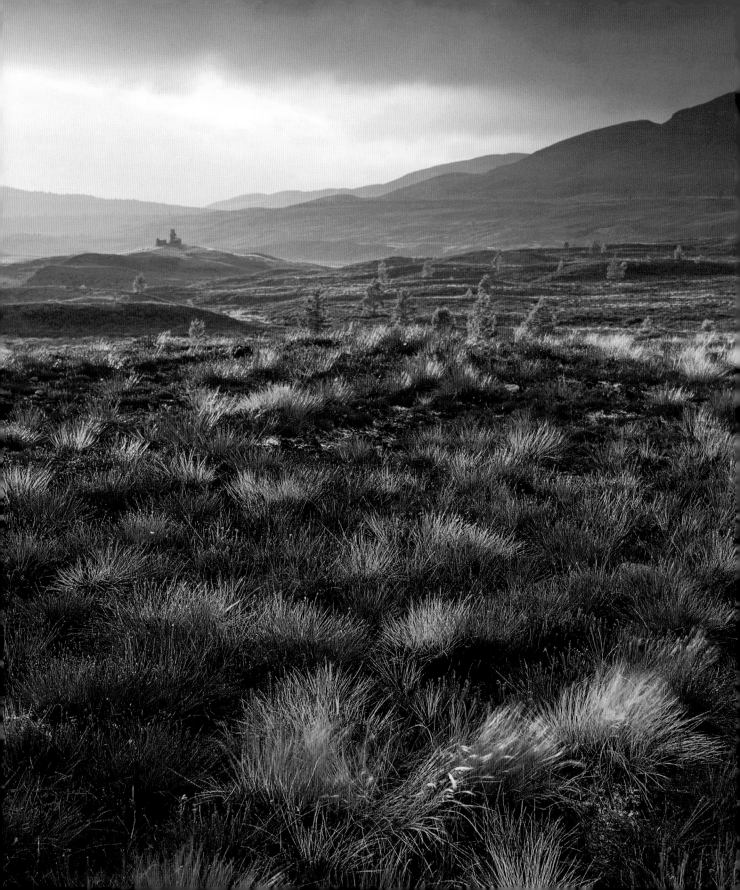

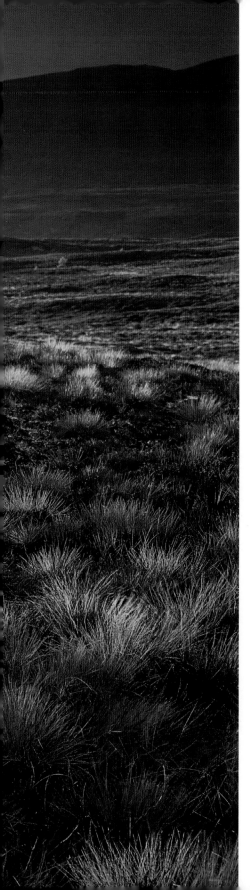

Tripod

Gitzo 1325 three-section carbon fibre, complete with Arca Swiss B1 QR ball head.

The Gitzo 1325 that I use is a three-section carbon fibre tripod with twist lock legs; it is robust, surprisingly light for its size and mechanically dead, i.e. no vibration is transmitted through to the camera. The Gitzo, like all good-quality tripods, has independently adjustable legs that allow you the flexibility to take pictures six inches off the ground or six feet high. I have complete faith in mine, a case of set it and forget it.

Married to my tripod is the Arca Swiss B1 QR ball head. It is a substantial piece of kit magnificently engineered with a few individual little features that make it my preferred choice. My camera is heavy and I often take long exposure shots, so stability is vital. The Arca Swiss ball head performs with consummate ease maintaining a vice-like grip.

Film

I've tried all sorts of films produced by various manufacturers, dabbling with fast grainy films and even monochrome transparencies, but inevitably I've returned to my favourite and now use Velvia 50 exclusively. It is high in contrast, highly saturated and has near invisible grain. For me at least, it manages to produce images in a realistic form with life and soul, something that is difficult to quantify. I've found ten rolls of 120 film a day (ten shots per film) to be sufficient.

ABOVE The Arca Swiss ball head attached to the Gitzo 1325 tripod provides an incredibly stable platform from which to conduct all my landscape photography, making it a joy to operate in the field.

PRO TIP

The minimum speed that you can reliably handhold your camera is considered to be the reciprocal of the focal length of the attached lens. If your camera is fitted with a 28–105 zoom, then picture sharpness will be compromised if shutter speeds are longer than 1/30 to 1/125sec respectively. A lense's vibration control mechanism can give up to two stops extra benefit, but it is not a replacement for a tripod and it should be turned off when the camera is attached to one.

LEFT A vast open tract of moorland is a good place to be to help you predict the approach of dramatic light. I was able to plan ahead and set up this shot in front of some tussocks of vibrant red grass which glowed like the embers of a forge at the first kiss of sunlight.

• *Pentax 67II, 55–100mm lens, 0.9ND grad, f22 at 1/4 sec, Velvia 50* •

Field Trips

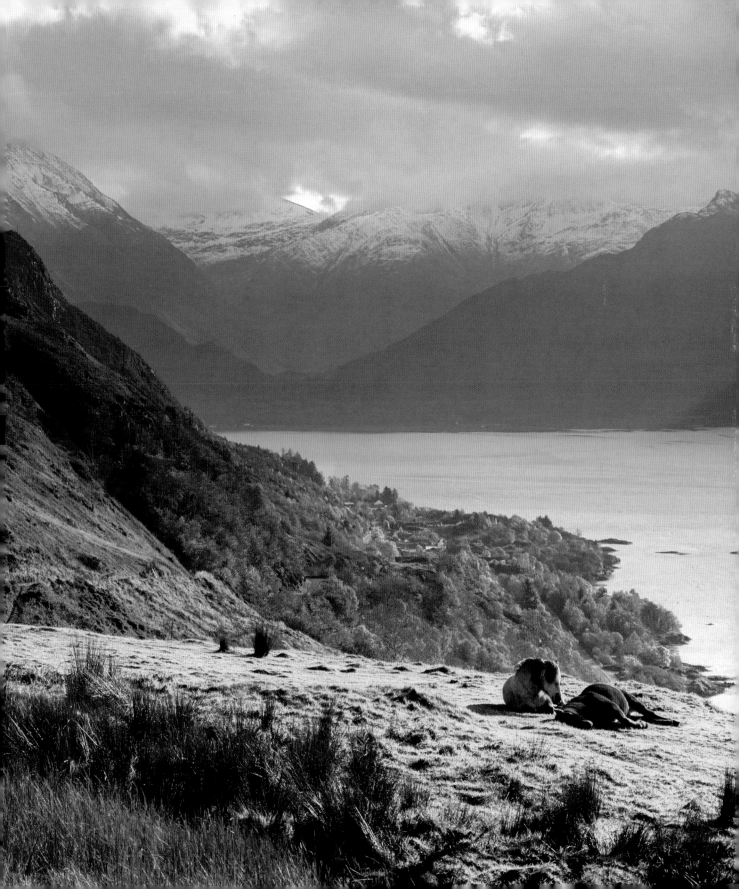

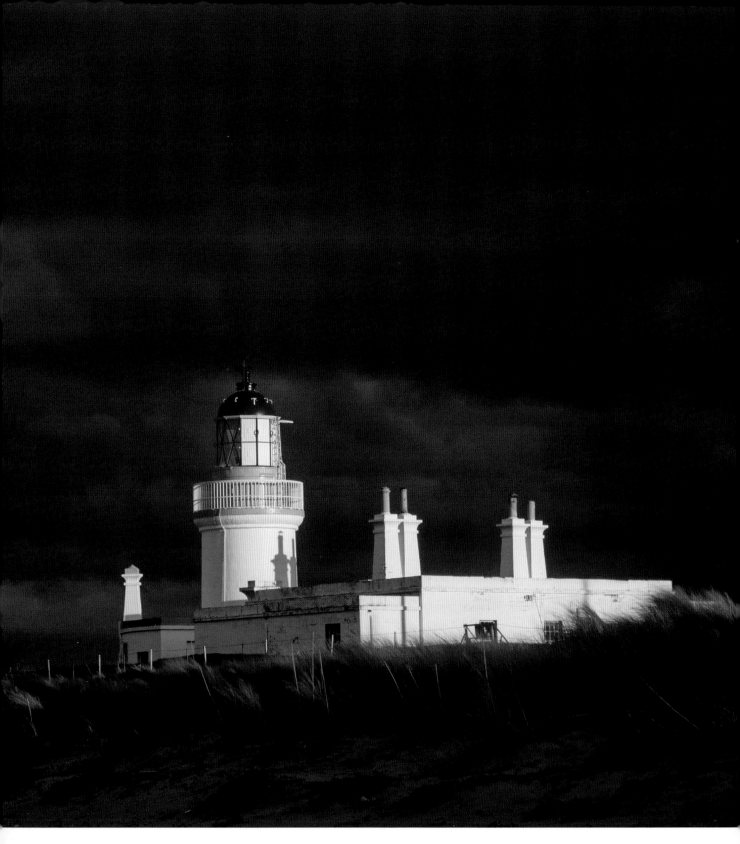

CHOOSING A LOCATION

After reading the first few chapters, you should have a pretty good understanding of the equipment you require and the preparation that goes into a successful field trip.

Now it's up to you – after an explanation of some of the techniques we will be using, we go into the field to take photographs and discuss, in terms of real life scenarios, the methodology used to take pictures. During the course of these field trips I will be illustrating my own personal workflow and encourage you to formulate your own.

If a photography book is capable of having soul, this chapter best represents the ideology that I place on it. Making use of its content depends as much on your ability to immerse yourself within the landscape, as it does on my capacity to convey the information to you. Try to imagine that you're actually there and just accept my presence as an instructive whisper in your ear. The leap of faith I've made is to assume that you, the reader, are not artistically challenged, otherwise I guess you'd have no interest in landscape photography in the first place.

Once you've chosen a preferred location, a workflow needs to be established.

PREDICTING THE LIGHT

Understanding light has been discussed in detail, but now I want to reinforce that understanding with anticipation, artful composition and sound technique relating to the landscape subject of choice. These considerations will be referred to throughout the forthcoming field trips.

I am obsessed with trying to maximize the chances of finding the best light. Before any field trip weather checks are carried out on several websites, and these commence a couple of days beforehand. Where possible, I use mountain forecasts as they tend to be both detailed and accurate, describing snow levels, temperature, wind velocity and air clarity, but ultimately predicting the light will depend on your ability to work out the prevailing circumstances at the specific location. Apart from the weather conditions, the time of year and consequent position of the sun will dictate whether or not certain aspects of a scene are going to be illuminated.

On arrival, I first try to find somewhere nearby that I can take in an expansive view, as doing so will make it easier to predict any sunlight that might appear. A heavy grey sky may not look promising but, if there are small gaps, then shafts of sunlight will find a way through and pepper the land beneath. By watching the movement of these patterns of light it is possible to determine the likelihood of it striking the subject of choice – the precise circumstances that give rise to transient light. It's very easy to be caught up concentrating on a specific shot, only to turn around 180 degrees and find that you have been oblivious to the tremendous light show going on behind your back.

Look for telltale signs in the sky, such as broken cloud, or subtle colour tints to cloud formations that may indicate the sun's imminent appearance. Predicting the light is very satisfying, capturing the result when no-one else is around to see it is the ultimate celebration of your achievement.

LEFT Chanonry Point, Moray, Scotland. A shaft of light tracking towards the lighthouse eventually hit. I set up in anticipation and, for just a few seconds, got lucky.

• Pentax 67II, 55–100 zoom, polarizer, spot metered from lighthouse, f/16 at ¼sec, Velvia 50 •

DEVELOPING A WORKFLOW

When you arrive on location, really take some time to drink it in. Look to create a strong composition out of the available elements. Composition is largely a matter of personal choice but adherence to compositional guidelines, is certainly worth considering. One approach is to decide what it is that you really like about a scene. If you can convince yourself of a valid reason for taking the picture, keeping only those elements which actually contribute to it, then you are well on your way to producing a meaningful photograph.

In my camera bag, the camera already has a mid-range zoom lens attached to it. It is left that way because I know that the majority of the shots I take will require this lens.

The next few minutes are all about fine-tuning, making small adjustments to the viewpoint, left, right, up or down.

Look to find the best way to portray the three-dimensional scene before you in two dimensions, in such a way that the viewer feels as though they are being gently guided through the picture.

Composition

It is composition that makes an image pleasing or satisfying to look at. A strong composition charms the viewer and helps them move easily around the displayed image in a coherent manner, finding something of interest to rest the eyes on before being guided to another point of interest. Here are the compositional guidelines that I instinctively employ:

Rule of Thirds

Artists have long known about the power of harmonious composition and the visual intersection, referred to as the golden mean. The photographic equivalent is called the rule of thirds. If you divide your picture into a grid containing nine equal rectangles, there would be four points of intersection a third of the way in from each edge. This is considered to be the strongest compositional place for your subject to be.

Visual Containment/Punctuation

Visual containment is the means by which you use the landscape to contain the subject. It is the boundary line that determines what to include or exclude from a scene. Certain less significant elements, such as trees and rocks, can be used as visual punctuation to stop the viewer's attention from wandering out of a frame. As a rule, lighter or more colourful elements should be kept towards the centre of the frame, as this will draw the viewer's eye. Nondescript features can occupy the periphery.

LEFT Burano, Venice, Italy. An old water fountain and faded painted walls provided a colourful urban study with the fountain sited on the right-hand third.

• *Contax ST, 80–200 zoom, polarizer, f/6.3 at 1/30sec, Velvia 50* •

RIGHT Bryce Canyon, USA. The tracery of light created by the sun glancing over a distant nest of hoodoos in Bryce Canyon forms a meandering path through a maze of repeating shapes with little to distract.

• *Contax ST, 300mm lens, polarizer, f/11 at 1/60sec, Velvia 50* •

Lead Lines/S-curves

Lead lines draw the viewer into the picture and guide them to the intended subject where you want to hold their attention. They can be either straight or curved or even form stepping stones. It is the perspective they generate, particularly in combination with wide-angle lenses, that pulls a viewer towards the desired area.

BELOW Mellon Udrigle, Laide, Scotland. Peat-stained streams, meandering down a beach towards the sea, form powerful leadlines that guide the viewer through a photograph.

• Pentax 67II, 55–100 zoom, polarizer, 0.45ND grad, f/27 at 2sec, Velvia 50 •

ABOVE Applecross, Scotland. With low contrast light and soft pastel colours laid out in a series of horizontal layers all adhering to the rule of thirds, the result is a soothing restful composition.

• Pentax 67II, 200mm lens, hard-edged 0.6ND grad, f11 at 1/8sec, Velvia 50 •

Image Dynamics

A composition can be made soothing and restful or exciting and dynamic. One way to influence this is by including horizontal, vertical or diagonal lines within your picture. Horizontal layering is calming, whereas diagonal lines imply movement and action.

Visual Weighting

If care is not taken in the construction of your composition, it can look seriously unbalanced. If all the features that create impact are on one side of the frame then the other side becomes redundant. In order to redress the balance, an element of visual interest has to be returned – this can be done by using contrast in the form of colour and shape.

RIGHT An Teallach, Dundonnell, Scotland. Without the silver pool diagonally opposite the picture would be weighted towards the setting sun and the rest of the image would be redundant.

• *Pentax 67II, 200mm lens, soft-edged 0.9ND grad, f/8 at 1/15sec, Velvia 50* •

Odd Subject Numbers

A picture that is strongly biased to a subject, where that subject comprises an even number of elements, can feel disjointed; the viewer's attention oscillates between the two parts. Using an odd number of elements will stop this imbalance and stabilize attention on the collective subject.

BELOW Antelope Canyon, USA. A simple subject utilizing colour contrast to create impact, along with diagonal placement for dynamism. An odd number of elements helps to maintain stability and balance.

• *Contax ST, 28–85 zoom, f/16 at 1/15sec, Velvia 50* •

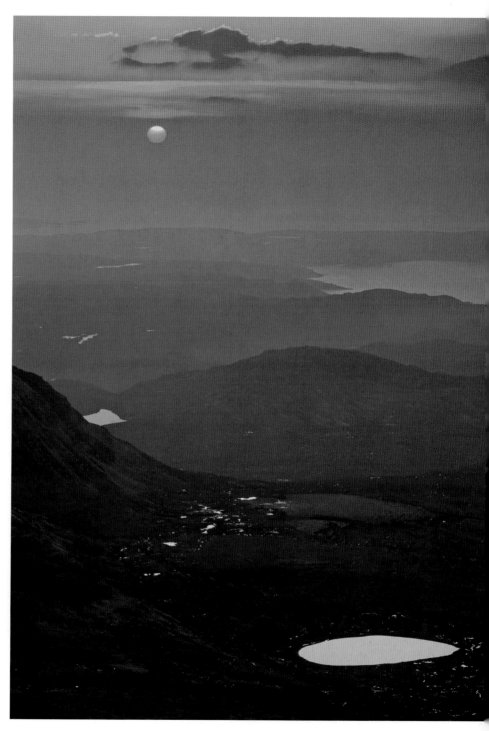

Repetitive Patterns/ Shapes/Textures

One of the strongest methods of maintaining interest in a photograph is to use repeating shapes, patterns and textures and then place a subject in a strong compositional location (rule of thirds) to break the thread of repetition.

Subject-less Abstracts

Abstracts have no defined recognizable subject and can leave the viewer wandering aimlessly around the picture not knowing where their attention is to be directed. The best abstracts create puzzled satisfaction and are visually compelling. The viewer is unable to say what they like about it, merely that it satisfies. The secret of abstracts is to try and construct a picture of balance and harmony from colour, shape and texture.

BELOW Cullen, Moray, Scotland. The repeating shapes of sunlit rooftops are used as a complex foreground pattern broken only by the viaduct with its corresponding repeating arched shapes.

• Contax ST, 80–200 zoom, polarizer, 0.3ND grad, f/16 at 1/15sec, Velvia 50 •

ABOVE Glencoe, Highlands, Scotland. A simple textural abstract picture created out of the patterns on a distant hill that seem to echo the appearance of water dribbling down a window pane.

• Contax ST, 80–200 zoom, f/16 at 1sec, Velvia 50 •

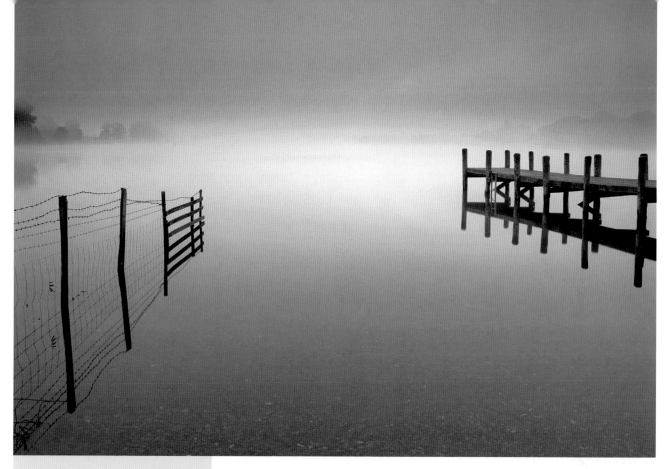

BREAKING THE RULES

One of the best reasons for knowing the rules of composition, is so you can break them. Stepping outside the traditional self-imposed boundaries of composition disconcerts. Photographers are notoriously bad at this – they adhere to the rule of thirds as though it were written in blood. Occasionally, breaking the rules disturbs the viewer to the extent that they can't keep their eyes off of it. Opinions on your picture will be polarized, some will love it, some will loathe it, there is rarely a middle ground, but the result is a picture that cannot be ignored. In a gallery containing a hundred or more images it will be this one that is remembered, while the others suffer the silent death of mediocrity.

Once the final composition is complete, any accessories I think I'll need – such as Pentax digital spot meter, filter wallet and holder, polarizer and cleaning cloths – are taken out of the bag and dumped beside me for ease of use.

Prior to making a photograph, one of the first considerations is to decide whether or not the picture will benefit from having a polarizer attached. Polarizers enhance colours, by eliminating surface reflections, but they also block up shadow areas particularly in contrasting light. I tend to assess the polarizing effect off camera, sometimes rotating it away from maximum, to lessen the contrast and drama in a scene.

ABOVE Coniston Water, Lake District, England. A picture that doesn't conform to the rules of composition – split lead lines leading nowhere, near centred, almost invisible horizon and no centre of interest.

* Pentax 67II, 55–100 zoom, polarizer, 0.6ND soft grad, f/22 at 30sec, Velvia 50 *

The filters that I use most often are the range of neutral-density graduated filters that compress the dynamic range within a landscape, allowing the user to retain detail in both the highlight and shadow areas. These filters are so useful and so often used that I prepare for their use in advance, attaching the filter holder to the lens.

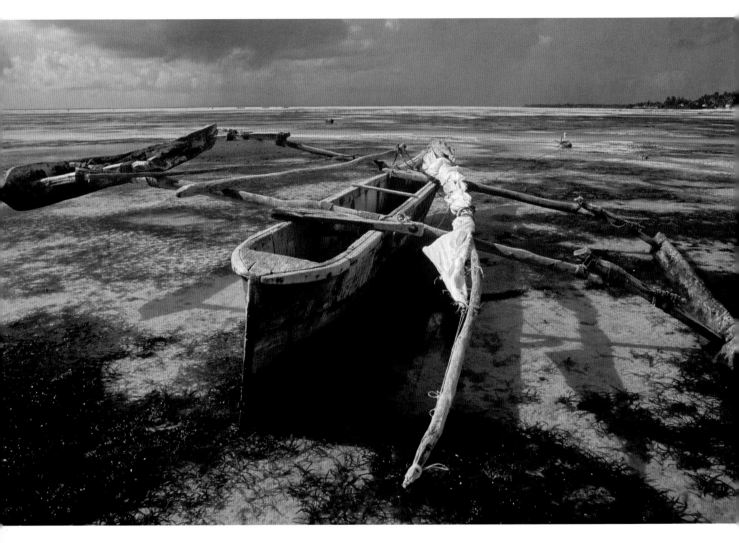

Depth of Field

The next priority is to optimize depth of field. Landscape photographers tend to think in terms of maximum depth of field, meaning that sharp focus is held from near to far. This optimum point of focus is rather impressively referred to as the hyper-focal point and is a means of sharing out the acuity of focus between the nearest and furthest points – there

are a number of methods for working it out. I use the age-old field-based method of focusing at a point a third of the way up from the bottom of the camera's viewfinder frame. It's a very practical solution, which rarely lets me down. It also happens to be a persuasive argument for switching your camera to manual focus, assuming of course that your eyes are up to the job.

ABOVE Zanzibar, Tanzania. The strong dynamic appearance of this beached outrigger necessitated a huge depth of field and use of the hyper-focal technique to hold it in sharp focus from front to back.

Contax ST, 24mm lens, polarizer, f/22 at 1/8sec, Velvia 50

Choosing the Exposure

Only at the very last moment is there any point in considering the exposure to give your selected scene. After all, landscape photography – as I continually emphasize – is about photographing the light on the land and, just because you're ready to commence taking pictures, doesn't mean that your subject is, so be patient!

Metering is usually achieved with reflectance light meters. These all work in exactly the same way, whether it is the multi-zone 3D-matrix metering of the latest generation of digital cameras, a dedicated spot meter, or an ordinary centre-weighted meter. They measure the reflectance of an object and insist on turning it to a mid-tone. If the reading isn't intelligently modified things can go drastically awry: it could mean that the black cat you have just metered and subsequently photographed turns out grey, similarly the dazzling white snow scene takes on a dull and dingy grey appearance, not at all what was expected or wanted.

Whilst a modern multi-zone matrix meter will probably anticipate that you are actually looking at snow and will – through its programming – apply the necessary compensation, a spot meter assumes that you the photographer will assign it an appropriate compensation correction. Personally I much prefer this extra creative control.

How to Meter

Transparency film and digital sensors are capable of recording detail over a range of just five f-stops, consequently your exposure needs to sit within this range or risk loss of visual information. At the lower end of this five-stop band your subject will appear dark, while at the other it will be light. The mid-tone reading obtained from your meter would sit slap bang in the middle of this five-stop scale.

As it is neither under- or overexposed we will, for arguments sake, call it position '0'; once that reference point is fixed, all other values of reflectance fall neatly into place. The very darkest object is detail-less jet black and will be a minimum of 2.5 stops darker, or -2.5 on our five-stop scale, whereas brilliant detail-less white will be a minimum of 2.5 stops brighter than our mid-tone, or +2.5 stops on our five- stop scale. Ideally, in between this range will be all the tonal values that make up the picture. It is important to remember that the landscape is seen in colour, not monochrome, so we are referring to its colour reflectance value, rather than mere shades of grey.

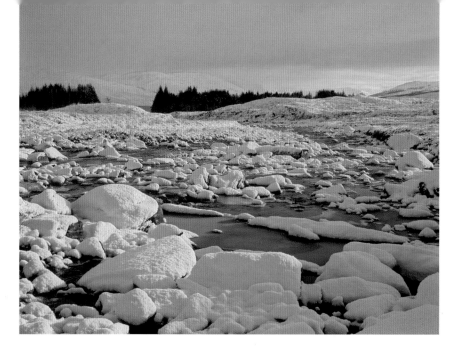

ABOVE Strathglass, Highlands, Scotland. Exposure compensation was applied to keep the snow clean and white.

• Pentax 67II, 55–100 zoom, 0.3ND grad, f/22 at 1/15sec, Velvia 50 •

-2.5	0	+2.5
Jet Black	Mid-tone	Pure White

OVERLEAF Hopeman, Moray, Scotland. The dynamic range of this scene was modified with a three-stop ND graduated filter to compress it within the five-stop limit.

• Pentax 67II, 55–100 zoom, 0.9ND grad stacked, f/22 at 2sec, Velvia 50 •

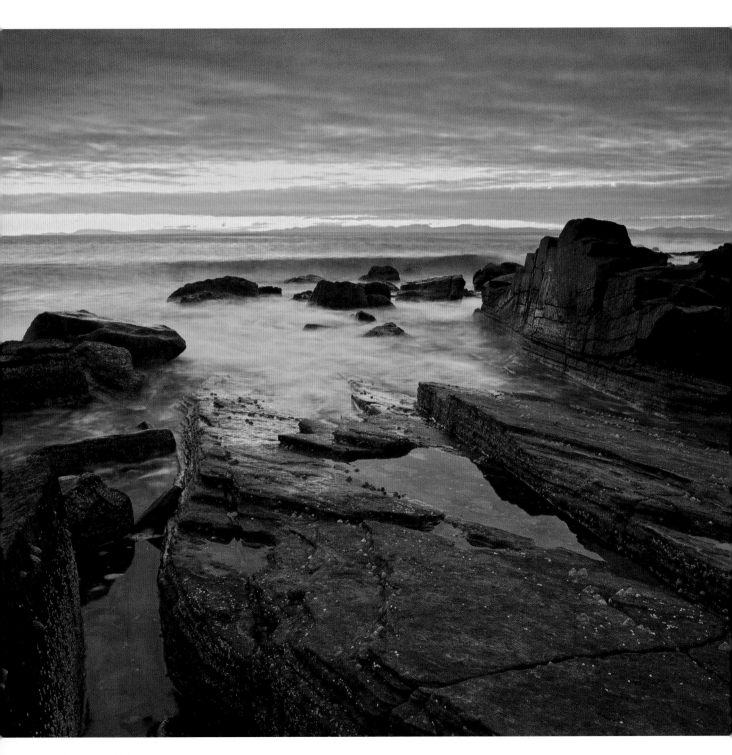

Identifying a mid-tone comes with experience, but here are a few useful ones for landscape workers:

- Blue sky, 45 degrees above horizon at right angles to the sun
- Summer green grass
- Mid-tone grey rocks

However, if these aren't present in your scene, elements with different reflectance values can be substituted, and the appropriate compensation dialled into the camera:

- Sunlit snow (+2 stops)
- Golden sand (+1 stop)
- Evergreen trees (-1 stop)

It is vital to point out that a meter will only read the same value for mid-tones if each of those subjects has the same amount of light directly falling on it from the same light source. If one of your mid-tones is sunlit grass and the other is shaded, then clearly the light falling on these patches of grass is different and the reflectance of both will show a marked departure from each other. In all cases it is better to prevent any area of the picture burning out (overexposure). Obtain the reading from the sunlit grass, allowing the other areas to take care of themselves.

With the best will in the world, and even though you may choose to shoot in the softest directional light available, the chances are that some parts of your landscape scene are going to step outside this rather restrictive five-stop exposure band. I mentioned before that there are choices: accept the film or sensor's limitations and sacrifice part of your landscape to detail-less shadow – used creatively this needn't be a problem and can lead to increased drama in the finished photograph. The other options are to use graduated neutral-density filters, or digitally blend images taken at different exposures, or simply double-process a raw image for highlight and shadow areas, then blend. The latter are not favoured techniques of mine; I prefer to get everything right in one shot, hopefully resulting in one perfectly exposed original image, rather than two or more, none of which would survive my bin independently. However, I appreciate that not everybody feels the same way and they simply treat it as a means to an end.

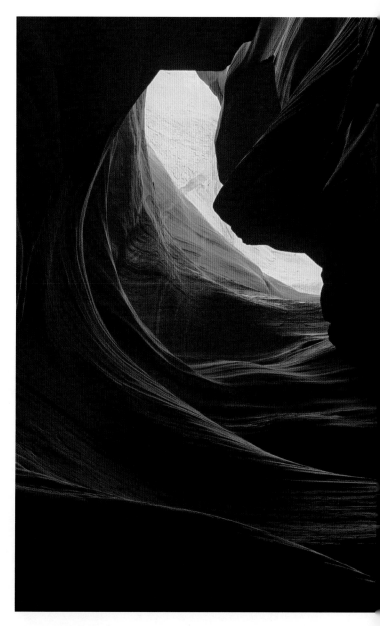

ABOVE Antelope Slot Canyon, Arizona, USA. Occasionally restricted dynamic range can be turned to your advantage to create graphic shapes and swirls with an astounding range of colours.

• Contax ST, 28–85 zoom, polarizer, f/22 at 90sec, Velvia 50 •

Independent Light Meters

I do all my metering independent of the camera. The Pentax digital spot meter, along with a select few other makes, is capable of taking light readings from a tiny one-degree area. The exposure value (EV) is calculated from an analogue scale of rotating dials on the meter. It sounds complex but in practice it is astonishingly easy to get to grips with it. Equivalent exposure readings are obtained at a glance, based on the sensitivity of the film or sensor setting used.

My spot meter has proved itself to be incredibly useful. Most photographers manage perfectly well without one, but I have found that it offers two very distinct advantages over a camera's internal metering system: the first is the ease and accuracy with which I can assign a specific exposure reading to a very small measurable area – this is quite an important concept, as I believe there is no such thing as a correct exposure, merely a preferred one.

The second advantage is not so obvious, but definitely useful. Since the meter is completely independent of the camera, and the camera can be operated manually, it is possible to adjust and fine-tune a composition exactly: set the focal point, apply any filters that might be needed,

and leave the camera in position until the exact moment the light materializes. When that moment transpires, the shutter speed and aperture reading is transferred to the camera, the mirror locked up and the shutter released, all this without once altering the position of the camera.

There are some disadvantages too. An integral meter takes account of any filters attached to your lens automatically. The spot meter requires you to remember they are there and make the necessary adjustments, demanding a methodical approach which has to be incorporated into your workflow. Whilst integral meters on modern cameras are phenomenally good, the metering system demands you trust it completely. It will doubtless work

wonderfully in normal lighting conditions, 95% of the time. Unfortunately, because we are landscape photographers, it is not ordinary light that we seek, it is extraordinary light. Should that situation arise, you will want to be able to take total control of the camera and make your own adjustments, not accept on blind faith the exposure reading provided by a camera's admittedly clever, but soulless programming.

BELOW Glencoe, Scotland. A thin sliver of intense light provides a very small area to measure from. A one-degree spot meter proves very useful in these transient conditions.

• *Pentax 67II, 200mm lens, polarizer, f/11 at 1/30sec, Velvia* •

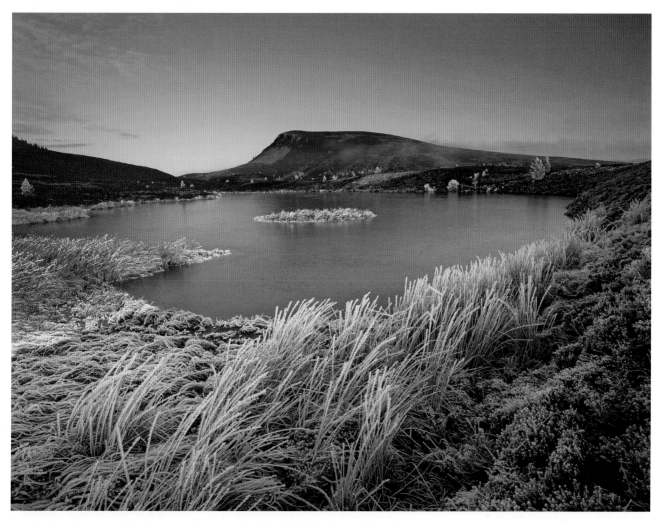

Now that you're fully acquainted with the techniques needed for getting the best out of a landscape, we will go into the field and tackle a variety of different environments.

Since photographing landscapes is about inspiration I have kept the text descriptive in the hope you will experience something of the passion I have for my chosen profession.

Inevitably, there are a few shortcomings that become apparent when conducting imaginary field trips. The first is environmental – whilst your imagination may take you to the top of a mountain, it is hard to re-create hardships likely to be encountered in the less than perfect conditions. The second problem is that, unlike those folk that take part in the workshops, it will not be possible to ask any questions, which leaves the onus on me to try and anticipate them.

ABOVE Dava Moor, Carrbridge, Scotland. At -19˚C an efficient workflow is essential. It was a race against the rising sun and melting frost.

• Pentax 67II, 55–100 zoom, polarizer, soft-edged 0.6ND grad, f/27 at 2sec, Velvia 50 •

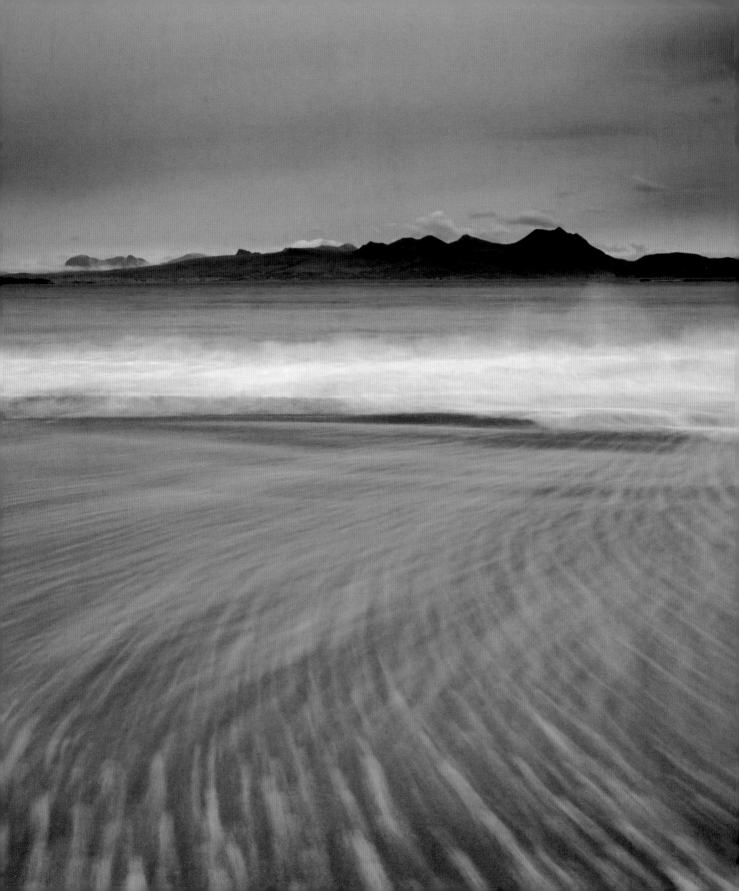

FIELD TRIP: COASTAL

For sheer variety of colour, texture and terrain, the coast provides some of the best photographic opportunities available. Large, flat areas of sand disturbed throughout the day, by human activity, are miraculously concealed by the returning tide twice each day. The coastal landscape is renewed and with it new inspiration arises.

Two of the most important considerations are the state of the tides and the position of the rising or setting sun in relation to the coastal area you want to photograph. The coast offers great diversity, whether it's pebbly beaches, rocky shorelines, sand flats, sand dunes or cliffs. Man-made features, such as jetties, piers, harbours and lighthouses, provide a strong focal point on areas otherwise devoid of subject interest.

Sandy Beaches

Generally lacking in surface details, quality light and strong composition is paramount, preferably with a prominent foreground to anchor the image. Look for pattern and texture revealed by side lighting, or isolate small areas of interest with a longer lens; getting down low will emphasize it, creating lead lines that stretch towards a subject. A featureless beach presents a clean palette which focuses attention on anything that breaks its purity. Keep compositions simple and clean, using graphic shapes.

Pebble Beaches

Full of texture and pattern; stony beaches provide all the foreground interest you could want. Combine it with soft directional light that wraps around stones and reflects off wet or shiny surfaces and the results are quite stunning. Get down to ground level and emphasize the foreground elements – these can be used on their own as abstracts, or as an integral part of a wider landscape. Careful composition is essential to prevent detail becoming a confused mess.

LEFT Mellon Udrigle, Laide, Scotland. Twice each day the returning tide sweeps the beach clean to reveal a new canvas with which to work.

• Pentax 67II, 55–100 zoom, polarizer, two-stop ND filter, f/22 at 40sec, Velvia 50 •

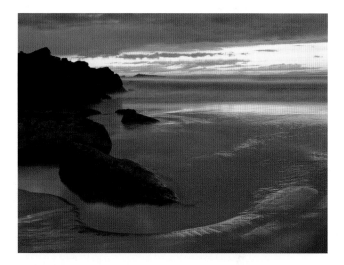

ABOVE Hopeman, Moray, Scotland. A rock embedded in soft, wet sand at low tide displays fine dendritic drainage patterns which are rim lit at first light.

• Pentax 67II, 55–100 zoom, 0.9ND grad, f/22 at 12sec, Velvia 50 •

BELOW Cove Bay, Moray, Scotland. A tumbling cascade of soft ball-sized stones spills into the transparent waters of the Moray Firth.

• Pentax 67II, 45mm lens, polarizer, hard-edged 0.6ND grad, f/22 at 2sec, Velvia 50 •

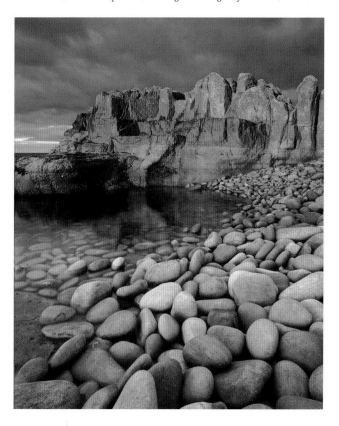

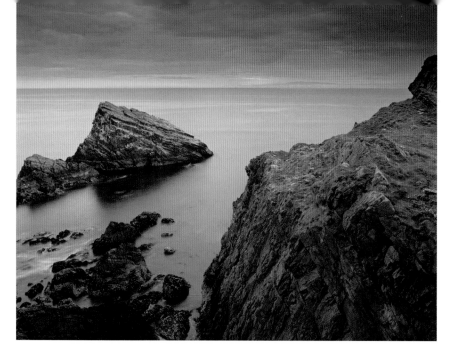

ABOVE Portknockie, Moray, Scotland. A lofty viewpoint overlooking the sea provides an unusual perspective. I photographed this at 3.45am when the pink glow of dawn passed with amazing rapidity back to slate grey.

• Pentax 67II, 55–100 zoom, 0.6ND hard edged grad, f/13 at 6sec, Velvia 50 •

Cliff Scenery

Cliffs provide a different perspective and they are particularly useful if the sky is uninteresting (it can easily be excluded from the photograph). Scenic elements such as rock stacks and arches can be isolated against a turbulent sea, providing a compelling combination of solidity and movement. Cliff-top scenery works best in rough weather with the creative use of longer exposures.

Sand Dunes

Sand dunes are primarily about using light and form and are revealed at their best at sunrise or sunset, when the angle of light is very low. The shadows cast by the wind shaped ridges can be used as attractive foreground features in a wider landscape, or as series of subject-less abstracts. The latter make wonderful fine art light and form studies that can be further simplified in monochrome. Keep everything simple and graphic with a limited colour palette.

Beach Abstracts

If the sky is white and the light diffuse, ignore the sky altogether and concentrate on beach details. Fortunately, rocks, stones and other beach jewellery are often very colourful and form distinctive patterns. Flat light is perfect for extracting fine detail and delivering maximum colour saturation, where shadows would otherwise be a distraction and conceal detail. I refer to these studies as intimate landscapes. Simplicity and refined composition is the key to a successful image.

ABOVE Death Valley, USA. A long lens was used to isolate this interesting textural swirl in a sand dune thrown into sharp relief by the hard morning light adding both texture and pattern.

• Contax ST, 80–200 zoom, f/11 at 1/125sec, Provia 100. Converted using Channels to black and white with Photoshop CS •

ABOVE Kinlochleven, Glencoe, Scotland. The vibrant rocks and stones that line the shores of Kinlochleven are startling. Diffuse light renders them all with astonishing detail.

* Pentax 67II, 55–100 zoom, Polarizer, f/22 at 2sec, Velvia 50 *

ABOVE Rhue, Inverpolly, Scotland. A man-made subject in a natural landscape often creates a strong sense of place. I tried to elicit more interest by composing it with the reflection in a nearby rock pool.

• Pentax 67II, 55–100 zoom, polarizer, 0.45ND grad, f/16 at ½sec, Velvia 50 •

Man-made

The inclusion of man-made features such as lighthouses, piers and jetties define a location, making it instantly recognizable and consequently marketable. Other photographers will be aware of this too, so it's up to you to find a unique selling point; extraordinary light or inspirational composition will doubtless help your photograph gain the attention it needs, should you wish to sell the results.

WORD OF WARNING

Sand and the inevitable rising tide are a camera's worst enemies. It is ridiculously easy to get engrossed in your photography only to find your camera bag is imitating Noah's ark. Tiny grains of sand will find their way into your camera if you change the lens – care and preparation are essential. Another casualty of the beach can be your tripod – they don't like sea water or sand, so make sure you wash them out afterwards or the screw threads will very quickly rust. Modern cameras are generally well sealed, but sea spray and salt are highly corrosive if left unattended.

ON LOCATION

About 7pm on a June evening I headed down to Cove Bay in anticipation of a fine sunset. The bay faces north and it's only for a couple of months during the summer that the rising and setting sun travels far enough around to shine directly into it.

On arrival, I find the sea is gently lapping over the rocks on the foreshore causing them to glisten in the low sunlight. The stones along this section of coast are remarkable, being pale in colour, of uniform size and rounded by the incessant grinding action of the sea. A pale surface picks up the colour of any light that shines directly on to it; correspondingly the shaded side of the stones will adopt the colour of ambient light. Immediately, I'm thinking in terms of contrasting colours, warm yellow light from a setting sun and cool blue shadows from the clear overhead sky.

I have plenty of time before sunset and use it to fine-tune a selection of compositions. I try to find both landscape and portrait versions of any photograph that I think will work, as there is a strong possibility that one format or other might prove preferential to illustrators in books or magazines. With such prolonged and beautiful light I find myself working rapidly and continually. Most of the time I adopt a wide-angle approach, shooting pictures six inches (15cm) off the ground, utilizing strong foreground texture created by the stones. Depth of field is an essential consideration and I use it in conjunction with the hyper-focal point to extend sharpness from front to back.

The effect of graduated filters and their subsequent alignment is checked with the depth-of-field preview. Should your digital camera not have this facility but you are able to use Live View, then back-to-front sharpness and filter alignment can be confirmed before shooting; if not, then a test shot or two will verify the position of these filters with a reasonable degree of accuracy.

If the filters you are using are apparent in the final shot, then you've chosen too strong a filter or your alignment is off – the filter should be invisible to the viewer.

I prefer to use a separate spot meter, taking into account the combination of filters and any preferred exposure bias, before relaying those settings to the camera. When filters are used over a sunlit section I look to meter from a mid-toned unlit foreground rock for my base exposure.

Before releasing the shutter I make absolutely certain that lens flare is not going to affect the quality of any exposure. If the sun's position is quite close to the lens axis but is nevertheless out of frame, then it's relatively easy to shade the front element of the lens with your hand. I find lens hoods to be bulky, inconvenient and too inaccurate for the job for which they are intended.

Location: Cove Bay, Moray, Scotland
Season: Summer
Predicted Weather: Low stratus clouds in a clear sky, windless
Sunrise/sunset: 4.00am/10.00pm
Tides: Approaching high tide

If I'm certain that a shot is going to be marketable, I will bracket half a stop either side of the metered reading and possibly take a second set of three to negate the possibility of emulsion scratching. Shooting digital Raw files will eliminate the need to bracket and in diffuse light bracketing exposures is unnecessary.

Digital cameras allow you to take as many exposures as you like without incurring the cost of development, but truth is, there always seems to be one brief moment when the quality of light defines a place and captures the mood more successfully than any other; consequently I take relatively few shots but I try to make them all count.

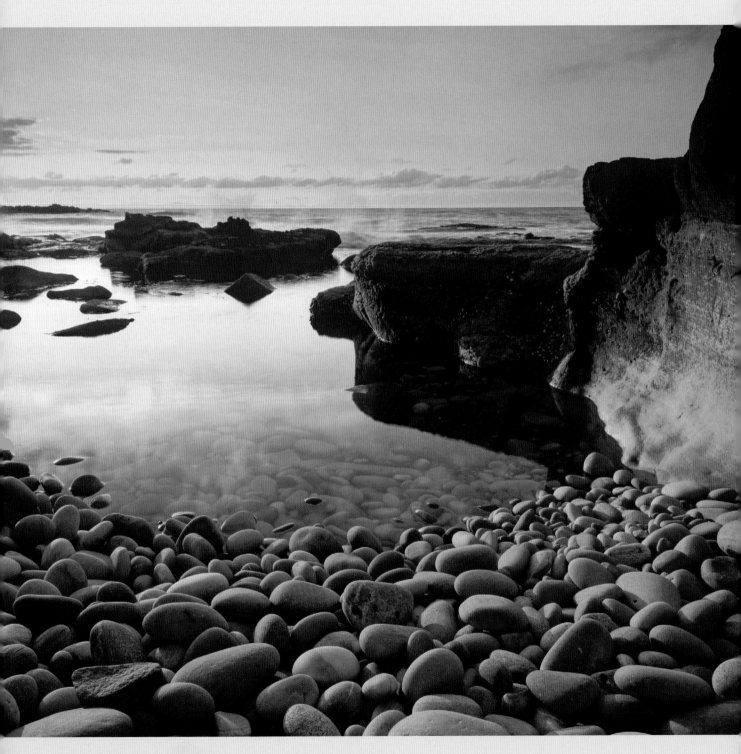

LEFT Cove Bay, Moray, Scotland. The setting sun just out of frame could have proved to be a problem, but with careful shading of the front lens element, the risk of flare is minimized.

• *Pentax 67II, 45mm lens, polarizer, 0.6ND grad, f/22 at ¼sec, Velvia 50* •

BELOW Cove Bay, Moray, Scotland. The combination of a setting sun disappearing behind cloud, wet shiny stones and the lapping of a rising tide proved an irresistible combination of colour, movement and solidity.

• *Pentax 67II, 55–100mm lens, 0.6ND grad, (handheld) diagonally staggered 0.3ND grad, f/32 at 8sec, Velvia 50* •

PRO TIP

When the lens axis is close to the sun but not in the frame, and the risk of flare is correspondingly high, casting a shadow over the front element of the lens will resolve the problem. Just make sure that you stand out of frame and that the shading object barely covers the lens, otherwise your landscape might include more than you bargained for.

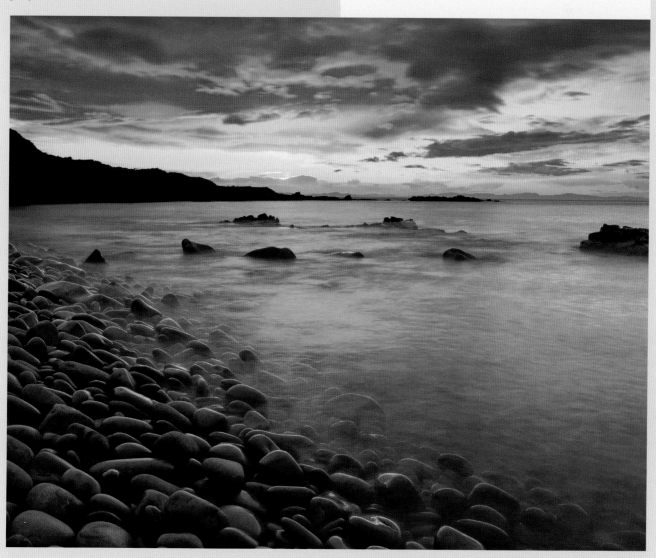

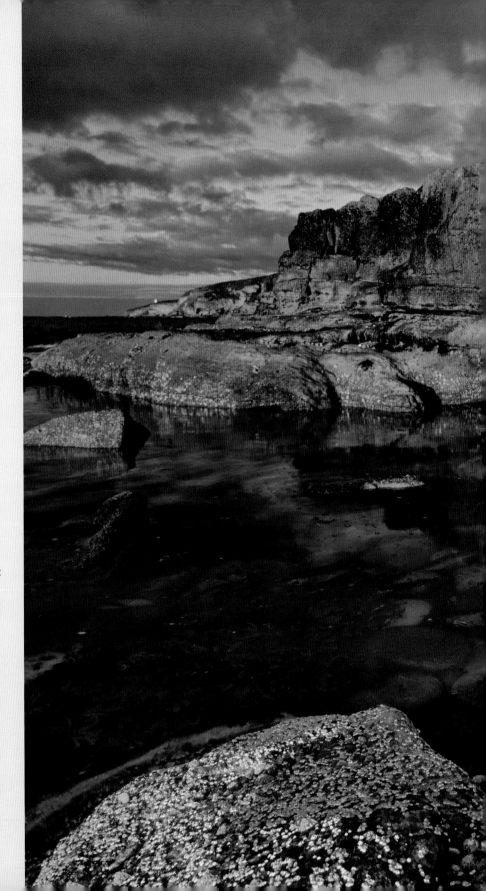

At Cove Bay there is a sandstone edifice above pale cobbled stones. At high tide a rock pool forms, the surface of which happened to be mirror smooth. As the sun began to set the edifice turned to gold and reflected in the pool. The water was very clear and I could see the stones below the surface which I anticipated would become much more visible with the addition of a polarizer, adding further interest to my chosen composition. The sandstone ledge is large but my physical position was limited to a single slab of rock, so I attached a wide-angle lens to include the whole shelf. Compositionally the interesting details were in the foreground so an aperture of f/22 was selected while focusing at the hyper-focal point to maintain sufficient depth of field. One further precaution; the sun was setting almost directly behind me so I had to ensure that my own shadow wasn't included within the shot – the camera's self-timer allows sufficient time to disappear while the exposure is made, but that still leaves the tripod's shadow. Fortunately water eliminates the problem, its liquid surface scattering the shadow sufficiently. As the suns dips lower the light becomes warmer, the edifice glows while the shadows soften, revealing more detail and correspondingly richer colours.

In addition to a polarizer I need a graduated filter to balance the contrast differential between the directly lit edifice and sky and the unlit reflected water surface, beneath which is a carpet of cobbled stones. I had no intention of sacrificing detail in this area. A 0.45ND (neutral-density) hard-edged graduated filter is chosen and positioned to cover the sky and shelf down to the waterline.

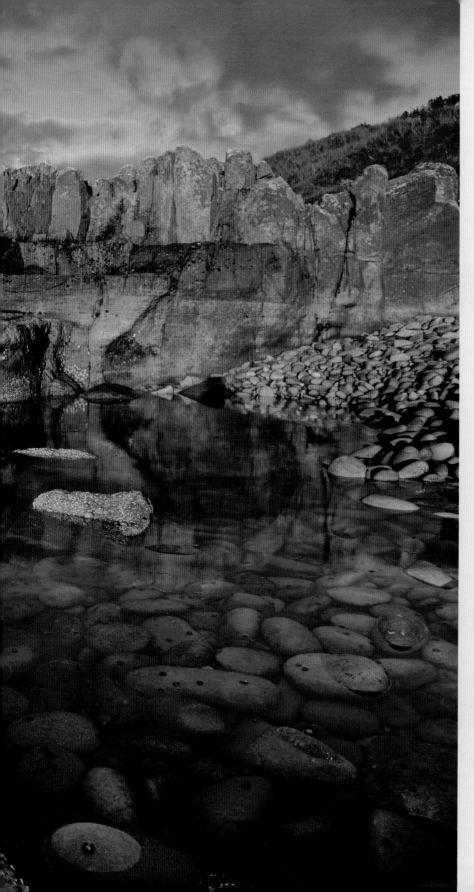

It takes the 'heat' out of the rock face and sky, balancing its reflection, while leaving sufficient detail in the stones beneath the water. A 0.3ND soft-edged graduated filter is added, inverted and used to cover the sunlit foreground rock. The soft edge of the filter masks the effect on the unlit water, but removes some 'heat' from the foreground rock.

With the spot meter I exposed for a mid-toned unlit foreground rock (not affected by the inverted one-stop grad) and then assigned it a half stop darker than the reading obtained. I decided that I didn't want to run the risk of burning out any part of the image. Once the lighting reaches its optimum potential the meter reading is transferred and manually input to the camera. I then lock the mirror up, set the self-timer to its shortest duration and move away while the exposure is made, thus ensuring my shadow isn't recorded. It was one of those images I was sure would sell so I took a total of six frames, two of each using a half-stop bracket either side of the metered reading.

The light changed rapidly, but remained stunning until well after sunset, providing me with one of the most productive shoots ever. I took twelve rolls of film (120 shots) – for me that's a lot, and I didn't return home until well after twilight subsided.

LEFT Cove Bay, Moray, Scotland. My favourite shot of the day. The sandstone edifice lit up gold while a polarizer revealed the jumbled stones beneath the sea against cloud-flecked blue sky a precursor to a summer squall.

• Pentax 67II, 55–100 zoom, polarizer, 0.6ND grad, inverted soft-edged 0.3ND grad, f/22 at 1/2sec, Velvia 50 •

FIELD TRIP: WATER

There are so many good reasons to include water in your landscape, it is difficult to know where to begin. Look back over your own photographs – how many of them feature water in one form or another? I reckon well over 75% of my pictures do. Most of the time water isn't even the intended subject, but it is often used to support the show, or provide reflections to double the impact and add symmetry; but water is so much more than a motionless entity: it moves, it has life – with skill its essence can be captured. Water exists in three states: solid, gas and liquid – we'll deal with each in turn.

Frost

The best time to photograph frost is on a crisp, clear winter morning, preferably on a day when the temperature is not predicted to rise above zero. After a series of cold mornings – and especially after freezing fog settles – frost can build up layer upon layer and coat every twig, branch and solid object with a thick layer of crystalline ice known as rime, or hoar frost.

Frost is ephemeral and once the first rays of sunlight strike it, it is only a matter of minutes before its magic melts away. You need to get there early and work fast, following the shadow around where it lingers. Because frost is white, it tends to dilute landscape colours – this can be used to your advantage, creating a subtle palette with sunlight bouncing into the shadows to present a light, airy, high-key image.

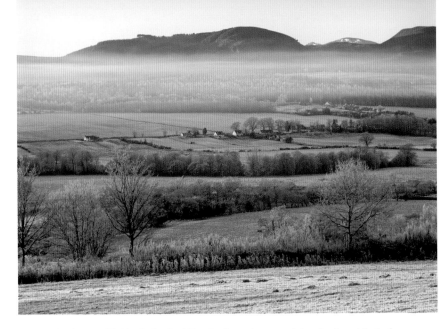

ABOVE Strathconon, Highlands, Scotland. Freezing fog settles over a sheltered valley, while the first rays of a winter sunrise tentatively spread their honey fingers into the shadows, causing the mist to rise and float wraith-like above trees and houses.

• *Pentax 67II, 200mm lens, hard-edged 0.6ND grad, f/16 at ½sec, Velvia 50* •

BELOW Yosemite National Park, California, USA. An early spring morning in one of the great national parks of America. Yosemite drips with iconic features such as this amazing blue ribbon of water tumbling over sheer cliffs.

• *Contax ST, 80–200 zoom, polarizer, f/11 at 1/60sec, Velvia 50* •

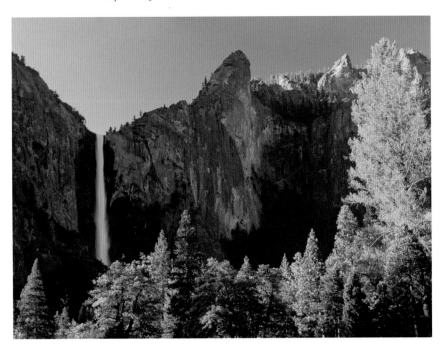

Snow

If frost masks colour and form, then snow totally obliterates it. The transformation it brings is so complete that even something as simple as your own back garden becomes a playground of unfamiliar scenery. Frost dilutes colour, leaving the shapes beneath familiar, but snow goes much further, it softly moulds around solid objects, filling in hollows, bouncing light into crevices, it becomes a simplified monochrome world. The best time to be out in it is immediately after the snow has fallen, preferably first thing in the morning. The scenery is pristine, no footprints, no melting slush, just immaculate perfection with drifting snow forming exotically carved shapes. If you are fortunate enough to be out at first light and you are treated to a winter sunrise then new snow will adopt the colour of the light reflected onto it. A fiery-red sky will give it a rosy hue, while a clear sky will turn it blue in the shadows. Once the sun appears and illuminates the snow, sunlit areas will turn blinding white where the shadows continue to harbour the colour of reflected light. It is this colour cast that makes snowscapes so fascinating. I would strongly advise against trying to filter them out – embrace them and use these colour differences to create pictures with impact.

There is a common misconception that photographing snow is difficult, but actually it is remarkably easy. A light meter left to its own devices will try to turn snow a yucky mid-tone grey but overriding this by metering from it and adding +2 stops of additional compensation will return it to brilliant white with just a hint of textural detail.

Ice

When water freezes it turns to ice, forming sheets. Dripping water generates icicles; the shapes are amazing and a strong subject in their own right. Ice is rarely transparent – small objects trapped within, such as air bubbles, twigs and leaves make it translucent filling it with texture and pattern. I like to photograph ice in one of two ways, either backlit as if it were fractured glass, or in diffuse light so that it picks up the colour of any reflected light. Photographing ice as abstracts is very rewarding – try using just the shape of contoured fracture lines, or trapped air bubbles to provide a centre of interest. Alternatively, ice patterns can be used as a simple, but compelling patterned foreground, to introduce a wider landscape.

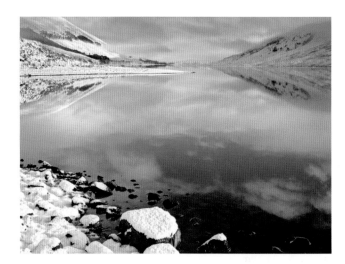

ABOVE Loch a Chroisg, Achnasheen, Scotland. An amazingly still winter morning, with snow covering rocks to the very edge of an eerily beautiful Scottish loch. sheltered by mountains on either side. • *Pentax 67II, 55–100 zoom, polarizer, 0.45ND grad filter, f/22 at 4sec Velvia 50* •

WORD OF WARNING

It is very easy to get carried away with these intriguing, intimate landscapes, but don't compromise your own safety by wandering onto a partially frozen lake. It could be catastrophic for you and your camera.

BELOW Triple Buttress, Torridon, Scotland. A partially frozen waterfall; its chocolate-coloured rocks rimmed with frost and ice at the same time convey both warmth and intense cold, moving water bouncing joyously between.

• *Pentax 67II, 55–100 zoom, polarizer. f/16 at 2sec, Velvia 50* •

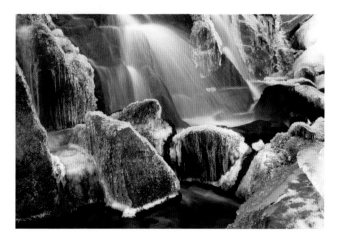

Mist and Fog

If snow, frost and ice represent water's solid state, then its gaseous phase would be mist or fog. It most frequently occurs at the extreme ends of the day, but is particularly prevalent first thing in the morning. Mist tends to form over large, open areas of ground or water that have been heated by sunlight during the day. Once darkness falls, the air just above the ground gets very cold and moisture starts to condense out of it, forming billions of microscopic droplets of water. In very still conditions the droplets hang in suspension but fail to dissipate, thereby forming mist or fog. Sometimes it is so thick that it is difficult to see through it at all, but this visual cloaking can be used to terrific effect, concealing a busy or cluttered backdrop, which might otherwise prove visually distracting to your chosen subject.

Mist and fog are a wonderful means of conveying a sense of distance in a landscape. Nearer objects are revealed with great clarity and colour saturation, while those further away are indistinct and nearly monochromatic. This lack of visual clarity generates subject separation, even in two dimensions where they overlap. Perhaps the most exciting aspect of mist and fog is to use its translucency to dull the power of intense light sources, such as the sun. Under normal circumstances if the orb of the sun is present in your proposed composition, then there is absolutely no chance whatsoever of making a decent exposure that isn't completely ruined by lens flare, but with mist, the impossible becomes possible.

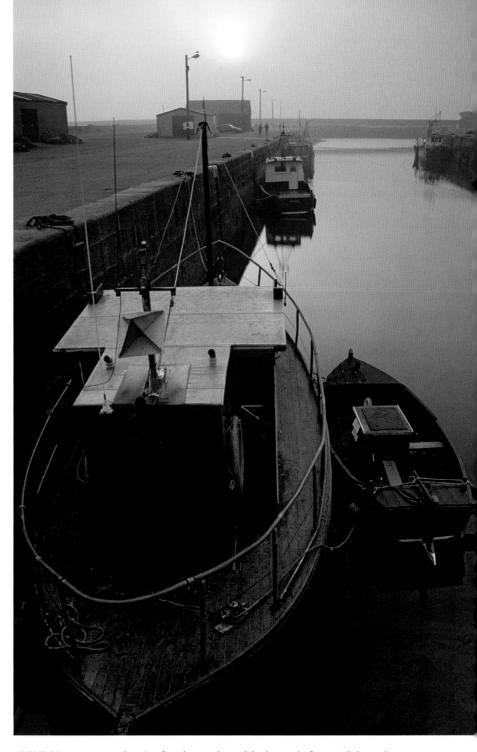

ABOVE Mist creates atmosphere. It softens distant colours whilst those in the foreground glow with unrestricted brilliance. A misty day is one of the few times you can include the sun's orb in the shot without risk of flare.

• Contax ST, 28–55 zoom, 0.45ND grad, f/22 at 4sec, Velvia 50 •

Water

For the remainder of this section we will concern ourselves with water in its liquid state, it's no less endearing, and the one that is most familiar to us. From the tiniest stagnant puddle to a thundering cataract, water enhances, and there are a multitude of different photographic techniques that can be used to reveal it at its best. A long exposure turns tumbling water to cotton wool, or a turbulent sea into a surrealistic gaseous soup, but at the other end of the scale water can be frozen into individual droplets. There is huge controversy amongst photographers as to how water should be represented.

BELOW Sequoia National Park, California, USA. The needles of a pine tree hanging over the edge of a waterfall is backlit and enveloped by blown spray that glitters brilliantly, simultaneously providing a visual echo by virtue of the choice of exposure time.

• Contax ST, 80–200 zoom, f/11 at 1/30sec, Velvia 50 •

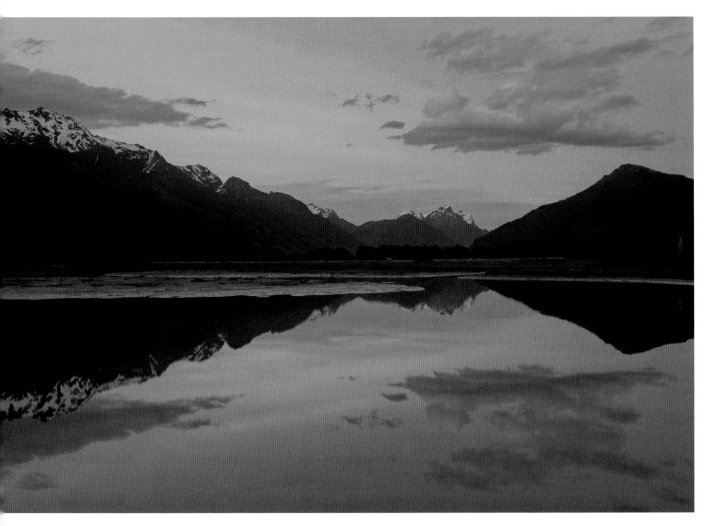

Reflections

Mirror-smooth reflections are comparatively rare during the middle of the day, but before dawn and after sunset the air is usually still, and reflections are much more likely. Even if a slight breeze should ruffle the surface, providing the water is shallow, the reflection will quickly repair itself. Coincidentally, this is also the time that rich twilight colours fill the sky, reflecting in the water, enabling beautiful symmetrical compositions. Without the use of graduated neutral-density filters, there is considerable disparity between the brightness of the reflection and the luminosity of the unreflected portion of the image. From experience, I have found that a hard-edged 0.45ND graduated filter (1.5 stops), carefully positioned to the waterline, provides just about the perfect balance of luminosity between both the reflected and unreflected elements. A separate meter reading taken from the reflected mid-tone will provide a satisfactory overall exposure.

ABOVE Queenstown, South Island, New Zealand. Perfect reflections are rare outside of dawn or dusk, but it's always worth exploring any opportunities you get to create a picture with perfect symmetry.

• *Contax ST, 28–85 zoom, hard-edged 0.45ND grad, f/16 at 20sec, Velvia 50* •

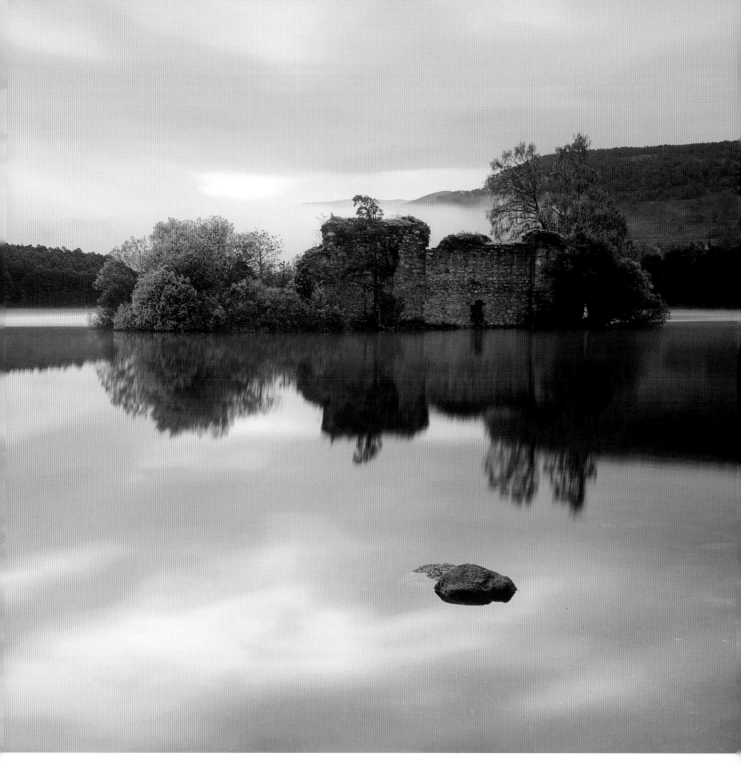

ABOVE A breathlessly still morning at Loch Eilean in Cairngorm, Scotland. The still conditions and mirror-smooth reflection create a subtle palette of hues that is very pleasing and tranquil yet laden with atmosphere.

• Pentax 67II, 55–100 mm lens, 0.45ND grad, f/22 at 8sec, Velvia 50 •

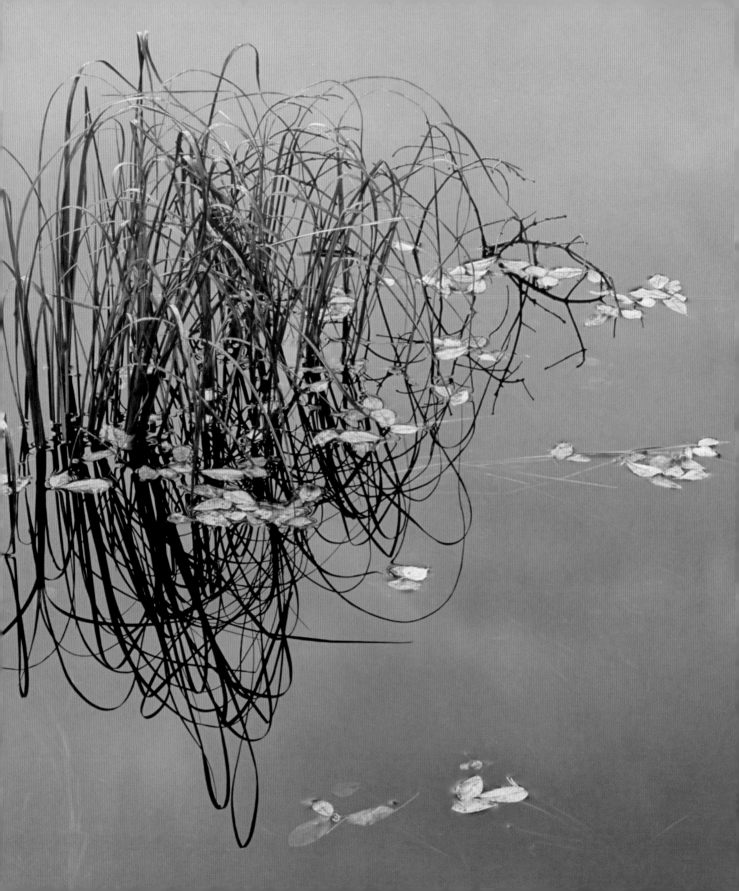

LEFT Blairs Loch, Forres, Moray, Scotland. A very simple image that works by virtue of careful composition. The reeds are like complex scrolls of Chinese writing and form a perfect reflection on a delicate palette of evening blues and pinks reflected from the sky.

• *Contax ST, 80–200 zoom, polarizer (backed off from maximum to just permit below surface detail to be visible), f/11 at 1/15sec, Velvia 50* •

Waterfalls

Usually depicted as subjects in their own right, waterfalls are sometimes placed at the power point (intersection of thirds) of a wider landscape, or alternatively photographed as an intimate frame-filling abstract, where just the most interesting section of the falls is represented. Landscape photographers as a rule tend to abhor anything that moves, as it renders that object blurred in the final photograph, but movement of water is something to be rejoiced. My personal preference is to use shutter speeds around ¼ to ½sec duration. I like a sense of movement to be conveyed, but prefer to keep its liquid appearance.

RIGHT Bridal Veil Falls, Chimanimani, Zimbabwe. This beautiful waterfall gets its name from the way it tumbles down, interrupted by rocks that jut out at various intervals, creating a veil-like effect, particularly apparent when taken with a relatively long exposure time.

• *Contax ST, 300mm lens, polarizer, f/11 at 1sec, Velvia 50* •

ON LOCATION

It had rained heavily for most of the previous week and water levels were correspondingly high, but sufficient time had elapsed to ensure that the water tumbling down from the glens was crystal clear and free of the usual detritus that accompanies swollen rivers. Since the more classical landscapes didn't look to be on the cards, I resolved to try my luck here.

On arriving at the falls I was pleased to see a sulky grey autumnal sky with a few small splashes of sunlight painting the background ridge of mountains. The waterfall has a pleasing shape to it, fanning out towards you and tumbling down approximately eight feet (2.5 metres) over a rocky ledge. I used a short zoom lens to emphasize the fan shape, and finalized my camera position before attaching it to the tripod. My chosen composition is hour-glass shaped with the waterfall outline forming the bottom bell and the 'V' shaped valley forming the upper bell, positioned so that they roughly mirrored each other. This effectively confines the viewer to the centre part of the image, where all the action is and all the lighter elements are. A small tree forms a tenuous link between the top and bottom parts of the scene.

Even though conditions are dull, contrast is relatively high. I decided against using a polarizer, fearing that the shadow areas would block up completely. The sky still needed help, so a soft-edged neutral-density graduated filter was used to retain detail in the sky and those few splashes of sunlight peppering the slopes.

Waterfalls are one of the few times where I give equal preference to shutter speed as I do to the aperture selected. Naturally I want to have adequate depth of field, but my other prime consideration is the choice of shutter speed, namely my preference of between ¼ and ½sec duration.

Location: Lower Falls, Glencoe, Scotland
Season: Autumn
Predicted Weather: Dense cumulus cloud, occasionally broken
Sunrise/sunset: 7.00am/6.00pm

ABOVE Glencoe, Highlands, Scotland. An angry autumnal sky created tangible mood and drama. The splash of light peppering the distant ridge of mountains was planned and very welcome.

• *Pentax 67II, 55–100 zoom, hard-edged 0.45ND grad, f/16 at ½sec, Velvia 50* •

RIGHT Skye, Scotland. A section of a beautiful mossy cascade tumbling down over a multitude of rocky shelves, the ribbons of white contrasting with the vibrant greens.

• *Pentax 67II, 200mm lens, polarizer, f/22 at 1/2sec, Velvia 50* •

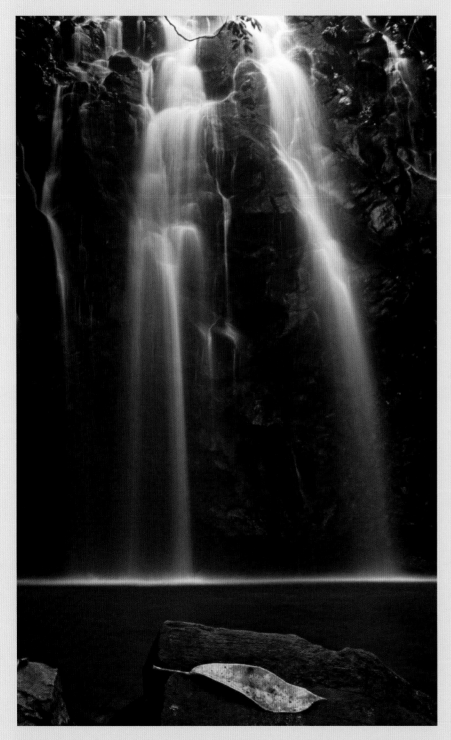

It is worth reiterating that, although I'm working with film and metering is done off camera with a separate light meter, all these field-based decisions equally apply to those with digital cameras. You simply have to adopt your own workflow and refine it for your own use. On the few occasions where there is a difference between film and digital I will clearly highlight it and this is one such occasion.

Whereas I am largely stuck with the same ISO setting relevant to the particular film I use, digital cameras have the flexibility to alter their ISO setting on a frame-by-frame basis. Confronted with a situation that required not only an aperture of f/22 to hold depth of field, but a set shutter speed of ½sec duration, then my only recourse would be to push the film at the developing stage to increase its sensitivity to light. Realistically, you can only achieve a one-stop variation either side of the film's nominal speed, without seriously affecting the quality of the final result. If you require less light to achieve the desired combination, then you could modify it by using a neutral-density filter, but it would be a huge advantage to be able to simply alter the ISO value of the image sensor at will.

LEFT Millaa Millaa Falls Circuit, Tablelands, Cairns, Australia. Where a close approach isn't practical, long focal-length lenses compress elements such as these leaves and the falls together.

• *Contax ST, 300mm lens, polarizer, f/22 at 8sec* •

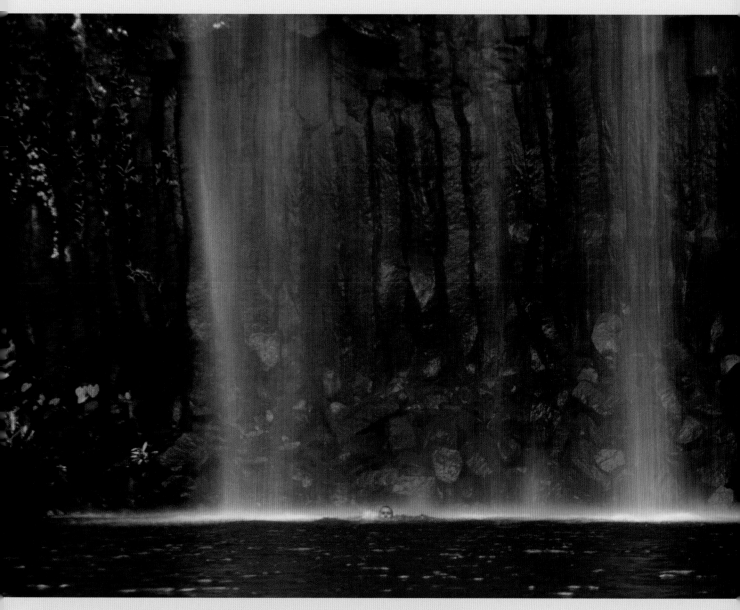

ABOVE Millaa Millaa Falls Circuit, Tablelands, Cairns, Australia. Even with waterfalls that are reasonably accessible it is sometimes a good idea to isolate the most interesting section – a person or familiar object can create a sense of scale.

• *Contax ST, 300mm lens, f/11 at 1/15sec, Velvia 50* •

With composition and focal point set, I can turn my attention to filtration and exposure. The sky is bright, my spot meter confirms there is six stops' difference between the brightest area of sky and the darkest black rock, which is in excess of the dynamic range of my film. The horizon is also a challenge – it's not level, so no matter what filter I choose it's going to darken both the hills and the sky. This is clearly a case where blending two or more exposures in the post-processing stage would resolve the problem, but you could also choose to compromise. It's most important that neither the sky nor the white foaming body of the waterfall burn out.

A 0.45ND graduated filter was chosen, reducing the brightness of the filtered section, namely the sky and hills by 1.5 stops, keeping it within the film's ability to record it, so now my only real concern is to ensure that the waterfall maintains some detail in the brightest parts. I meter the whitest area of foaming water and assign it two stops brighter than a mid-tone. An exposure of f/16 at ½sec is transferred to the camera and the mirror is locked up to await shutter release. To alleviate some of the problems caused by the application of the filter, I wait until the sky is as dark as possible and the background hills are spattered with light, to force the viewer's attention entirely back on the waterfall. With awkward exposures such as this, and given sufficient time, I tend to bracket half a stop either side of the metered reading.

ABOVE Coromandel Peninsula, North Island, New Zealand. Try out a different technique. I wanted to convey the power of the waterfall along with the energy displayed by the canoeist battling with it. Without the peripheral, crisply focused rocks, this could appear to be an accidental exposure.

• Contax ST, 80–200 zoom, polarizer and two-stop ND filter, f/22 at 1.5sec, Velvia 50 •

FIELD TRIP: MOUNTAINS

For a landscape photographer there is no finer place to be than on the summit of a mountain at sunrise, watching awestruck as the first rays of sunlight splash the peaks of neighbouring mountains. The topology of the mountains presents a majestic theatre of light and for me it epitomizes the ultimate in landscape photography. There's never a free lunch, of course; a colossal amount of effort needs to be put in to experience this rarefied beauty. Preparation is the key and it will determine your success when the summit is finally reached.

From a photographic standpoint, climbing a mountain with stacks of photographic equipment is both tiring and time-consuming and plenty of daylight hours are needed if you are considering a return on the same day. If you aren't, then camping is likely to be the only option and that means more gear to carry – compromises have to be made. I usually sacrifice one of my lenses, but the tripod always joins me and tends to get used as a glorified walking stick.

I have just two rules that decide whether or not I go to the summit:
• Time available – can I get back before dark (if not camping)?
• Is the summit likely to stay clear?
Whilst I enjoy climbing mountains, my aim is to take photographs – I certainly wouldn't be hauling all my heavy gear up there otherwise, and the last thing I want is to find myself engulfed by cloud.

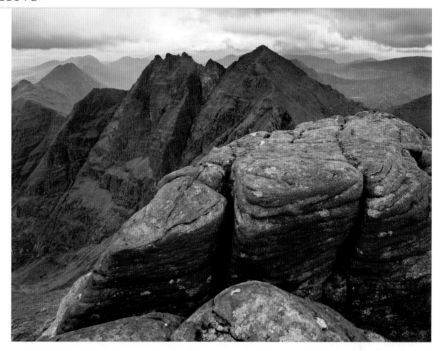

ABOVE An Teallach, Dundonnell, Scotland. Although the forecast was unpromising the view from the summit, as always, is astonishing and worth all the effort put into climbing it. Strong composition, mixing the melted red, ice- cream rocks of the foreground with the jagged green ridge beyond, helped to offset the poor light.

• *Pentax 67II, 55–100 zoom, polarizer, 0.45ND grad, f/22 at 2sec, Velvia 50* •

WORD OF WARNING

Climbing mountains should never be undertaken lightly, your safety is paramount and causing someone else to compromise theirs due to thoughtlessness or reckless behaviour is to my mind shameful. To that end let me provide the absolute bare minimum guidelines given to me by a friend and ex-RAF helicopter rescue pilot whose responsibility it was to pluck hapless souls from the summits of Scottish mountains in times of dire need.

Check the weather, use the mountain forecasts and be advised by them. Dress appropriately and be seen: wear bright jackets with reflective strips. Stay dry and warm with waterproof clothing; ensure you have adequate food and water, and bring a fully charged mobile phone, a torch so that you are easy to spot, and a compass and map (and know how to use them). Most importantly, let someone know where you are going to be and your intended time of return.

ON LOCATION

If you intend to stay out longer and set up camp near the summit of inhospitable mountains, it's far safer to take someone with you. Fortunately, I have a very good friend that climbs these things for the love of it. When I'm at the summit I want as much shooting time as possible and camping overnight gives me the option of a sunset then a sunrise the following day.

It took three hours of quite hard climbing to finally reach the top of Tom Na Gruigach – a 3000 foot (975 metre) Munro that overlooks the roof of the Torridonian peaks. This would be my third time at the top, but my first overnight stay and I still never tire of the view.

There were high winds and it was unbelievably cold, with just the barest hint of snow dusting the top. All the way up to the summit there is not the slightest indication of the staggering view that will greet you as you trudge the last few paces to the summit cairn. I can assure you that all the effort expended immediately becomes irrelevant. I surveyed the scene: it was very gusty and the sky was leaden, but here and there large gaps had opened periodically, letting shafts of light burn through to pepper the Tolkeinesque landscape with brilliant patches of intense colour. This was clearly going to be transient light at its briefest and very finest.

Location: Tom Na Gruigach, Torridon, Scotland
Season: Late Autumn
Predicted Weather: Dense cloud base and high winds above summit
Sunrise/sunset: 8.00am/5.30pm

In less than ideal circumstances, I had to get everything set up perfectly beforehand and then wait for the optimum conditions – and I had to do it rapidly.

LEFT Tom Na Gruigach, Torridon, Scotland. Overnight a blizzard struck and battered the tent in which my climbing friend and I had stayed. Next morning I awoke to one of the finest sights imaginable and the best day of photography I can remember.

• *Pentax 67II, 55–100 zoom, f/11 at 1/60sec, Velvia 50* •

RIGHT Beinn Alligin, Torridon, Scotland. With heavy cloud cover, the chances of sunlight breaking through seemed low but, as luck would have it, gaps opened and shafts of rapidly moving light peppered the slopes; one of these simultaneously hit the summit of Beinn Alligin while the other illuminated a distant loch, adding an extra blip of colour.

• *Pentax 67II, 55–100 zoom, 0.6 ND grad, f/22 at 1/2sec, Velvia 50* •

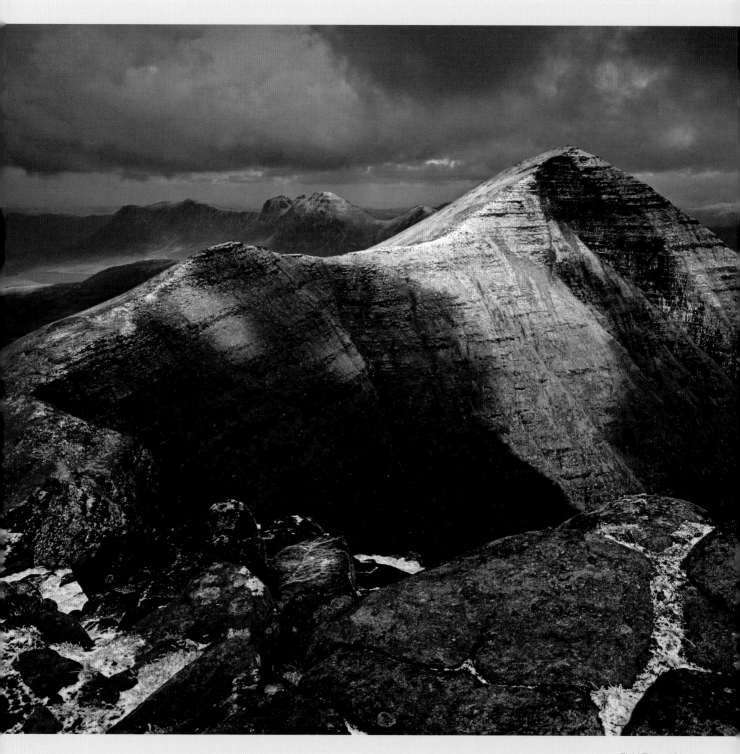

With heavy gusting winds a low camera position is essential; I didn't want the unthinkable happening – my tripod and camera being cart-wheeled over the edge. It was numbingly cold, my hands were frozen despite the gloves and my nose was dripping like a tap. Changing film was not an option I relished, so I was very glad that I had planned ahead and loaded a new one. Although the light was coming from my right and there was a clear opportunity to saturate the existing colours with a polarizer, I decided against it as I was concerned that the loss of two more stops of light might exacerbate any problems with camera shake. Instead, I used a two-stop graduated filter to accentuate the leaden sky.

When on a mountain summit, it is a good idea to incorporate foreground elements and, if possible, use these to guide the viewer through the picture. A strong foreground can lend scale to a mountain scene and it also has the advantage of not looking like it was taken through the window of a plane. A foreground element requires a large depth of field and careful selection of the hyper-focal point. The problem is that focusing a third of the way up from the bottom of the frame in these circumstances, is actually a point in thin air and consequently impossible to gauge. This is one of the few occasions I use the depth-of-field preview in its more traditional role – closing down the lever darkens the viewfinder but gives me a good idea whether both the foreground and background are adequately sharp. Digital photographers with Live View should be able to check the foreground and background sharpness and make any relevant adjustments to the hyper-focal point.

Once everything is set, the mirror is locked up and I wait until the peak of transient light. In this case I hoped that a shaft of light would strike the summit of Beinn Alligin. It took 15 minutes, during which time I was hopping up and down beside my camera in an effort to keep warm, but eventually I saw a beam of sunlight moving towards the summit. I guessed it would strike it, so I took a substitute light-reading from a sunlit mid-tone with the spot meter and transferred the reading to my camera, firing the shutter as the light struck the summit. It was a magical moment. There was no time for a second exposure and no repeat performance. That night a blizzard struck and the following morning I awoke to one of the most memorable mountain views I've ever seen.

FIELD TRIP: WOODLANDS

I rarely go out on a photographic trip with the sole intention of shooting woodlands, but I frequently find one on my travels that appeals to me. Woodlands have become an established part of my portfolio.

Just as it is best to tackle waterfalls in subdued light, with little contrast, the same is also true of forests. In strong sunlight the canopy of leaves and the close proximity of the trees create inordinately high contrast, which is beyond the ability of film or image sensor to record.

In diffuse lighting, woodlands provide a wealth of photographic opportunity – a few of my favourites are listed below:
- Repeating patterns
- Backlighting
- Seasonal colour
- Abstracts and intimate landscapes

LEFT Feshiebridge, Cairngorm, Scotland. A Caledonian pinewood. White sky has been more or less eliminated to reduce distractions.

• *Pentax 67II, 55–100 zoom, polarizer, f/22 at 1sec, Velvia 50* •

Repeating Patterns

The most obvious woodland patterns are those created by the vertical lines of tree trunks, but there are many others, the concentric rings on a cut tree, bark, even the patterns established by leaf fall. To maintain image coherency you need to find a way of visually separating each element so they don't blend into one amorphous lump. Use contrast, colour, light and shade – anything to reduce the percentage of overlap between the repeated shapes. A very useful technique is to separate similar shapes by using a shallow depth of field. The viewer is in no doubt what the out-of-focus elements are, but their attention is immediately drawn to the single sharply focused subject.

BELOW The repeated shapes of these slender poplar trees around the perimeter of a field, echo the arches of Culloden Viaduct.

• Contax ST, 80–200 zoom, f/11 at 1/30sec, Velvia 50 •

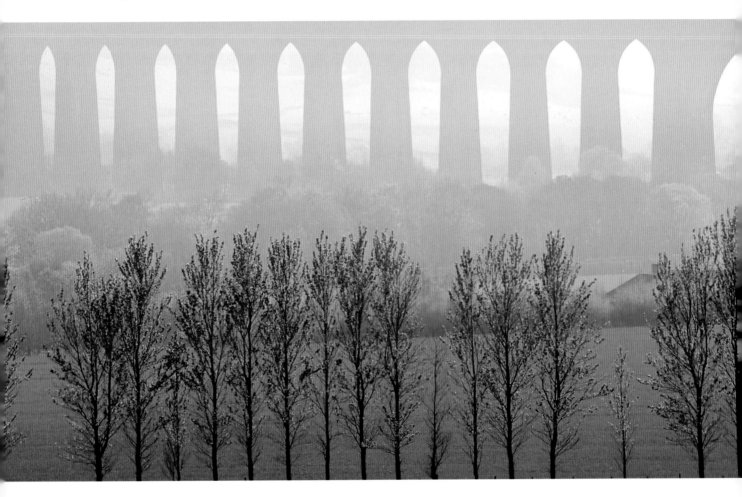

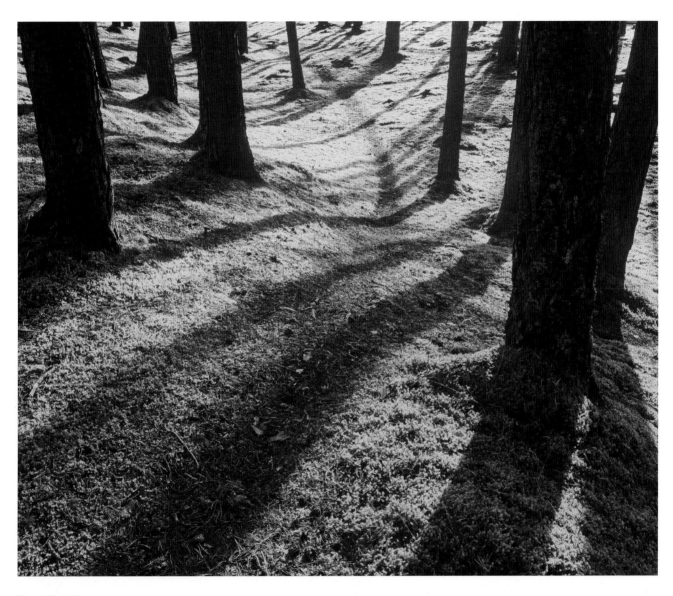

Backlighting

In dense woodland virtually no light is able to penetrate the canopy, consequently, inside the woodland contrast and overall illumination is low. Should a single area of white sky show through it immediately dilutes the impact and atmosphere within, drawing the viewer's attention. Try to eliminate white sky from your composition completely. There are some exceptions that are worth exploiting – occasionally very strong images can be made in woodland using backlight, particularly in conjunction with mist; positioning the camera so that the sun is hidden creates shafts of light that spill around the trees.

ABOVE Cannich, Scotland. A green carpet of moss crisscrossed by red-needled pine pathways makes a wonderfully distorted canvas upon which to paint the shadows of the pine trees brilliantly lit by low sunlight.

• *Pentax 67II, 55–100 zoom, polarizer, f/22 at 1/4sec, Velvia 50* •

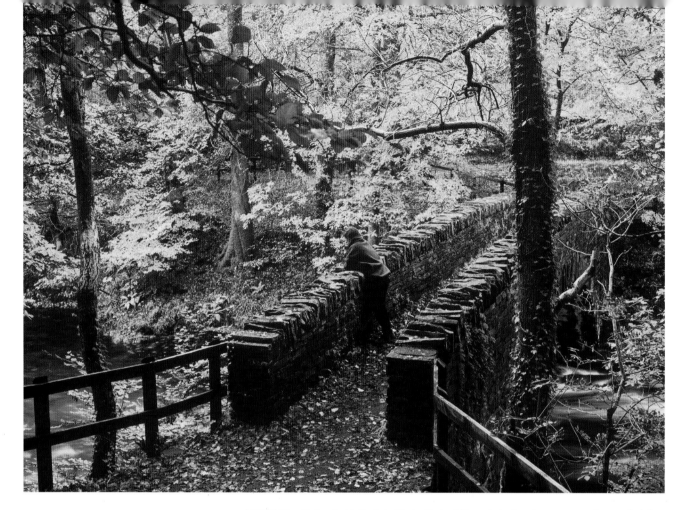

Seasonal Colour

Some areas in Canada and the USA are renowned for autumn colour, a whole industry having grown up around this spectacular seasonal event.

ABOVE River Rothay, Ambleside, Lake District, England. To maximize the colour saturation of autumn look for white skies, wet leaves and use polarizing and warm-up filters. I chose this scene as the bridge provides a place for the eye to rest and the person gazing over becomes a distinctive focal point.

• Pentax 67II, 55–100 zoom, polarizer, 81B filter, f/16 at 1/2sec, Velvia 50 •

Autumn is the one time of year that I relish and actively seek deciduous woodland. Mid-October to early November in Scotland is filled with intense autumn colour; the very best of it might last just one or two days. When to go is dictated not only by the richness of colour, but also by the quality of light present. I look for windless days with white, flat, even cloud cover, preferably just after it has rained.

This combination of circumstances ensures vivid colours intensified by rain-washed foliage. An 81 series warm-up filter exaggerates colours further and the final punch of colour saturation is delivered by the polarizer – a twist on this will eliminate all trace of surface reflection from the shiny wet leaves and the colours will quite literally leap off the screen.

WORD OF WARNING

Whilst all the above will ensure maximum saturation in your autumnal colours, the 81 series filter tends to make blue skies look insipid and white clouds cream-coloured. I would recommend dispensing with this filter if the sky appears in your photograph. Further, if the sun appears and the contrast increases, a polarizer will cause the shadows to block up, producing an ugly, heavy picture.

Abstracts and Intimate Landscapes

Woodland abstracts are immensely rewarding; isolating small colourful elements from a greater whole and juxtaposing them with different shapes and colours, confined by the rectangle that is your viewfinder, offers limitless possibilities. The secret is balance; there is no formula that will help you define a successful composition, it is simply one that satisfies where nothing jars or feels out of place.

BELOW Leaves trapped in the cleft of a felled oak create a pleasing abstract. The subtle colours prevent distraction, gently enhancing the picture.

• Pentax 67II, 55–100 zoom, f/16 at 2sec, Velvia 50 •

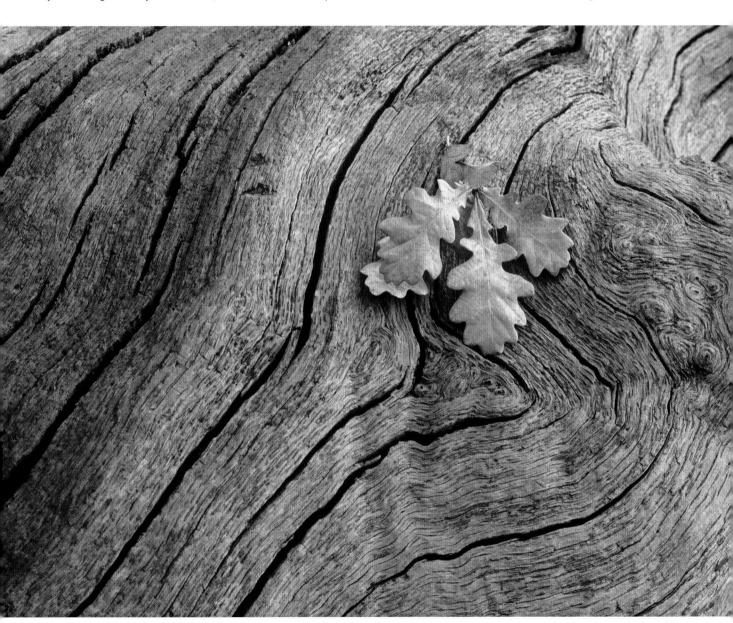

ON LOCATION

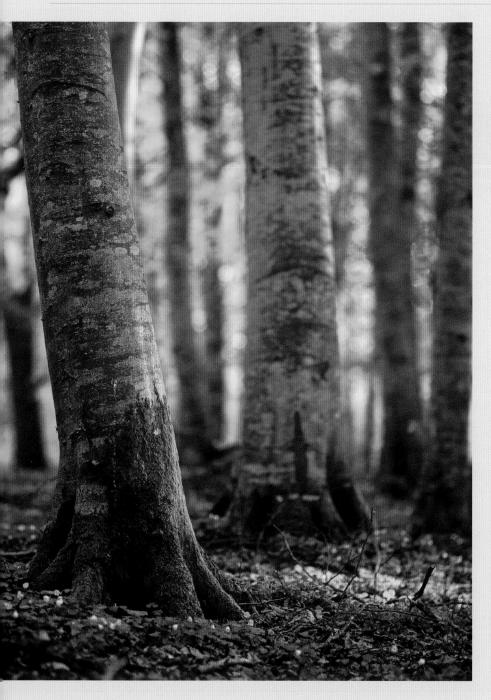

Location: Forres, Moray, Scotland
Season: Winter
Predicted Weather: White cloud base leading to a clear horizon
Sunrise/sunset: 8.30am/4.30pm

There are a lot of densely packed pine plantations in Scotland. I don't particularly like these forests, they're dark and the trees grow so close together that nothing else can survive beneath them. But the repeating patterns they create are very strong and the lack of growth beneath does mean that there is little visual clutter. Although it is virtually impossible for light to penetrate through the canopy, the trees at the edge of these woodlands do permit light to enter from the side, particularly at the ends of the day.

LEFT Beech woodland, Elgin, Moray, Scotland. A deciduous woodland allows light to filter through, generating life on the woodland floor. Using a limited depth of field throws the rest of the forest out of focus, minimizing visual confusion, but the backdrop is still instantly recognizable.

• *Pentax 67II, 200mm lens, polarizer, f/6.3 at 1/30sec, Velvia 50* •

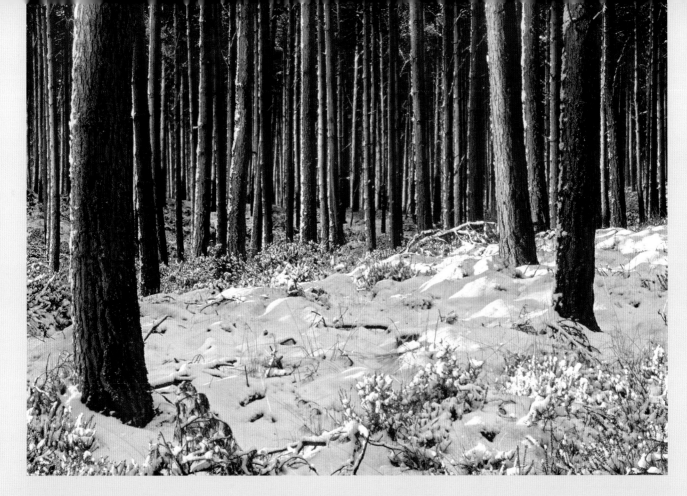

It had been snowing and the woodland I was walking through looked like something out of Narnia. Snow spattered one side of the trees and a little light was being reflected onto the trunks. As the sun set I hoped it would stream in through the edge of the woods and paint the trunks with an orange glow – I figured that the snow would help reflect even more of this light, but presently it looked distinctly uninspiring. I decided to use my longest lens to compress the perspective – squishing the trunks of the trees together and flattening the view – to instil an even greater sense of repeating vertical lines and really emphasize the claustrophobic nature of the forest. Looking through the viewfinder it became clear that there was just a vague sense of pattern, with no visual separation between the trees, but I continued to prepare in anticipation

of fine light. I adjusted my composition to include a sliver of snow on the ground and used two closer trees to frame the sides of the picture to contain the scene I'd envisaged. No filters were necessary but I wanted to hold sufficient depth of field to keep all the trees in crisp focus. After that there was little more to do than wait and see what happened.

Soon, the sun broke free of the clouds and orange, raking light streamed in through the side of the woodland, illuminating one side of every tree trunk. The red hue of these pines exaggerated the colour still further. Each tree looked as though it had been set on fire; the dark woodland served only to emphasize the intensity of light. The trees that had previously merged, magically separated and the scene was transformed.

ABOVE Pine woods, Forres, Moray, Scotland. Side lighting at the periphery of dense pine woods is often the only way of getting light into the forests. Snow reflected warm light onto the reddish-brown trunks and what had been dark and uninspiring became an intimate theatre of light.

• *Contax ST, 80–200 zoom, f/22 at 1/2sec, Velvia 50* •

A spot meter reading was taken from a sunlit tree and the exposure transferred to the camera. I bracketed a few extra shots before trying out alternative compositions, but it was the first shot that proved to be the best.

FIELD TRIP: AGRICULTURAL LANDSCAPES

Generally I prefer to shoot the wilder landscapes, untouched and unaffected by the hand of man, but on occasions human intervention can work very sympathetically with the landscape. Farming methods tend towards mono-crop cultures and vast tracts of land are given over to the growth of one particular crop. These crops are often planted in long straight parallel lines and these lines give rise to powerful compositions that can be found in any season:

- Plough lines
- Mature crops
- Harvest

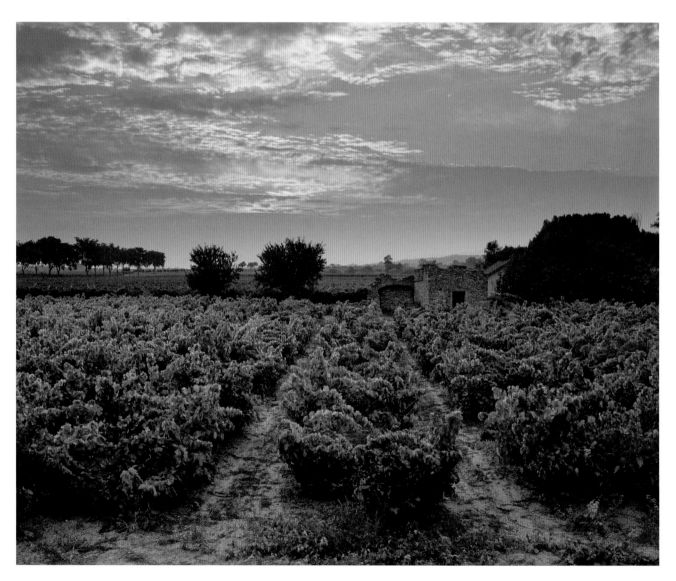

LEFT Siran, Carcassonne, France. The vineyards of southern France are planted in long, neat rows. The problem of photographing them is chiefly one of gaining sufficient height to create vertical depth.

• *Pentax 67II, 55–100 zoom, hard-edged 0.9 ND grad, f/22 at 16sec, Velvia 50* •

Plough Lines

During the winter months the fields are prepared and ploughed into muddy furrows, which form deep parallel lines. By adopting a low viewpoint and pointing the camera slightly downwards these lines converge to a point in the distance, giving tremendous impact to a picture. If you're fortunate enough to find a field that is side lit then every furrow will cast a shadow onto its neighbour, heightening the contrast, texture and pattern. It's not just the wider view that works, a telephoto lens can be used to abstract lines and patterns created by these same plough lines. Placing a subject, such as a tractor or scarecrow, in a prominent area can make a very simple yet powerful image.

ABOVE Elgin, Moray, Scotland. The geometrically precise furrows of a ploughed field form strong converging lines. Cross-lighting ensures that each furrow casts a shadow onto its neighbour, thus enhancing texture.

• *Pentax 67II, 55–100 zoom, polarizer, 0.3ND grad, f/16 at 1/8sec, Velvia 50* •

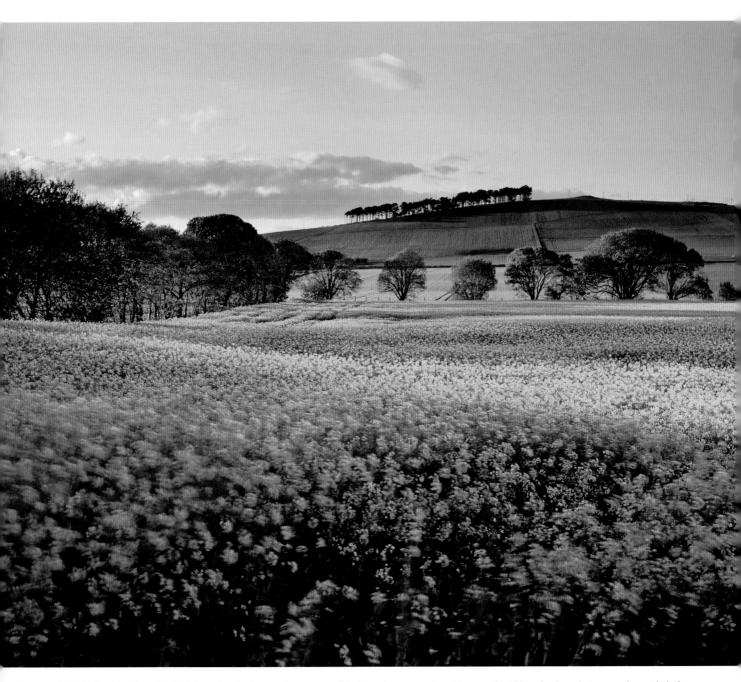

ABOVE Roseisle, Moray, Scotland. A swathe of yellow rape is very eye-catching but quite overpowering. Where possible I like to break up the intense colour with shadows, which brings back a little texture to the scene.

• *Pentax 67II, 55–100 zoom, polarizer, 0.3ND grad filter, f/22 at 1/4sec, Velvia 50* •

Mature Crops

Once crops have reached maturity the whole field will turn a uniform colour. Some crops – like flax and lavender – turn blue, while rape fields paint the land with swathes of yellow. It is sometimes difficult to reveal texture in such a mass of bright colour; one option is to get as far away from these fields as possible, adopting a high viewpoint and then photograph them as patchworks of alternating colour. Another approach is to get up close and use shadows, wind, anything to break up these vast blocks of colour, returning texture and contrast.

Below are some of the most photogenic agricultural crops:

* Lavender fields
* Tea plantations
* Rice fields
* Rape fields
* Sunflower fields
* Olive groves

ABOVE Mezel, Provence, Southern France – a scented playground, with row after row of blue flowers, often in the most scenic locations.

• Pentax 67II, 55–100 zoom, polarizer, 0.3ND grad filter, f/22 at 1/4sec, Velvia 50 •

RIGHT Tea plantation, Cameron Highlands, Malaysia.

• Contax ST, 80–200mm lens, polarizer, f/16 at 1/2sec, Velvia 50 •

ABOVE Aups, Provence, southern France. Limited depth of field concentrates attention on the olive tree plantation, set against a backdrop of brick-red-soil.

• *Pentax 67II, 200mm lens, polarizer, f/6.3 at 1/60sec, Velvia 50* •

LEFT Aups, Provence, southern France. Another French speciality, look for backlit blooms but watch out for lens flare.

• *Pentax 67II, 200mm lens, polarizer, 0.45 ND grad, f/22 at 1/2sec, Velvia 50* •

ABOVE Duffus, Moray, Scotland. Swathes of yellow amongst greenery, beneath stormy grey or azure blue skies.

• *Pentax 67II, 200mm lens, 0.9 ND grad, f/13 at 1/8sec, Velvia 50* •

ABOVE Not strictly an agricultural crop but certainly associated with it and a very rare sight in Britain these days. I found this glorious field of poppies intermingled with countless thousands of daisies beneath a very threatening sky in Kilconquar, Fife.

• *Pentax 67II, 55–100mm lens, 0.3ND grad, f22 at 1/8 sec, Velvia 50* •

OVERLEAF Gorepani Trek, Nepal – plateaus of waterlogged pools form endless steps down mountain slopes, each pool irrigating the one beneath and all bristling with new-planted rice stems.

• *Contax ST, 28–85 zoom, polarizer, f/16 at 1/2sec, Velvia 50* •

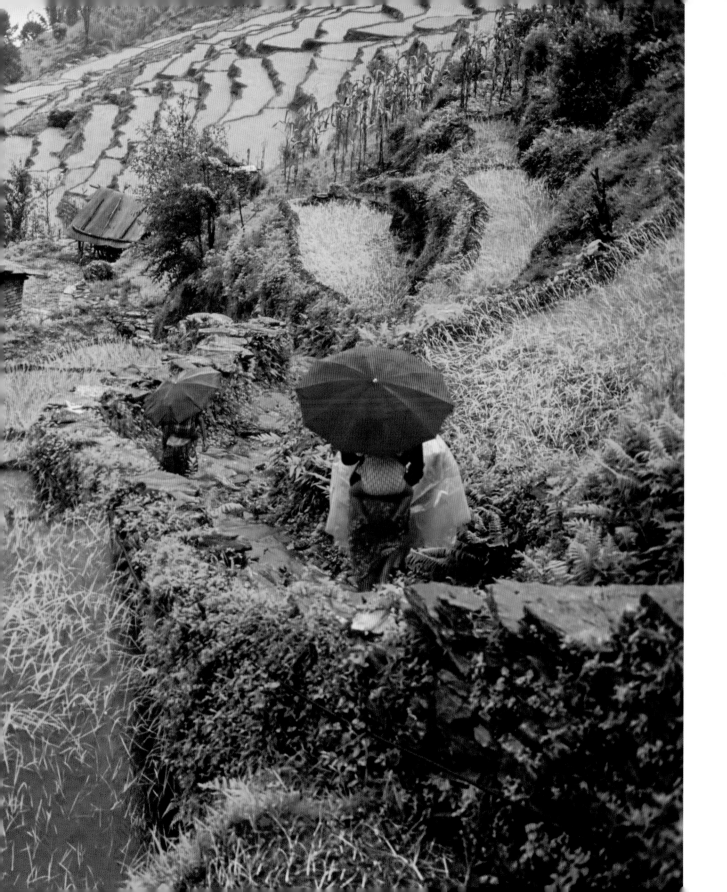

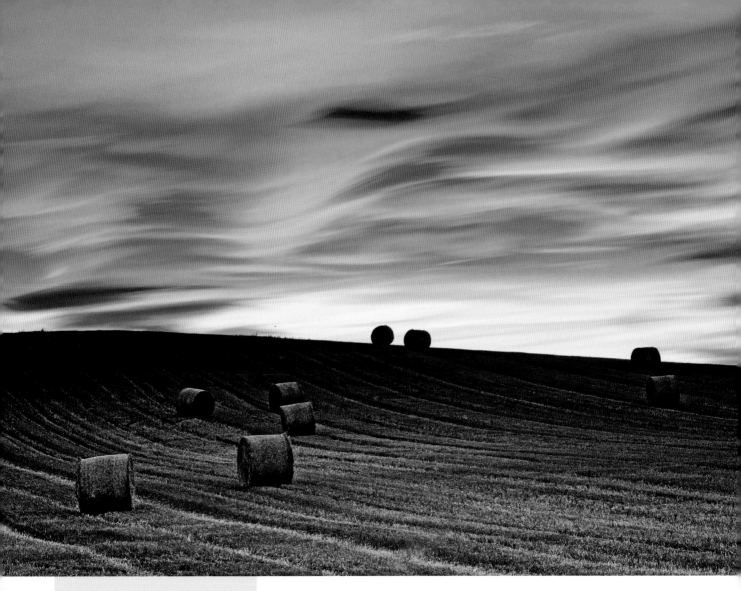

PRO TIP

Fields of ripened and harvested crops have immediate impact when viewed through your own eyes. Unfortunately, when this is translated to two dimensions in print, the swathe of colour – or bales of straw – occupy a thin strip. To give your picture impact, you need to get up higher, or find a field that slopes, to provide some vertical depth.

Harvest

After maturity the crops are harvested and in most cases what is left is photographically uninspiring, but harvested wheat remnants are gathered into bales of straw, and they make wonderful patterned landscapes, rich in colour and texture. Photographers love them, though they have become a bit of a cliché – it's up to you to try and do something different with them; for example, try using black and white, limit depth of field, or juxtapose it with farm implements. A little imagination can create a powerful image out of a familiar scene.

ABOVE A scene that pushed the human eye to its limit, never mind the limited capabilities of the film I was using. The application of two stacked 0.9ND graduated filters held the contrast sufficiently, albeit with a surreal effect on the sky due to the sun setting through the moving clouds.

• Pentax 67II, 55–100 zoom, 0.9 + 0.9ND grad stacked, f/13 at 6min, Velvia 50 •

ON LOCATION

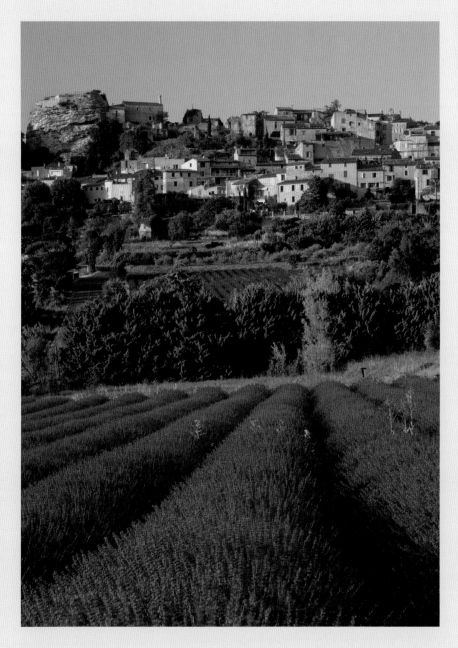

Location: Mezel, Provence, France
Season: Summer
Weather: Clear blue skies, limited cloud cover

There are few more classical agricultural landscapes than the lavender fields of Provence, in the South of France. Even the most artistically challenged can hardly fail to register delight at the perfect precision presented by row after row of purple-blue lavender bushes; the intoxicating fragrance and the thrum of a million bees all add to the delight. Every year, in late June through to early July, the lavender reaches its peak colour and thousands of sightseers and photographers alike descend on the rural regions of Provence, touring the lavender routes.

LEFT Saignon, Provence, France. The two staggered lavender fields were conveniently situated on a slope with a stunning backdrop. Having ascertained the best viewpoint, I returned later and the setting sun illuminated the town and fields, to show both at their best.

• Pentax 67II, 55–100 zoom, polarizer (backed off from maximum), f/22 at 1sec, Velvia 50 •

Generally speaking taking photographs in the middle of a summer's day is far from ideal, but with this crop it can actually be a benefit. Hard, direct overhead sunlight creates very short shadows; even when a polarizer is attached little detail is lost as the black areas are tiny. Atmospheric haze, usually the angel of death in fine landscape photography, surprisingly assists, exaggerating the sense of distance and scale, while the blue reflected light from a near cloudless sky enhances the colour of the lavender.

When I arrived at the lavender fields near Mezel I was completely captivated by their sheer scale. Although, I could clearly see the patterns generated by the lines of lavender I wanted something extra, a focal point on which the viewer's eye could rest. A lot of the fields were devoid of just about anything to break the skyline, but one of them contained an old ramshackle stone shed with a red pan-tiled roof. Here was my centre of interest, and although it wasn't the nicest-looking stone building I had ever seen at least it was distinctive and clearly broke the flow of converging lines. I made my way to the edge of the field and set up on some chalky soil adjacent to a particularly well-manicured line of lavender. This would be my immediate foreground element and I wanted it to be as immaculate as possible. The tripod was set to its maximum height – I needed to get some vertical depth. I placed the shed on a power point a third of the way into the frame for an off-centred classic composition and attached a polarizer to saturate the colours and remove some of the reflected light; finally, I used a one-stop graduated neutral- density filter to deepen the sky colour just a little more. Depth of field was critical – I wanted absolute sharpness from front to back.

I used the smallest aperture at my disposal which was f/32 and set the hyper-focal distance a third of the way from the bottom of the frame, doing a quick visual confirmation with the depth of field preview; at the same time taking the opportunity to align the filter to the horizon.

I have an aversion to plain blue skies but, as luck would have it, I could see some cloud patterns lining up out of shot, so I waited until they appeared in the viewfinder. I noticed that they were forming into converging lines, creating a visual echo of the lavender. A meter reading was taken from the sunlit green stems, the mirror locked up and the exposure made.

In a situation like this, where the light isn't changing much, I had plenty of time at my disposal to photograph both upright and landscape compositions. Lavender fields are always marketable and gathering a wide variety of images increases the likelihood that they will sell.

BELOW Mezel, Provence, France. The little stone shed, was the only object conveniently close by that would serve to break the repeating lines of converging blue lavender. I set the tripod as high as it would go to create some vertical depth to my composition.

• Pentax 67II, 45mm lens, polarizer, 0.3 ND grad, f/32 at 1/2sec, Velvia 50 •

FIELD TRIP: URBAN LANDSCAPES

Urban scenics offer huge diversity for the landscape photographer. Towns, cities and other infrastructures can sometimes appear lacklustre during daylight, but at twilight the urban structures' own artificial lighting supplements natural light, making it far more interesting.

Grand Scenic

This is the classic urban overview, the entire structure or city interpreted in one frame and likely to be taken from some considerable distance away from it. In order to make these shots work you need light of the very highest quality and a strong composition to match. Every single person that has visited your choice of urban structure, whether it be a cathedral, a bridge or even an entire city will probably have taken a photograph from the exact same position. Your unique selling point boils down to finding an unusual viewpoint and extreme lighting. If time is limited then postcards are an excellent way to ascertain the choicest views.

RIGHT San Francisco, California, USA. I found a viewpoint that would just about shoehorn the Golden Gate Bridge into my 35mm frame. A 300mm lens meant a polarizer was needed to cut through some of the atmospheric pollution generated, and I waited for the bridge traffic lights to change, to freeze the motion of the cars.

• Contax ST, 300mm lens, polarizer, f/22 at 2sec, Velvia 50 •

BELOW St Marks Square, Venice, Italy – a popular subject that has been taken many times before, but here shot prior to dawn, when mist enveloped the canal. The motion of the gondolas blurred the boats whilst the mist created an uncluttered backdrop with limited colour.

• Contax ST, 28–85 zoom, polarizer, 0.45 ND grad, f/22 at 10sec, Velvia 50 •

Abstracting a View

An abstract view can mean getting in closer to a structure, taking photographs that give the viewer a recognizable sense of place, without depicting the whole of it – reflecting a familiar building in a puddle, or recognizable shapes that tell the viewer where the shot was taken. Or it could be even more vague, such as an un-named street scene that gives merely a suggestion of place. The ultimate expression of the abstracted view is to use shape, line and colour to create pictures where the subject matter is wholly unrecognizable and, more to the point, irrelevant. Without doubt, this is a great way of ensuring that your view of an urban scene is unique. In combination with a series of related works it can provide a powerful picture essay.

ABOVE Burano, Venice, Italy. The colourful houses hung with immaculately washed clothes are part of the Monday ritual of the citizens of Burano. A longer lens provides a sense of place, abstracting a flavour of the town or city without trying to tell the whole story.

• *Contax ST, 80–200 zoom, polarizer, f/11 at 1/15sec, Velvia 50* •

The Twilight Zone

Whilst it is perfectly possible to shoot at twilight and beyond in a wholly natural landscape, the gift of fine light more or less disappears with the setting of the sun. Occasionally you are left with a fine afterglow that is attractive in its own right, but it doesn't create enough illumination to put colour back into the land, and eventually all goes dark.

Mankind doesn't appreciate the curtailment of activity at sunset so we have learnt to supplement our own illumination, which glows at various colour temperatures, providing a mix of hues. When artificial lighting is approximately the same intensity as natural ambient light, then a period known as crossover lighting is reached and truly memorable pictures can result. This artist's palette of colours is not perceived particularly well by our own eyes but film and image sensors pick them up and record them all.

BELOW City View, Sydney. The blend of twilight and the incandescence of multiple artificial light sources is astonishingly beautiful, but the window of opportunity lasts a relatively short time – a period referred to as 'crossover' lighting. • *Contax ST, 80–200 zoom, polarizer, f/11 at 30sec, Velvia 50* •

Natural light sources do not tend to move about, but artificial illumination can, especially if it happens to be attached to cars, lorries and other forms of transport; long exposure will show up as traffic trails, which are confined to the city streets – position yourself above a busy and complex junction on a footbridge and some quite extraordinary pictures can be recorded with flowing lines of coloured lights.

Try exposures in the region of 40 seconds and if there's a lull in the traffic, simply cover the lens and then continue once the traffic reappears. A digital camera's LCD display is ideal for evaluating the length of time that the shutter should be left open.

RIGHT Blackpool Pier, England. Fairground attractions create trails of colourful lights. The Wagon Wheel on Blackpool's pier provided the inspiration for this delightfully simple twilight landscape.

• *Contax ST, 80–200 zoom, polarizer, (used as a two-stop ND filter), f/16 at 30sec, Velvia 50* •

ON LOCATION

Auckland city centre has a fine skyline with some interesting and complex shapes to it and one of the most distinctive buildings, the Silver Sky Tower casino, makes a great focal point. Looking at a city map I realized that I could position myself on the eastern side of the harbour and watch the sun sink behind the city. My plan was to photograph the city skyline reflected in the harbour at twilight.

Location: Auckland, North Island, New Zealand
Weather: Clear, cloudless skies
Time: 30 minutes after sunset

I got there early and scouted out a position that gave me an uninterrupted view across open water. It had been clear all day and I hoped I would see a rich colour gradient in the twilight sky. The plan was to shoot when the ambient light was within a stop or so of the city's artificial lights. As I set up the camera it became apparent that this particular evening was going to be magnificent. As darkness fell I finalized my composition. A long lens eliminated foreground clutter and simplified the view, leaving enough space in the water to pick up any illuminated reflections. It also negated the problem of converging verticals, ensuring that the buildings remain parallel with the edge of the frame. A final positional adjustment prevents a crop through any significant building on the skyline.

Although the water surface is a little choppy I am pleased to see that the reflected colour is still apparent. Since the shutter speed is likely to be relatively long the result should be a hazy blur of mixed colours. Depth of field is not critical so I choose the lens' best performing aperture, f/11, as the basis for my overall exposure. During the next few minutes I use my spot meter frequently to ascertain the period of crossover lighting. The one-degree measurement area is very useful for picking out the exact spot to meter from. No filters will be necessary as the exposure is inherently based on a balance of lighting.

LEFT Auckland, North Island, New Zealand. The mesmerizing, beautiful, twilight wedge of earth's shadow settled above the Auckland skyline, staining the marina in soft pink light.

• *Contax ST, 28–85 zoom, polarizer, f/11 at 4sec, Velvia 50* •

For a limited time there is an opportunity to make several exposures, albeit of fairly lengthy duration. Positive bracketing, i.e. biasing longer exposure times, is a sensible option, particularly if you use film which has characteristics known as reciprocity failure to contend with. Exposures longer than ten seconds need additional time added to compensate for loss of sensitivity. Technically there is a colour shift too, but this can be used to your advantage to create some genuinely beautiful and surreal results.

PRO TIP

Virtually all camera lenses perform best between f/8 and f/11. If there are no extenuating reasons for selecting extensive depth of field and the shutter speed choice is not relevant to your composition, make this the aperture of choice.

BELOW Auckland, North Island, New Zealand. As crossover lighting approaches and ambient light balances with artificial, city scenics are often revealed at their best. Shooting across open water creates diffused reflections of the various illuminated buildings.

• *Contax ST, 80–200 zoom, f/8 at 40sec, Velvia 50* •

Post-processing

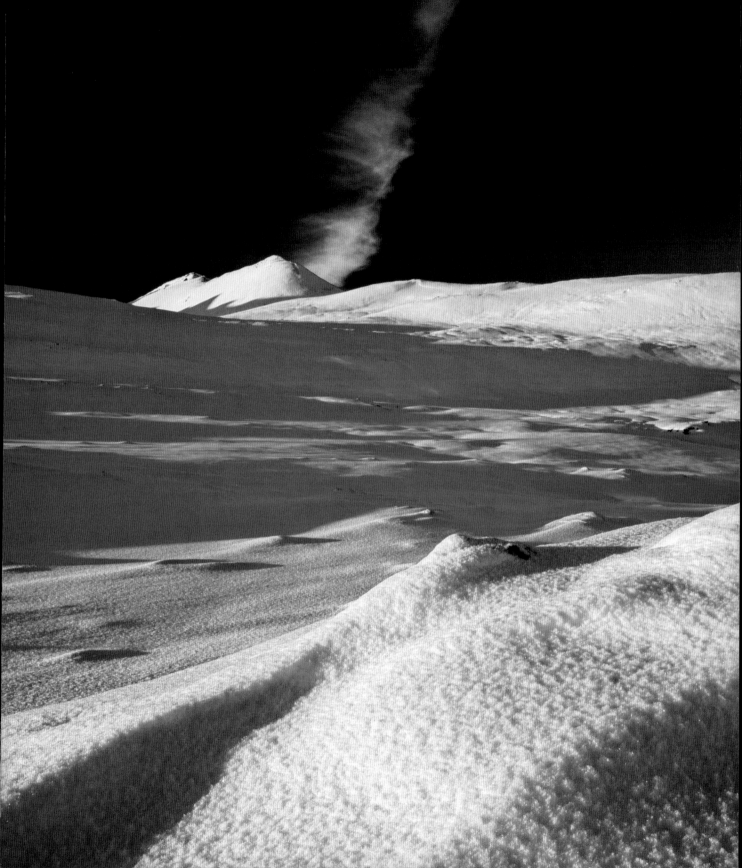

CONVERTING PHOTOGRAPHS FOR PRINT OR DISPLAY

Generally speaking, the less post-processing that is needed, and the less time I spend at the computer, the more I enjoy the business of photography. My preference is to get it right at the picture-taking stage, so that most of the donkey work has already been done.

Now that you have the photographs, you need to decide what you want to do with them and convert them to a form that you can print or display. It is likely that you will want to do this in such a way that a person with remote access can see it the same way that you intended, namely with identical hue, saturation and contrast.

Included within this chapter are diagrams and screen grabs showing the route through post-processing, which relates to digital and film.

Let me guide you through my own digital workflow, one that has been tested rigorously and one that works for me. It won't suit everyone, but it does provide a valuable starting point from which you can adapt your own.

There are many books dedicated to post-processing and colour management, but remarkably few give definitive settings and values. I will start from the opposite premise, giving you the parameters that I use, and include some background information to justify my decisions.

Post-processing can be broken down into three phases:
- Image Input
- Image Processing
- Image Output

Before transferring all your images, it is worth doing a preliminary sort of the shots that you have taken. Digital images can be quickly reviewed on the camera, or by using a display storage device. Check for image sharpness and eliminate all those that don't come up to standard. The tremendous flexibility offered by Raw capture and subsequent Raw-processing software means that even quite severe exposure errors are recoverable.

Film is not quite as versatile; either it is a good, well-exposed and sharp image, or it isn't. Check it under a magnifying loop on a light box – if it doesn't measure up, or it's overexposed, you might as well bin it. If there's a hint of underexposure, there is some latitude left to recover the image in post-processing. With transparency film the image is ready for projection – mounting it in a plastic case may be all the post-processing you ever need.

I prefer to assume that your photographs are so good you will want to share them with others, either as prints, or as web-based images and to do this we must get the image into the computer.

PRO TIP

Don't waste your time and effort trying to create a silk purse from a sow's ear. Put your efforts into an image that is already of high quality and consequently worth the effort.

PRO TIP

Whenever possible work with 16-bit images and refrain from applying any image sharpening until the output stage of your post-processing workflow.

IMAGE INPUT

Digital cameras present two options for capturing an image – they can either be saved as Jpegs of varying resolution which take up less memory space, or as digital Raw files.

Raw Capture

Raw files are completely unprocessed representations of the captured image. They are superior to Jpegs and offer greater flexibility at the post-processing stage. The shooting parameters are applied later with Raw converter software programmes. Some of the best third-party software offers an incredible array of features, almost taking the place of editing programs such as Paintshop Pro and Photoshop in its various guises.

If the Raw option isn't open to you, it doesn't mean your digital camera can't be used. Select the finest quality Jpeg compression on offer. Provided you take into account the information presented in the previous chapters of this book, then superb quality can still be achieved. To get the best out of in-camera Jpegs use the following settings:

- Select finest-quality Jpeg
- Choose Auto white balance or cloudy white/bright
- Select unsharpened OR no sharpening
- Select Adobe RGB (1998) not sRGB (colour mode).

Once the Raw image is adjusted, or a fine-quality Jpeg image is downloaded, you will need to save it in a meaningful location, preferably using a name that describes both the image subject and the state it is in.

Scanning

Transparency film is the analogue equivalent of a digital camera's Raw file. All the information captured is on a transparency, but chemistry is needed to make it visible. Thereafter, you merely need a device that will accurately transpose this visual information into a bitmap image. A scanner is just such a device – they come in all ranges from cheap, table-top flatbed scanners, right up to horribly expensive specialist drum scanners costing vast amounts of money.

My own preference is to use a transparency scanner, as they are reasonably fast, offer very high resolutions and are capable of extracting all the detail of the original slide in both highlight and shadow. I use a Nikon 9000ED with a glass carrier – it is capable of scanning negatives or transparencies up to 2½ x 3½in (6 x 9cm) and produces quality that is commercially acceptable, providing that your source material is of the best quality. For 35mm users I would recommend either the Nikon 5000ED scanner or the slightly cheaper Nikon V.

Once the hi-res scan or the images from the digital camera are in a state that can be interpreted by suitable image-processing software, they can be saved as 300dpi unsharpened 16-bit Tiffs, tagged with the working profile Adobe RGB (1998); this is the commercially accepted standard for high-quality RGB images. Only the pre-press environment works with CMYK. Tiffs enable further post-processing work to be done, minimizing damage to your re-saved and newly processed image.

PRO TIPS FOR SCANNING

- Scan at the largest dimensions you are likely to want at 300dpi
- Critically adjust colour and contrast in preview prior to final scan
- Scan using the attached profile Adobe RGB (1998)
- Scan in 14- or 16-bit mode
- Scan un-sharpened only
- Use multi-pass scanning to eliminate colour noise in dark images

IMAGE PROCESSING

There are many different types of processing software: Paint Shop Pro, Photoshop Elements, but the heavyweight champion and undisputed world leader is Adobe Photoshop, its latest guise being Photoshop CS3. Most photographers will use less than 5% of its capabilities and it's not cheap. All references, from this point on, will apply directly to the full Photoshop CS (+) package; this is the processing software which has become the industry standard. From Photoshop 7 onwards colour management is fully integrated into the package and Photoshop CS onwards is capable of 16-bit processing.

We are now in a position to begin some basic colour and contrast correction. Please accept that there is any number of ways to skin the proverbial cat, my methods may seem simplistic, possibly even crude, but the solution is effective and arrived at with minimal fuss, taking very little time to complete. From download to print-ready file, I can complete the entire post-processing workflow in less than six minutes. Choose whichever technique works best for you.

Colour Management Options

Initially, Photoshop needs to be set up with certain parameters located under the edit tag in colour settings. This is related to colour management and ensures the correct working profile is assigned to all images imported into Photoshop. Mine are set up as below:

This is a vital stage don't ignore it, you should tackle this before anything else and once set up correctly you can more or less forget it and know that it will deal with any new or imported files in a consistent and controlled manner, asking the relevant questions of you before you commence any post-processing on your images.

The list below represents the order in which I deal with each imported image and the final result is a fully adjusted 8-bit image file that has been colour and contrast corrected then re-saved as an unsharpened picture. From there it is a simple matter of using the corrected image to output it either for web use or as a fully sharpened colour-managed print.

1. Crop for composition (crop tool)
2. Clean up image (healing tool)
3. Adjust to size (image size)
4. Adjust for full tonal range (levels)
5. Adjust hue (colour balance)
6. Adjust contrast (curves)
7. Adjust saturation level
8. Make local adjustments to colour (replace tool)
9. Make local adjustments to contrast (dodge, burn)
10. Convert to 8-bit image file (mode 8 bit)
11. Apply noise reduction (neat image)
12. Save as 8-bit file (unsharpened)

LEFT Photoshop Toolbox

1. Crop for Composition

- In Photoshop open the image you wish to work on.
- Using the crop tool, select the portion of the image you wish to use and exclude any black borders or intrusive objects that compromise your picture. Right click and select crop.
- Applying minor rotation at the crop stage, and ensuring the boundary lines are maintained inside the image, is a useful way to correct tilted horizons.

2. Clean up Image

This is best done with the healing tool. Most images have dust spots on them but, although scanners that incorporate ICE 4 are very effective at eliminating them, the digital sensors on cameras are extremely prone to collecting dust and sometimes have dead pixels (red, green or blue spots). Use the healing tool with the image at 100% size and go over each section of the image meticulously.

3. Adjust to Size

Under the image tab, select image size and adjust your picture to the desired document size. It is recommended that you keep the image size as large as possible at this stage, as it's easier to reduce and retain information than to try and gain it back from a smaller image file. Ensure your resolution is maintained at 300 dpi for whatever size you eventually select.

4. Adjust for Full Tonal Range

A quick check under the **Image > Adjustments > Levels** tab will indicate the tonal range of your image. See the example below.

5. Adjust Hue

Under **Image > Adjustments > Colour** balance you are able to alter the hue of the entire image and bias its effect towards shadows, mid-tones or highlights. The easiest way to see if your image displays a colour cast that needs correcting is to find a neutral grey area on the image and a near white area. Colour casts are easier to see and easier to correct when you find these on your picture. Ensure preview is ticked to review the changes in real time.

6. Adjust Contrast

Although you've already completed levels adjustment to elicit a full range of tones from dark to light you can accentuate the mid-tones by adjusting the contrast around this area using the curves tool.

By generating an S-curve around the centre point of the curves grid, contrast is significantly increased, but not at the expense of damaging the highlight and shadow areas. A reverse S-curve can be used to soften contrast. Whatever adjustment you use, be aware that a subtle change is all that is usually needed. The S-curve depicted above is an extreme example used for effect.

Pixels are not as resilient as you might think: they do not take kindly to being pushed, pulled and stretched too far. My approach to post-processing is strictly MNC (Minimum Necessary Change).

Adjust Saturation Level

Adjusting curves (previous page), will bring about an overall change in the contrast of the image, but it should leave the white and black points untouched, as these points do not deviate from the straight line of your original curve. However, any change of contrast will also affect the overall saturation of an image, probably beyond acceptable limits. Using the Hue/Saturation control located under the tab **Image > Adjustment > Hue/Saturation**, will bring up the control box above; moving the sliders will allow you to change not only the overall saturation of your image, but the ability to shift the saturation, hue and brightness of any one of six different hues, cyan, magenta, yellow, blue, red or green. This amazing flexibility is incredibly powerful and can be used to rapidly correct for any unpleasant colour casts.

Make Local Adjustments to Colour

Occasionally, when an image is imported into Photoshop and opened, and you have completed the earlier adjustments to overall colour balance, you will find that one or more of the hues in your photograph is not quite right, while others seem perfect. The replace colour tool is an excellent solution to the problem. Under the header tag **Image > Adjustments > Replace Colour** you will find the work box presented below.

Ensure preview is ticked and use the eye droppers in conjunction with the fuzziness control to select the colour you wish to alter, together with the tolerance hue of that selected colour. This can be reviewed within the monochrome representation of the actual image. Once the fuzziness slider is optimized then the hue, saturation and brightness can be adjusted with the three sliders below. This is a very powerful and useful tool, although an extreme example is shown here.

Make Local Adjustments to Contrast

The very last tool I want to discuss is another unique feature to Photoshop CS and later. Again it is very powerful and does a superb job of increasing detail in the highlight and shadow areas. Do remember if there is no detail present in the extreme bright and dark areas to start off with, you will simply generate noise, an unpleasant artefact of pushing Photoshop's abilities too hard.

Image > Adjustments > Shadow/Highlight and then immediately tick the 'select more' options box. The above dialogue box should result, which will permit good control over the highlight and shadow areas, followed by a contrast and colour adjustment associated with the settings you have adjusted. I would recommend keeping the highlight and shadow sliders towards the left ends of their respective scales, and the radius relatively small. Overuse will result in image halos.

Convert to 8-bit Image File

At this stage you are, hopefully, left with a fully prepared and colour-corrected 16-bit 300dpi unsharpened RGB Tiff, at the maximum size you will ever require. It is likely that the image will be huge, and now that you have completed all your adjustments it is time to reduce the 16-bit file to an 8-bit file. At present no printer works with 16-bit colour info. In the Photoshop header tabs go to **Image > Mode>** then tick **8 Bits/Channel.**

Apply Noise Reduction

Photoshop is such a powerful image-processing program that most plug-in packages are of dubious benefit. **Neat Image Pro +** is one that I recommend; it works in conjunction with Photoshop under the Filter tab. Neat image effectively eliminates any trace of noise, smoothing out continuous tones in a seamless way. Below is a typical screen shot of Neat Image in action. I use it in Auto mode, which I've found to be excellent – noise reduction is carried out with just three button presses.

Save as 8-bit File

The final stage of my post-processing workflow is to re-save the 8-bit image over the top of the 16-bit version that we were working on. Since there are currently no options for 16-bit printing and our image processing is complete, there is little point in taking up the extra hard drive space demanded by the 16-bit file. From now on, whatever your future requirements for the image, you can use this file as the reference point and prepare it for printing or for publishing on the World Wide Web, secure in the knowledge that you have squeezed every gram of quality out of it.

Those familiar with Photoshop and its commercial equivalents will notice that I haven't yet made reference to sharpening the image. This is dealt with in the forth-coming sections (Image Output), but suffice to say that this should be done at the very last stage prior to printing or placing on a website. The amount that an image is sharpened and the technique used depends amongst other things on the final size of output, so it makes sense to leave the saved 8-bit image in an un-sharpened state.

IMAGE OUTPUT

- Digital Printing
- Web image Output

At some stage, after all the image processing has been carried out, it is likely that you will want to launch your picture on the unsuspecting world – this usually takes one of two forms: either a digital print on an inkjet printer or as presentation for display on a web page.

Digital Printing

The holy grail of print production is to make the print output identical to the image viewed on the computer screen. Although it is an unattainable goal, a very good approximation is possible, but this assumes that you operate in a colour-managed workflow. Part of that workflow is to ensure that your monitor operates to a known and calibrated reference. You can liken this to walking into an electrical wholesalers – if you turn on one television the colours will probably look perfectly OK in isolation, but turn on all the other televisions and it will quickly be apparent that each is different – which is correct? A Spyder is a device that is used to calibrate a monitor and it does it by referring reference colours to a look-up table. The profile is then stored in a designated area of colour management-savvy-image processing software, such as Photoshop.

Managing Colour

Assuming your monitor is calibrated and you have been using the working profile of Adobe RGB (1998), then the chain of colour management can be carried forward to the printer.

All inkjet printers have built-in paper profiles that they call up automatically and utilize for fine-quality print output. The system works well, provided you don't want to use another manufacturer's paper. If you do, then you need to install additional paper profiles specific to your printer, that take into account the type of inks used and the paper you have selected. These profiles have to be placed in a designated area so that the printer can look them up and use them. Paper profiles can be obtained free from the paper manufacturer's own websites, specific to the model of printer you use.

It is worth reiterating at this point that only the full Photoshop package from version 7 upwards is fully colour managed.

Preparing to Print

The general workflow for printing is as follows:
- Open 8-bit RGB 300dpi Tiff (Adobe RGB1998)
- Adjust to desired size 300dpi
- Sharpen
- Save as Name_(print size)_(S or U)_ (Paper type)
- Print

OPEN FILE

Open your recently stored 8 bit Tiff and view at full size on the calibrated monitor. A quick check should confirm it is tagged with a working profile Adobe RGB (1998).

ADJUST TO SIZE

Image > Image Size: Ensure that the original file is 300dpi and then specify the dimensions of your print – they will remain in proportion unless otherwise specified.

SHARPEN

Once the file is re-sized for output and is fully adjusted to the contrast and saturation levels of your choice, this is the time you should sharpen your print in preparation for output and is the very last action you should do.

Under the Photoshop tabs go to **Filter > Sharpen > Unsharp Mask** and choose the following parameters:

- Amount 225%
- Radius 0.5 to 0.7
- Threshold 0

It is always worth experimenting with these values, but I have found these to be perfectly adequate for most landscape photographs up to A3 size.

There are some much more sophisticated sharpening packages available on the market today. Nik Pro Sharpener is a very powerful but expensive tool that does a superb job of selective area sharpening.

SAVE AS (FILE NAME) + (PRINT SIZE) + (S) + (PROFILE)

Once an image is sharpened for a specific size and for a specified paper, I save it in a suitable location. The print files are labelled with the common file name, the relevant saved size (16 x 12), whether or not it has been (S)harpened and finally the paper profile (Ilfo) is appended.

PRINT

The print is ready for output. If you are choosing to use the printer's own recommended papers, it is simply a case of following the printer's instructions. Usually the quality is perfectly acceptable as the in-built profiles have been set up accurately by the manufacturers. Should you wish to use third-party papers, the generic profile is supplied with a list of instructions relating to your printer; these should be religiously followed and, once that has been done, you can expect high-quality output.

WORD OF WARNING

Over-sharpening an image looks considerably worse than one that hasn't been sharpened at all. It takes the form of white halos on defined edges and increased granularity in even-toned areas. It should be avoided at all costs.

Web Image Output

Digital photography has come of age and whilst a hard copy output of your work will always be wanted, the photographs are just as often viewed on the World Wide Web. The limitations of screen resolution, capacity and time taken to download or upload images, requires quality compromises.

However, it is likely that given these limitations you are still going to want to ensure that your client/friend sees quality images and that they appear on their monitor as an entirely accurate representation of the image that you are seeing on yours.

Once again a couple of assumptions have to be made:
- Your monitor has been properly profiled
- Your client/friend's monitor has been properly profiled.

Needless to say if your client/friend's monitor isn't profiled, then there is little hope that they will be able to view your image as it should be.

Let's assume that you want to prepare a crisp and colour-correct 800 pixel-wide version of the original 8-bit 300dpi, Adobe RGB (1998) profiled, Tiff file, previously saved on your computer.

This is the workflow that I've adapted from a technique used by a fellow photographer and colleague, Marc Adamus.

- Open file
- Adjust size
- Sharpen
- Sharpen
- Adjust to final size
- Convert to Monitor Profile
- Save for web

Open File

Open the original, unsharpened, colour and contrast-corrected 8-bit 300 dpi 16 x 12in Tiff file. Currently it should display with the working profile Adobe RGB (1998) attached to it.

Adjust Size (intermediate)

Presently, the full-sized Tiff image is in the region of 5000 pixels wide, much too big to display as a web image, which in any case can only resolve 72dpi on screen. Select Image > Image Size and in the appropriate dialogue box space type width 1800 pixels. Ensure that the image changes size proportionally {tick} relevant boxes.

1st Sharpen

In Photoshop go to **Filters > Sharpen**.

2nd Sharpen

Once again go to **Filters > Sharpen**. If you are looking at your image at full size, you will see that the image has been grossly over-sharpened, has haloes around the edges and displays acute granularity. In short it looks terrible (see below).

Adjust Size (800 pixel)

Now the magic bit, by simply reducing the image size to less than half of the intermediate size the granularity and haloing disappears, leaving a crisply sharpened image with no artefacts, perfect for displaying on the web.

Try experimenting for yourself around the values given, for smaller web images (500 pixels), an intermediate size of 1600 pixels should provide a nice crisp image free from artefacts.

ABOVE Sectional crop from 1800 pixel image after 2x sharpen routines.

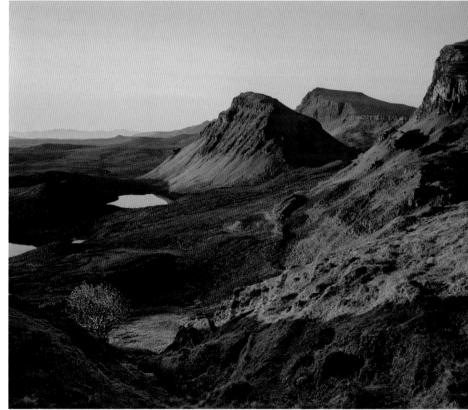

Convert to Monitor Profile

The penultimate stage in the process is the preparation for displaying your image, as you yourself see it, on another person's, hopefully, colour-corrected monitor. It simply involves changing the existing working profile Adobe RGB (1998) to the monitor profile (already saved in your system).

In Photoshop go to **Image > Mode > Convert to Profile** and then from the drop- list pick your current monitor profile – mine is currently **PhotoCal 050707**. It was sourced from the available list of colour profiles stored in the computer, and inserted there automatically when I created a monitor profile with the Spyder device mentioned earlier. Next, make the rendering **Intent > Relative Colorimetric** .

Save for Web

The final stage is to save your image for the web using the Save for Web function. It offers the greatest flexibility when it comes to maximizing the efficiency of file-size generation, although some initial setup of the **File > Save for Web** function is required (see dialogue box right).

GLOSSARY

Adobe RGB
A working space profile considered best for printing images.

Aperture
The variable opening on a lens through which light passes on its way to the camera sensor – relative size denoted by f-stops.

Artefacts
Unwanted noise or visual anomalies present on a digital file.

Bit Count
Related to digital resolution – a high bit count represents higher resolution.

Bracketing
Exposures marginally darker and lighter than the metered exposure – used to offset problems with exposure error.

CMYK
Cyan Magenta Yellow-Key (Black) – four-colour pre-press, used mainly for publishing.

Colour-compensating Filters
Filters used to offset light of different colour temperatures (see colour temperature).

Colour Management
A system that provides solutions to match colour across a variety of devices.

Colour Temperature
Descriptive term relating to the colour of a light source, with reference to a known standard reflectance.

Colour temperature is measured in Kelvin – cool colours have a higher Kelvin rating, warm colours are lower.

Depth of Field
The amount of an image that is considered acceptably sharp, extending from foreground to background – one third in front and two thirds behind the point of focus.

Depth of Field Preview
An option provided on many cameras. It enables the photographer to get a visual indication of the depth of field by viewing the proposed composition through the stopped-down or picture-taking aperture.

Digitally Blend
A method by which the most suitably exposed elements of two or more images are digitally blended together using image manipulation software to form one photograph with full dynamic range.

Display Storage Device
A hard drive with a visual display interface for viewing stored images.

Dpi
Dots per inch – a resolution usually applied to printed output.

Dynamic Range
The ability of a device to retain detail in the darkest and lightest areas of an image.

Exposure Value (EV)
A combination of both f-stop and shutter speed, usually found on independent exposure meters.

Film Speed
Relates to the sensitivity of film (see ISO).

f-stop
A fraction of the diameter of the aperture of a lens. 'f' represents a lense's focal length.

Graduated Neutral-density (ND) Filters
Filtration used to manage dynamic range within a scene – the filters display either a sharp or gradual transition from transparent to various degrees of translucency, but with no apparent colour shift.

Grain
Clusters of silver halides that clump together following development of film – the digital equivalent of noise.

Hyper-focal Point
A critical point of focus that evenly distributes degrees of sharpness between the furthest and nearest elements of a framed image.

ICE 4
A highly effective infrared scratch removal system incorporated by Nikon scanning software, its latest guise being ICE 4.

ISO Rating
International Standards Organization representing the sensitivity of film.

Jpeg
Joint Photographic Experts Group – the industrial standard for compressing image files.

Kelvin (K)
A scale used to measure colour temperature.

Magnifying Loop
A corrected magnifying lens used to check the quality of the exposed film.

Megapixel
One million pixels.

Memory Card
A removable storage device for digital cameras.

Mirror Lock-up
Locking a mirror up prevents vibration being transmitted when the mirror snaps out of the way. Modern digital SLRs require this feature to access the sensor for cleaning.

Multi-zone 3D Matrix Metering
A very sophisticated means of mapped metering present in various forms on all modern cameras.

Neat Image
Professional noise reduction software plug-in.

Neutral-density Filters
Translucent filters that modify overall exposure times with no apparent colour shift.

Nik Pro Sharpener
Professional sharpening software plug-in.

Noise
Random stray electronic data, the digital equivalent of film grain, which degrades the quality of the recorded image more seriously at increased ISO.

Pixels
Picture elements – the individual units which make up a digital image.

Polarizer
A filter used by landscape photographers to removes surface reflections and enhance colour.

Profile
A data file in a standard format defined by the international colour consortium that describes the colour behaviour of a specific device.

Raw Capture
A digital file format incorporated in digital cameras – the shooting parameters are present but not applied.

Raw Convertor
Software used to apply embedded information from raw capture and convert to a format understood by image- manipulation software.

Reciprocity Failure
A diversion from the normal rules of reciprocity exhibited by film-based cameras, particularly when long exposures are employed. Under exposure and a colour shift result if additional compensating time and colour compensating filters are not added.

Scanner
A device for transposing hard-copy pictorial images into a high-resolution bitmapped image that can be interpreted by image-manipulation software.

Schleimpflug Principle
A technique employed by large-format camera users to extend usable depth of field massively. These cameras are capable of manipulating the plane of focus.

Shutter Speed
The duration that light is permitted to reach the image sensor or film through lens aperture.

Spot Meter
A reflectance light meter for metering very small areas.

Spyder
A hardware device used to calibrate a computer's monitor to a known reference standard.

sRGB
A working space profile considered best for viewing web-based images.

Tiff
Tagged Image Format File. An industry standard image file format that features lossless compression (LZW).

Transparency Film
Chemically processed positive film viewed transmissively on a light box or projector giving superb colour fidelity.

Tungsten Light
Artificial illumination by tungsten filament lamps creating extremely low colour temperatures resulting in extreme colour shifts.

White Balance
Colour-temperature compensation for digital cameras.

FURTHER READING

Below is a list of books that I would recommend as further reading; each has made a tangible impact on my own photography, whether through technique or inspiration.

If you only ever read one book on landscape photography make sure it's this one: *Mountain Light* by Galen Rowell (Sierra Club, 1986) – Inspiration, admiration and groundbreaking photography.

The Making of Landscape Photographs **Charlie Waite** Collins & Brown C&B 1992 (Publishing Date)	An inspirational man utilizing Hasselblad square format cameras.
Photos That Sell – The Art of Freelance Photography **Lee Frost** David & Charles D&C 2001 (Publishing Date)	How to get started in the world of freelance photography – thought provoking and genuinely helpful.
John Shaw's Landscape Photography **John Shaw** Amphoto 1994 (Publishing Date)	Superb book with strong images and great technique that is explained in a straightforward manner.
Creative Landscape Photography **Niall Benvie** David & Charles D&C 2003 (Publishing Date)	Strong technique-driven book with some great ideas.
The Backpackers' Photography Handbook **Charles Campbell** Amphoto 1994 (Publishing Date)	A really excellent small-format book with strong images and superb field-based technique – a good read and highly recommended.
The Photoshop CS2 Book for Digital Photographers **Scott Kelby** New Riders (Voices that matter) 2005 (Publishing Date)	My first choice for Photoshop techniques written in a humorous, straightforward fashion with genuinely useful guidance.

INDEX

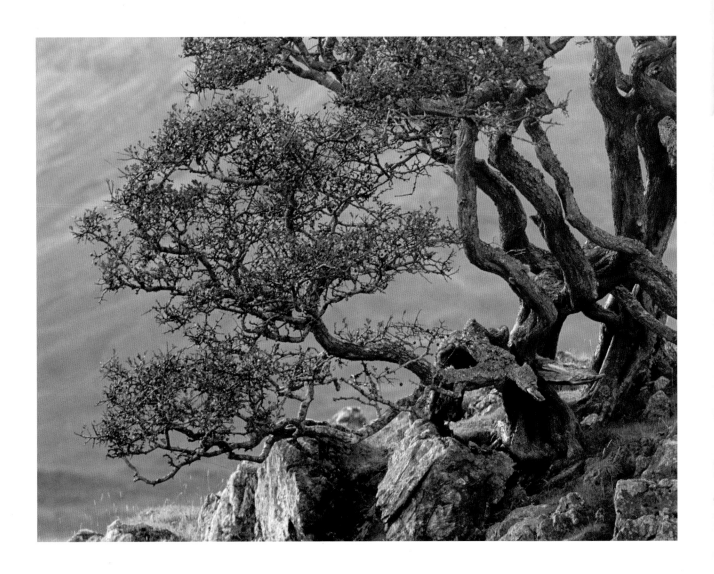

Photographers' Institute Press
Castle Place, 166 High Street, Lewes
East Sussex BN7 1XU, United Kingdom

Tel: 01273 488005 Fax: 01273 402866
Website: www.pipress.com

Contact us for a complete catalogue, or visit our website.
Orders by credit card are accepted.